HISTORY OF AMERICAN CERAMICS:

An Annotated Bibliography

by

SUSAN R. STRONG

The Scarecrow Press, Inc.
Metuchen, N.J., & London
1983

Library of Congress Cataloging in Publication Data

Strong, Susan R., 1944–
 History of American ceramics.

 Includes indexes.
 1. Pottery--United States--History--Bibliography.
I. Title.
Z7179.S85 1983 [TP798] 016.666'3'973 83-10046
ISBN 0-8108-1636-9

Dedicated to my family and to

the memory of my parents

CONTENTS

v

ACKNOWLEDGMENTS

I wish to thank Susan Myers, curator of the Division of Ceramics and Glass at the National Museum of American History, who allowed me to examine the books in her office; and Reggie Blaszczyk, who kindly showed me the office files and library of the Division. I also want to thank the staffs of Ohio State University Libraries, New York Public Library, Boston Public Library, National Museum of American History Library, Renwick Gallery, Smithsonian Institution, and Library of Congress. They were always courteous and helpful. I am grateful to many libraries that lent books, some of which were old and fragile.

The enthusiasm of Dr. Mel Bernstein has been important to this project; in sharing just some of his ideas with me, he has proposed work for a lifetime. Many thanks are due to Sue Bianco, interlibrary loan clerk at Scholes Library, New York State College of Ceramics at Alfred University, who located and borrowed hundreds of books over a period of years from libraries across the country. Terese Palmiter also requested many books on loan for this project. Shirley Creeley, student worker in the library, demonstrated professionalism and fortitude with unflagging cheerfulness in typing a difficult manuscript. The assistance of several people at the College of Ceramics was crucial.

Most important was the constant support of my husband and children, who encouraged me even when it meant a litter of paper and weekends without soup.

S. R. S.

INTRODUCTION

"Of the art of the potter in the United States there is not much to be said" [184, p. 161*]. This harsh judgment was passed by George Nichols after viewing the American ceramics display at the Philadelphia Centennial Exhibition of 1876. Another viewer remembered the display as a "mortifying showing" [211, p. 8], particularly when contrasted to the quality of European and Japanese ceramics. Abuse was general; the dismay of American visitors echoed the disparagement of European critics.

Distressed observers began to suggest methods to improve American artistry, perceived as "lower than any other civilized nation" [129, p. 187]. George Nichols, for one, fervently hoped that the Exhibition would have a great influence on American art education and art industry.

> The experience of other nations teaches us what we have to do, and how it is to be done. It is by technical education in public and special schools; by the study of great works of art; by the establishment of museums which shall be open to the public; by the organization of societies in the interest of special industries; by expositions of pictures, statuary, objects of ancient art, and of all products into whose composition art may enter. [184, p. 21]

The response to this humiliation was immediate, lasting, and remarkably productive, for it resulted in a national consciousness of the value of ceramic art. Cultural energies, stimulated from abroad by the first stirrings of the Arts and Crafts Movement, the establishment of art education programs, and the spectacle of international expositions, were suddenly focused and a series of artistic movements began which trans-

*Bracketed numbers throughout the Introduction refer to entry numbers in the Bibliography. Page numbers refer to those original sources.

formed American ceramics. Its literature was created at the same time; in fact, it is very difficult to find any books written before 1876 that discuss pottery in the United States.

What was the condition of American ceramics during the seventeenth and eighteenth centuries? One might almost think pottery did not exist here before the Centennial Exhibition and for all practical purposes, fine quality wares did not. Most elegant tableware was imported because foreign-made china was cheaper than American (until the tariff laws were revised at the end of the nineteenth century). The popularity of imported china also reflected a national tendency to look back to Europe for artistic inspiration and legitimacy. Jennie Young observed in The Ceramic Art:

> The foreign competitor comes branded as a genius, and home critics hesitate about issuing a verdict in favor of a countryman. They appear to have a lack of confidence in their own judgment, and would rather endorse or modify another's opinion, than take the responsibility of issuing an independent one of their own.... American art may be good, even equal to the best, but unfortunately it is American. [64, p. 444]

It should be noted that some recent revisionist critics view the Centennial Exhibition as the end, not the beginning, of American ceramics because of subsequent dependence on foreign-born styles.

The dominance of imports, which continued for nearly two hundred and fifty years after the first settlement, was so strong that American pottery manufacturers not only copied European designs, but also copied European marks (or did not mark their pieces at all) in the hope that native products would pass for the more fashionable imports. A few porcelain factories attempted to produce high quality wares but their successes were short-lived. Until 1876, even books on collecting and appreciating ceramics originated abroad. The few American publications were largely based on previous European compilations and concerned only with European and Oriental ceramics.

In spite of the flood of imports and dearth of written commentary, pottery in fact was made in the United States throughout this period. While porcelains and tablewares were shipped from Europe to American homes, obscure pot-

ters, neglected by historians, were making utilitarian earthenwares and stonewares in every colonized area. The work of folk potters, however, was not acknowledged by the art world of the eighteenth and nineteenth centuries. An appreciation of their craft grew only after the "discovery" of folk art in the twentieth century. Although kilns in America have been dated back to the early seventeenth century, and although there was undeniably an existing tradition of attractive utilitarian wares long before 1876, indigenous pottery was ignored by writers until the end of the nineteenth century. As a result, the literature of ceramics did not develop until Americans turned their energies to "artistic" pottery.

China-painting manuals were the first native publications. Art pottery catalogs, exhibitions of early studio potters, classic historical studies, works on industrial design, and advocacy of the revival of craftsmanship were subsequent areas of literary activity that recorded the development of American ceramics from Colonial times to the present.

A craze for china-painting overcame the country almost immediately after the Centennial Exhibition. Only one year later, John Sparkes, in Hints to China and Tile Decorators [117, pp. 9-10], noted: "With their characteristic enthusiasm (stimulated by the Centennial Exposition) our people are beginning to emulate the older nations of the world in their pursuit of this form of art." Significantly, Mary McLaughlin's China Painting [106] was also published in 1877 and it was reprinted many times as this pastime became increasingly popular.

The acerbic voice of M. L. Solon in his great bibliography, Ceramic Literature [9], excoriated the majority of manuals published not only in America but also in Europe.

> The number of ladies, young and old, who took to the fascinating pursuit of covering plates and vases with painted ornamentation of a nondescript style, was really amazing.... While the infatuation lasted, as soon as a fresh treatise on china-painting was brought out, it was sure to command a ready sale amongst the crowd of unwary probationers. A few good manuals were written by practical painters; but the majority was not above the common catch-penny pamphlet, compiled for the occasion by some obscure scribbler. [p. 491]

Time has not softened this judgment; I have included in this volume only the more prominent books on china-painting.

Most manuals may have been repetitive but an important few were significant links to the art pottery movement. Mary Louise McLaughlin, a Cincinnati native, was an influential author and decorator whose ambitions soon led her past painting "blanks." For instance, the technique that she developed in admiration of French barbotine ware and then described in Pottery Decoration Under the Glaze [107] became standard at Rookwood and other art potteries. Later she developed a fine porcelain body and decoration named Losanti ware. Susan Frackelton, author of Tried by Fire [101], experimented with local clays and salt-glazed stoneware, developed a portable kiln, and formed the National League of Mineral Painters. George Nichols, who hoped "to show that the manufacture of Pottery may become one of the great art industries in the United States" [111, p. iv], published a treatise on china-painting in 1878 illustrated by his wife, Maria Longworth Nichols, the future founder of Rookwood Pottery.

McLaughlin and Nichols, followed by Mary Chase Perry (founder of Pewabic Pottery) and Adelaide Alsop Robineau, ventured beyond the constraints of china-painting to more arduous (and male-dominated) skills; they began to experiment with difficult underglaze techniques and even throwing on the wheel. The art pottery movement was born from their trials and enthusiasm which coincided with popularization of idealistic tenets derived from the Arts and Crafts Movement, for "in the words of Miss McLaughlin, 'tidings of the veritable renaissance in England under the leadership of William Morris and his associates had reached this country'" [201, p. 119].

The Arts and Crafts Movement emerged from dissatisfaction with the monotonous labor and debased artistry that accompanied the Industrial Revolution.

> As the factories replaced the true craftsmen with semi-skilled laborers doing just one phase in the production of ware, standards of quality, good workmanship, integrity and pride in the finished product disappeared. With the increased use of machinery, workmen became less conscientious and the quality of the wares decreased considerably. [192, p. 64]

In reaction to mechanized industrial techniques, contemporary critics urged establishment of workshops and craft guilds that would revive the traditionally intimate relationship between artists and their work. This, it was hoped, would restore aesthetic quality and the harmonious social order of the past. Art potteries, small and creative, embodied the ideals of the Arts and Crafts Movement. They remained vigorous and popular until about 1920 when they were overtaken by industrialization and economic depression.

Confidence grew as art potteries succeeded and even won prizes abroad. When the Pennsylvania Museum held its second ceramics show, Exhibition of American Art Industry of 1889 [211], the judges felt it demonstrated a great improvement in artistic quality, a "really remarkable display." In 1892, Alice Morse Earle surmised that America "has had a larger manufacture of pottery and porcelain than is generally known" [37, p. 71]. Only one year later, Edwin AtLee Barber proved that Earle was correct. In 1893, he published the first edition of The Pottery and Porcelain of the United States [26], which has remained fundamental to the study of American ceramics. Although current researchers point out the need for corrections, the magnitude of Barber's accomplishment remains undiminished. He also published a collection of one thousand American pottery marks; "discovered" Pennsylvania Dutch slipware and collected it for the Pennsylvania Museum; published a glossary to standardize ceramics nomenclature; and issued guides to lead-glazed pottery, salt-glazed stoneware, tin-enameled pottery, and soft-paste porcelain.

Barber asserted,

> Foreign writers would have the world believe that the United States can boast of no ceramic history. I have endeavored here to present a condensed but practically complete record of the development of the fictile art in America during the three centuries which have elapsed since the first settlement of the country. [26, pp. iii-iv]

At least one foreign writer held firm to his belief; Louis Solon's disdain is a measure of how distant American ceramics were from general acceptance:

> It is questionable whether what [Barber] has to say about many a pot works which had existed only a

few years and was doomed soon to disappear should be noticed in a general history of ceramic art; but we do not doubt that parts of the book may be of interest to the American reader, who is the best judge of the true value to be attached to the meed of praise so lavishly and inconsiderately distributed by a most indulgent critic. [9, p. 16]

Solon also held a more generous view that "judging from what has been achieved during the past few years, the potter's art [in America] should soon attain a high degree of eminence. This is no longer a hope, but an absolute certainty." Apparently the future was one thing, but "the miserable results obtained by the half-skilled artisans" of the past was another.

Barber's history, published in several editions at the turn of the century, coincided with a serious effort to improve the technology of pottery, which was distinctly old-fashioned in America and abroad. Industrial potters relied on hand-me-down recipes which were copied into notebooks that were frequently kept secret. Most glazes and bodies were compounded on the basis of these recipes and hit-or-miss guesswork. In 1895, Karl Langenbeck published The Chemistry of Pottery [104], the first American text that attempted to establish a science of ceramics. Langenbeck found that "the information at command concerning the chemical needs of the potter has been so meager, that their efforts have been practically abortive" [p. vi].

Simultaneously, Charles Binns was preparing Ceramic Technology [93] for English potters, which proposed a central laboratory for ceramic research. Binns observed that rivalry of trade prevented pottery manufacturers from sharing information; advancement of knowledge would have to be forced by executive authority.

The most concerned potters banded together to form the American Ceramic Society in 1899. They urged establishment of ceramic schools, the use of scientific principles, and publication of scientific literature. At its first meeting, the founders proposed compilation of a manual for scientific calculation of glazes and a translation of the collected writings of a German ceramist, Hermann Seger. In 1906, the Society published the first American bibliography, John Branner's A Bibliography of Clays and the Ceramic Arts [3], a comprehensive work of 6,027 entries, greatly expanded from his 1896 edition.

America's first ceramic school was founded in 1894 by Edward Orton at Ohio State University. In 1900, the New York State College of Clay-Working and Ceramics at Alfred University opened under the direction of Charles Binns, now removed from England. Alfred became a leader in American ceramics because of Binns's powerful influence as a teacher and because he united art with technology at a time both were needed.

Heinrich Ries's country-wide survey of the clays and clay industries of the United States helped gather information necessary for exploitation of the country's resources. In 1909, he published History of the Clay-Working Industry in the United States [142] with Henry Leighton. He also studied many individual states.

At the same time that scientific research increased so dramatically, the concept of the studio potter developed as well. Art potteries flourished on the handmade quality of their one-of-a-kind objects; however, the labor was not completely integrated for the pieces were thrown by modelers, who were men, and then painted by decorators, usually women. In Art Pottery of the United States [203, p. 4] Paul Evans points out that up to twenty-one persons worked on a single piece of Rookwood pottery. This division of labor was eventually rejected by studio potters who took full artistic control, throwing and glazing each piece themselves.

Emergence of the studio potter was announced in 1910 by two publications: Charles Binns's The Potter's Craft [95] and Frederick Rhead's Studio Pottery [116]. Binns points to industrial conditions that studio-potters rebelled against, the same conditions the art pottery movement had rebelled against before.

> On the one hand there is the manufactory, teeming with "hands," riotous with wheels, turning out its wares by the thousand and supplying the demand of the many; on the other, there is the artist-artisan. He labors at his bench in sincere devotion to his chosen vocation. His work is laborious and exacting, he can make but a few things and for them he must ask a price relatively high. [95, pp. xiv-xv]

In his manual, Binns taught throwing, molding, glaz-

ing, and firing for individual workers. He was conscious that this singular enterprise had not been attempted before (although any folk potter would scoff at the mention of its novelty).

> Twenty years ago [this book] would have been impossible, for the science of ceramics was not then born. Ten years ago it would have been wasted for the Artist-potter in America had not arrived, but now the individual workers are many and the science is well established. [95, p. viii]

Rhead's Studio Pottery was published as the text for a correspondence course at Peoples University, University City, Missouri, where Rhead taught in company with Taxile Doat and the Robineaus in a short-lived but exciting venture. Rhead shared Binns's view of current conditions.

> About the only available sources of instructive information open to the average pottery student are a few books of a desultory and tentative nature totally inadequate for teaching purposes, and the promiscuous articles which appear more or less frequently in the pottery magazines....
> Students who obtain a situation in a pottery manufactory in the hope of learning the art find themselves drafted to do only one branch of the work, and thus become specialists entirely incapable of making a piece of pottery from start to finish....
> The fact is that pottery-making in this country, as practiced by the individual, is entirely a new art. [116, p. 3]

Rhead, Binns, and Robineau were all acquainted with and influenced by Taxile Doat, a French "artist-potter" who published a series on porcelain and stoneware in Keramic Studio that was reprinted in 1905 as Grand Feu Ceramics: A Practical Treatise on the Making of Fine Porcelain and Grès [100]. Binns hailed Doat's series as "the most important pronouncement upon the production of hard porcelain which has appeared in the English language [95, p. 189] and added two chapters on "American Clays for Grand Feu Wares" to enhance the series' usefulness to American potters.

Art potteries succeeded only as long as a "creative tension" described by Paul Evans [203, p. 2] between artist

and technician could be sustained. They remained in what proved to be a delicate balance for about fifty years, but as the number of studio potters grew and industrialization intensified, the problems inherent in such a relationship increased. Industrial art was now perceived as an impossible paradox and its two components split apart. Studio potters' ideals unfolded on a course that was increasingly independent of industrialization and mass-production techniques. This development dominated the twentieth century but it was not quickly appreciated and not reflected in the literature until recently.

Some fine historical studies appeared in the first half of the twentieth century. Ironically, they were concerned with early American pottery rather than art pottery or contemporary work. John Spargo published The Potters and Potteries of Bennington [449] and Early American Pottery and China [55] in 1926. Arthur Clement published several important investigations of early pottery and porcelain. James made a close study of The Potters and Potteries of Chester County, Pennsylvania [343] in 1945. John Ramsay's American Potters and Pottery [53] contains an extensive checklist that has yet to be updated; Lura Watkins' comprehensive survey of Early New England Potters and Their Wares [297] contains a checklist of seven hundred potters. These are broad studies, some of which are modeled on Barber's work; no recent writer has attempted such coverage.

Appreciation for crafts gradually grew during the Depression when unemployed artists were put to work across the country decorating public buildings, photographing rural areas, and documenting American folk art. The Index of American Design, a massive compilation of 17,000 watercolors of crafts and folk art, was a program of the Work Projects Administration.

In 1937, Allen Eaton published Handicrafts of the Southern Highlands [311], an important contribution to the scholarly study of craft and regional folklife. Eaton hoped to document and preserve vanishing crafts and encourage their revival. Nine years later he conducted a nationwide study of crafts in rural areas for the Extension Service of the Department of Agriculture [275] and followed that with Handicrafts of New England [295]. The forces that underlay the craft revival can be sensed in Eaton's introduction:

There is desperate need to recapture values that

have been lost in the transition from a handicraft to a highly industrialized economy and culture, and in a too heedless race for power, both personal and mass power. We must remind ourselves again and again of our relatedness to the earth which war in our time has so desecrated; we must regain the sense of respect, yes, of reverence for all life on the earth. [295, p. xvi]

The ideals of the Arts and Crafts Movement were still valid to Eaton.

The American Crafts Council was founded in the 1940s, an outgrowth of a marketing and educational organization for New York craftworkers that evolved during the Depression. The Council became an important patron and forum for discussion, sponsoring many exhibitions with accompanying catalogs and publishing Craft Horizons (now American Craft). As an example of the Council's publicizing, the 1953 exhibition, Designer-Craftsmen, U. S. A., provided the first "comprehensive idea of what is being done in the craft field in the United States" [259, p. 1].

Revival of craftsmanship, appreciation of folk art, acknowledgment of the studio potter's art, and fascination with our national history have combined to produce an abundance of literature in the last decade, one hundred years after a first excited exploration of ceramics. Many scholarly studies have appeared recently, far more than ever before; some were occasioned by the Bicentennial celebration.

Early writers such as Barber, Spargo, and Ramsay published comprehensive surveys (albeit stressing the Northeast over the rest of the country), but recent research has been narrower in focus and more intensive, concentrating on one movement, state, county, city, or individual. Much has been discovered in the last few years; perhaps this is why no researcher appears to feel equipped to tackle the whole country again. Georgeanna Greer would not publish a checklist of potters in American Stonewares [40], believing that far more research was required before such a list could be valid.

Richard Wattenmaker's essay in American Slip-Decorated Earthenware [354], states that "the basic source [for Pennsylvania slipware] remains Barber's pathfinding study which has not been superseded." Like many research-

ers, he regrets the paucity of information: "the overwhelming majority of early American pottery has never been published, reproduced in any comprehensive way and therefore no truly systematic evaluation has been published." When a work which rivals the scope of Barber is written, it will certainly be built on the varied and excellent studies being made today.

Several strands of inquiry have contributed to this surge in publications; they can be highlighted here. American potters were given an understanding of their forgotten past by Robert Clark's The Arts and Crafts Movement in America, 1876-1916 [201], which included the first significant retrospective of art pottery. In 1976, The Ladies, God Bless 'Em [394] documented the china painters' contribution to the art pottery movement, and two years later Kirsten Keen's American Art Pottery, 1875-1930 [207] concentrated attention for the first time on art pottery. The most ambitious survey was A Century of Ceramics in the United States, 1878-1978 [29], sponsored by the Everson Museum of Art, long a patron of ceramic art. That exhibition celebrated one hundred years of art and studio pottery. Conspicuous for its large scale, it is symbolic of the heightened interest in ceramics. Most research, however, has been less broad.

The first attempt to present a comprehensive selection of Fulper's art pottery was published in 1979. Extensive studies of Rookwood, the most famous art pottery, and Pewabic Pottery, founded by Mary Chase Perry (Stratton) and Horace J. Caulkins, inventor of the popular Revelation Kiln, have also appeared. The first retrospective of Grueby's pottery was held and the first detailed study of the Overbecks was made. There have also been publications on Robertson's Dedham and Chelsea potteries, Hampshire Pottery, Newcomb College, and a multitude of collector's guides.

Individual potters have been the subject of important publications. Peter Voulkos: A Dialogue with Clay [620], the "most extensive book on a major figure in modern American crafts" [p. v], was issued in 1978 to accompany an exhibition. In 1981, Adelaide Alsop Robineau: Glory in Porcelain [612] examined the work of an important early studio potter. The idiosyncratic, forgotten work of George Ohr was opened to the art world during the 1970s. Ohr had packed his pottery away seventy-five years ago to await a more appreciative generation and turned to selling cars. Other such

xix

historical figures as Arthur Baggs, Edwin Bennett, Guy Cowan, Susan Frackelton, the Meyers of Texas, Herman Carl Mueller, and Artus Van Briggle have been discovered at the same time that contemporary potters are receiving greater attention.

Early American ceramics have been explored by many recent studies. The results of these investigations are dramatically demonstrated by the fact that in 1959 John Pearce was able to identify one hundred and sixty-seven potters in The Early Baltimore Potters and Their Wares, 1763-1850 [364], but in 1893 Barber had known of only two. Evidence of pottery making has been discovered almost everywhere in the country and the important role played by native potters is now better understood. Beth Bower, in The Pottery-Making Trade in Colonial Philadelphia [339], asserts that "the potters in Philadelphia were a significant presence in colonial times" [ℓ. 2], not just coarse craftsmen as had been thought. Graham Hood [455], through careful research, identified extant pieces from the Bonnin and Morris factory of 1770-1772 that had not been known before. Manlif Branin published the first full-length study of Maine potteries [299] and William Ketchum did the same for New York [322]. Recent investigators have frequently used census or tax records, newspapers, and archival material from local historical societies to trace the events of one hundred or two hundred years ago. These documents have been valuable to researchers as analysis of ceramics has broadened beyond artistic appreciation to an examination of their relationship to industrialization and their role in cultural interpretation.

Many records are buried in local governmental and historical agencies. Others are literally buried, awaiting historical archaeologists to expose and interpret them. Refuse heaps, excavated dwellings, and lost kiln sites can tell a tale of daily life for this domestic art.

Historical archaeology has played an important role in exploration of the early period. One of the first excavations in America was carried out in 1943 but not published until 1978: Historical Archaeology at Black Lucy's Garden, Andover, Massachusetts [150]. Excavations of kilns and homes in North Carolina, Virginia, and Iowa have revealed information that would otherwise be very difficult to obtain.

For years a regional bias dominated the study of American ceramics and only recently has it been redressed.

Early writers focused on the Northeast and Ohio, ignoring the South, Midwest, and West. Researchers have unanimously lamented a lack of information on pottery outside the favored Northeast (there are even regions of the Northeast that have been ignored): Indiana stoneware is a "relatively unexplored field" [409, p. 3]; Midwestern craftsmen "have been greatly neglected by historians" [413, p. xi]; folk pottery is a neglected craft in the South [385]; "the earliest history ... and the original center" of the development of the southern alkaline glaze "are still undiscovered" [373, p. 8]. William Ketchum warned that there is

> little information on the many clay workers once active in the South, Southwest, and Far West. Until other areas are researched for books such as Lura Watkins' Early New England Potters and Their Wares ... and my own Early Potters and Potteries of New York State ... it will be necessary for you to do most of the work yourself. [44, pp. xiv-xv]

A beginning has been made. The pottery of North Carolina, South Carolina, Georgia, the Shenandoah Valley, Mississippi, Indiana, Illinois, Iowa, Michigan, Missouri, Minnesota, Texas, and Utah has been analyzed just in the last ten years.

Painstaking research, oral history techniques, folklore studies, and historical archaeology have done much to increase knowledge and correct errors of previous writers. This is an exciting time in the history of the literature of American ceramics. One purpose of this bibliography has been to reveal the topography of research at the present time and to suggest areas that need study. Although much remains to be discovered, one thing is certain: research and changing tastes have modified the harshness of Nichols' judgment. There is much to be said and much to be admired.

SCOPE OF THE BIBLIOGRAPHY

American ceramic art from Colonial times to 1966 is covered in this comprehensive historical bibliography. The year 1966 was chosen as the terminus because that year's Abstract Expressionist Ceramics exhibition can be said to divide modern from contemporary ceramics, although abso-

lute division is of course impossible; unfortunately, a few contemporary potters who began work before 1966 have been cut off after their early years.

Ceramic technology, manufacturing treatises, and practical guides to pottery making are excluded. However, some studies of the history of American manufactures and some early technology manuals are included for readers who wish to understand the context in which the art developed and the information available to early china-painters and studio potters. Therefore, the categories "Technique," "Expositions," "Manufacturing," and "Antiques" include only selected important works although the bibliography on the whole is intended to be comprehensive.

The clay resources and industries of each state have been reported by the individual Geological Survey offices. These are not listed here, but Ralph Mason's excellent Native Clays and Glazes for North American Potters: A Manual for the Utilization of Local Clay and Glaze Materials (Portland, Ore.: Timber Press, 1981) contains a guide to state publications.

Collector's manuals, which are usually no more than identification and price guides, are noted so they can be distinguished from historical studies. The dates that a pottery opened and closed may conflict from author to author because some enterprises began informally or because the dates of incorporation, first production, or partnership differ. Rather than attempt to resolve these discrepancies, I have left the dates as reported.

Books (or portions of books), pamphlets, exhibition catalogs, trade catalogs, theses, and dissertations published before 1983 are included, but there are no articles, and with few exceptions, no reprints from periodicals. All are in English, although not by design; I did not find relevant studies in another language. Unpublished manuscripts were judged unsuitable because of their relative inaccessibility. Trade catalogs that I have actually seen are included; certainly many more exist in company archives and personal collections.

With rare exceptions, the entries are annotated. Frequently, the authors are quoted to reflect their intentions in their own words. The few books that I have not seen, usually theses that a university could neither lend nor photocopy, are noted "Not seen."

HISTORY OF AMERICAN CERAMICS:

AN ANNOTATED BIBLIOGRAPHY

I. BIBLIOGRAPHIES

1. American Crafts Council. Research & Education Department.
 Bibliography: Clay. New York: American Crafts Council,
 1977. 24 p.
 A general bibliography which lists recently published books,
 periodicals, and selected articles from Craft Horizons (now en-
 titled American Craft), including manuals and handbooks on
 techniques and background reading on history, both worldwide
 and American. The 1977 edition contains an addendum to the
 1973 list.

2. Arts in America: A Bibliography. Bernard Karpel, editor.
 Washington, D.C.: Smithsonian Institution Press, 1979.
 4 vol. Index.
 The Archives of American Art sponsored this massive, an-
 notated, well-indexed, comprehensive guide to the literature on
 American art, which, it is hoped, "will serve as a foundation
 on which to build further studies and greater awareness of the
 role of the arts in America." There are twenty-one subject
 categories, including decorative arts, and about 25,000 entries.
 The bibliography includes nearly ninety books on American ce-
 ramics.

3. Branner, John Casper. A Bibliography of Clays and the Ce-
 ramic Arts. Columbus, Ohio: American Ceramic Society,
 1906. 451 p.
 Published by the American Ceramic Society a few years
 after its formation, this is an expansion of the original edition
 (which contained 2,961 titles) published in 1896 as Bulletin 143
 of the U.S. Geological Survey. This volume (with 6,027 titles)
 includes books and articles from the U.S., Britain, and West-
 ern Europe on all aspects of ceramic art and technology.

4. Campbell, James Edward. Pottery and Ceramics: A Guide to
 Information Sources. Art and Architecture Information Guide
 Series, vol. 7. Detroit: Gale Research, 1978. 241 p. Indexes.

1

Includes about 850 books in these categories: general works, ancient and pre-Columbian, Eastern, Western from ancient Greece to the twentieth century, the U.S., Canada and Mexico, contemporary world ceramics, ceramic collections, marks, and technical works. Periodicals, organizations, and museum collections in the U.S. are also listed. Fifty-two books on American ceramics are included. Campbell annotates each entry.

5. Ferguson, Eugene S. Bibliography of the History of Technology. Society for the History of Technology Monograph Series, no. 5. Cambridge, Mass.: Society for the History of Technology and the M.I.T. Press, 1968. 347 p. Index.

A thorough, annotated bibliography which stresses the relationship between technology, defined as "activities of man that result in artifacts," and cultural history. "The purpose of this book is to provide a reasonably comprehensive introduction to primary and secondary sources in the history of technology." Useful as background.

6. Free Public Library, Trenton, N.J. List of Books on Ceramics. Trenton, N.J.: True American Pub. Co., Printers, 1906. 30 p. Index.

Demonstrates the books available to the turn-of-the-century manufacturers in New Jersey. As the "Notice" states: "The consideration of local manufacturing interests has largely determined the character of the collection of books listed hereafter." In 1911, an eleven-page supplement, Additions to List of Books on Ceramics, was published.

7. Hindle, Brooke. Technology in Early America: Needs and Opportunities for Study. Needs and Opportunities for Study Series. Chapel Hill: Published for the Institute of Early American History and Culture at Williamsburg, Va. by the University of North Carolina Press, 1966. 145 p. Index.

A bibliographic essay which is very thorough and informative, surveying the literature and collections available for the study of American technology and culture before 1850. This bibliography was prepared for a conference designed to explore research opportunities in a neglected field. Whitehill's The Arts in Early American History was also published in this series.

8. New York Public Library. List of Works in the New York Public Library Relating to Ceramics and Glass. Bulletin, vol. 12, no. 10. New York, 1908. 38 p.

Bricks, tiles, and terra-cotta were excluded from this bibliography, which is classed as follows: Bibliography; Periodicals; Collections and Exhibition; General History, Marks and Monograms; Ceramics of Various Countries; Manufacture and Trade; Painting and Decoration; Glass; Stained and Painted Glass. Some little-known books are listed here.

9. Solon, Louis M. E. Ceramic Literature: An Analytical Index to the Works Published in All Languages on the History and

the Technology of the Ceramic Art; Also to the Catalogues of Public Museums, Private Collections, and of Auction Sales in Which the Description of Ceramic Objects Occupy an Important Place; and to the Most Important Price-Lists of the Ancient and Modern Manufactories of Pottery and Porcelain. London: Charles Griffin, 1910. 660 p. Indexes.

This marvelous bibliography was compiled when it was still possible to gather together all the literature on ceramics in the world. As Solon says, "In the wild stretch [of printed matter], ceramic literature forms a quiet oasis. From end to end of the region, the distance is not so great that the traveller should feel his forces exhausted before he has had time to visit its most remote and secreted spots. " Most entries are annotated: "It is now our intention to record, candidly and to the best of our ability, the opinion we have formed as to their comparative importance and particular utility, from the ceramist's point of view. " Solon acknowledges Champfleury's Bibliographie Ceramique (1881) as the foundation of his own labors. Part II contains classified lists of the books in the basic bibliography, such as technology, Oriental ceramics, "U.S. of America, " acoustic pottery, terra sigillata, and stoves.

10. Weidner, Ruth Irwin. American Ceramics Before 1930: A Bibliography. Art Reference Collection, no. 2. Westport, Conn.: Greenwood Press, 1982. 279 p. Index.

This first bibliography to concentrate on American ceramics contains 596 books, pamphlets, chapters from books, catalogs, theses, and 2,325 articles from 232 periodicals. "Although the focus here is on American ceramics from the Civil War through World War I [the art pottery era], this bibliography covers the history of pottery making from the earliest colonial manufacture through about 1930, when styles, production methods, and terminology changed as the activities of folk potters and pottery companies gave way to the preeminence of the studio potter. " The emphasis is on decorative ceramics; some technical publications are included. The entries are not annotated.

11. Weinrich, Peter H. A Bibliographic Guide to Books on Ceramics--Guide Bibliographique des Ouvrages sur la Ceramique. Ottawa: Canadian Crafts Council/Conseil Canadien de l'Artisanat, 1976. 272 p. Index.

"This is a bibliographic guide to books devoted solely to ceramics"; articles in periodicals and sections of books are not included. "This list is intended primarily for craftsmen, with the general reader and collector second. " Weinrich lists thousands of books that are of general interest, historical, or technical; he also includes the categories Africa, America, Asia, and Europe. Books on the United States are listed on pages 95-102.

12. Whitehill, Walter Muir. The Arts in Early American History:

Needs and Opportunities for Study. Needs and Opportunities
for Study Series. Essay by Walter Muir Whitehill. Bibliog-
raphy by Wendell D. Garrett and Jane N. Garrett. Chapel
Hill: Published for the Institute of Early American History
and Culture at Williamsburg, Va. by the University of North
Carolina Press, 1965. 170 p. Index.
In the same series as Hindle's Technology in Early Amer-
ica, Whitehill's essay on research in American arts and
crafts with the Garretts' extensive annotated bibliography
seeks to stimulate research. The essay surveys attitudes
toward American arts and the gaps in documentation. The
bibliography includes the basic writings of the last forty
years, excluding most earlier books as insular and amateur.

II. DICTIONARIES AND ENCYCLOPEDIAS

13. Barber, Edwin AtLee. The Ceramic Collectors' Glossary.
Da Capo Press Series in Architecure and Decorative Art,
v. 7. New York: Da Capo Press, 1967. 119 p. Many
black and white drawings.
Reprint of the 1914 edition published in New York by the
Walpole Society. An international glossary of terms designed
to bring uniformity to the cataloging of ceramic collections.
"The definitions here furnished are, in the main, original,
and include many terms never before brought together."
Many border designs, ground patterns, handle types, cover
finials, shapes, and other terms are specified. Barber, a
man of many enthusiasms, served as curator of the new De-
partment of American Pottery and Porcelain at the Pennsyl-
vania Museum from 1892 to 1901, then as curator of the
museum from 1901 to 1907, finally as director of the mu-
seum from 1907 until his death in 1916. He worked hard
to document American pottery and to encourage greater
productivity. Also reprinted in 1976 by Da Capo Press as
The Ceramic, Furniture and Silver Collectors' Glossary.

14. Boger, Louise Ade. The Dictionary of World Pottery and
Porcelain. New York: Scribner, 1971. 533 p. 562 black
and white illus., many drawings, and 58 color illus. Bibli-
ography: pp. 525-33.
An extensive work which expands the ceramics contents
of The Dictionary of Antiques and the Decorative Arts, writ-
ten by Boger with her husband, H. Batterson Boger. Based
on much research, this is "a comprehensive but concise
guide that will be useful to the collector and student as well
as the general reader." American ceramics are included
with Continental and Oriental ceramics.

15. Jervis, William Percival. The Encyclopedia of Ceramics.

New York, 1902. 673 p. Many black and white illus. Bibliography: pp. 48-51. Index.
This excellent early encyclopedia includes entries on American potters, clays, and pottery companies. Jervis notes, "The history of modern pottery in the United States is necessarily brief and ... mainly imitative." Pottery marks are appended. The encyclopedia is a revision of articles, written for Crockery and Glass Journal, which cover the world history of ceramics. Jervis' preface states: "As the work is not intended as a directory, I have refrained from inserting the names of some hundreds of firms, whose names are known to me, but who only make wares of a strictly commercial character, some bad, some good, and which would be of no interest to the general reader."

16. Ray, Marcia. Collectible Ceramics: An Encyclopedia of Pottery and Porcelain for the American Collector. New York: Crown, 1974. 256 p. 14 color, 290 black and white illus.
An encyclopedia of eighteenth-, nineteenth-, and twentieth-century ceramics--European, Oriental, and American--by a past editor of Spinning Wheel. The coverage of American pottery is good and rarely mentioned potteries, such as Brookcroft Pottery and Dorchester Pottery Works, are included. Such shapes as pie birds and shaving mugs are also defined. Although there is no bibliography, certain books are recommended in the text.

III. MARKS

17. Barber, Edwin AtLee. Marks of American Potters, with Facsimiles of 1000 Marks, and Illustrations of Rare Examples of American Wares. Ann Arbor, Mich.: Ars Ceramica, 1976. 174 p. 33 black and white illus. Index.
Reprint of the 1904 edition published in Philadelphia by Patterson & White Co. This basic source "was the first book entirely devoted to the subject of American potters' marks"; it contains eight hundred more marks than Jervis reported in 1897. A historical essay accompanies the marks for each pottery. Barber earlier (1893) gathered one hundred marks for Pottery and Porcelain of the United States. "Previous to that time," he asserts, "none of the manuals on potters' marks contained any reference to the ceramic products of this country." A new introduction describes important publications in American ceramics since Barber's original edition. This has also been reprinted by Scholarly Press and by Cracker Barrel Press.

18. Darty, Peter. The Pocketbook of Porcelain and Pottery Marks. London: Dalton Watson, 1969. 183 p.

A handbook of European and Oriental marks which includes 111 American marks, mostly of the late nineteenth century. It is not comprehensive.

19. Hartman, Urban. Porcelain & Pottery Marks. New York: Hartman, 1943. 128 p. Index.
A handbook for collectors which includes European marks and 185 American marks. Like Darty's handbook, this is not comprehensive.

20. Haslam, Malcolm. Marks and Monograms of the Modern Movement, 1875-1930. A Guide to the Marks of Artists, Designers, Retailers and Manufacturers from the Period of the Aesthetic Movement to Art Deco and Style Moderne. New York: Scribner, 1977. 192 p. Many black and white illus. Index.
Includes American and European marks for ceramics as well as glass, metalwork, jewelry, graphics, furniture, and textiles. This is particularly useful because pottery marks of the recent period are not often published. Fifty-nine American marks are illustrated; they are mostly of art potteries.

21. Jervis, William Percival. Book of Pottery Marks. Newark, N.J.: Jervis, 1897. 101 p. Index.
Continental, Oriental, and American marks are illustrated. Pages 74-97 contain nearly two hundred marks of the United States. This doubled the number of marks identified by Barber in 1893, but is many fewer than Barber reproduced in his Marks of American Potters (1904). Jervis designed this list for the requirements of American readers; "great care and no small amount of trouble have been taken with the American section." Historical information is given for each company. Also published: Philadelphia: Wright, Tyndale & Van Roden, 1897.

22. Kovel, Ralph M., and Terry H. Kovel. Dictionary of Marks: Pottery and Porcelain. New York: Crown, 1953. 278 p. Bibliography: p. x. Index.
Nearly three thousand marks from European countries and America are illustrated. They are arranged either alphabetically or by shape. Chinese, Japanese, and majolica marks are excluded. "Many American marks and twentieth-century marks are included."

23. Maddock's (Thomas) Sons Co., Trenton. Pottery: A History of the Pottery Industry and Its Evolution as Applied to Sanitation with Unique Specimens and Facsimile Marks from Ancient to Modern, Foreign and American Wares. [Philadelphia: Printed by Dando, © 1910.] 224 p. 99 black and white illus.
A study of the process of manufacturing sanitary ware (the flush toilet) with a detailed history of the many patents

and improvements that led to the modern toilet; Maddock's was the first American factory to make toilets. More than a thousand Continental and Oriental pottery marks are appended as well as about seven hundred and fifty American marks from Pennsylvania, New Jersey, New York, New England, Ohio, southern, and western potteries.

24. Thorn, C. Jordan. Handbook of Old Pottery & Porcelain Marks. New York: Tudor, 1947. 176 p. 46 black and white illus. Index.

"Thousands of pottery and porcelain marks of more than 25 nations" are contained in this guide. More than a thousand American marks are here, "the most comprehensive list of marks that has appeared to date" (1947). Very little information on the factories or potters is given; that must be found elsewhere.

IV. GENERAL HISTORY

25. American Craftsmen's Council. Museum of Contemporary Crafts. Forms from the Earth: 1,000 Years of Pottery in America. New York, 1962. 21 p. 25 black and white illus. (in portfolio).

Catalog from an exhibition of modern American ceramic art and its historical background; the exhibition included 299 pieces. American Indian pottery, Colonial pottery, and eighteenth-, nineteenth-, and twentieth-century ceramics are discussed in brief essays.

26. Barber, Edwin AtLee. The Pottery and Porcelain of the United States; An Historical Review of American Ceramic Art from the Earliest Times to the Present Day. To Which Is Appended a Chapter on the Pottery of Mexico. Combined ed. [n. p.]: Feingold & Lewis, Distributed thru J & J Publishing, New York, 1976. 621 p. 333 black and white illus. Index.

Reprint, with Marks of American Potters, of the third edition, published in 1909 (New York: Putnam). This meticulous work, based on thorough research, is a pioneering history by a man who championed American ceramics when they were still disregarded or disguised as European. The first edition was published in 1893 and the second in 1901. The second and third editions add the new developments in this active period of American ceramics. The introduction to this edition by Diana Stradling and J. G. Stradling stresses the importance of Barber's work and gives details of his life. They mention, as do other researchers, the need for correction or reappraisal of certain areas of Barber's study.

27. Binns, Charles Fergus. The Story of the Potter, Being a Popular Account of the Rise and Progress of the Principal Manufactures of Pottery and Porcelain in All Parts of the World, with Some Description of Modern Practical Working. London, New York: Hodder and Stoughton, [1898]. 248 p. 57 black and white illus. Index.

History of pottery intended for the reading public, rather than specialists and collectors, published while Binns was still in England. "'The Story of the Potter' has been written in the endeavour to render into popular language the most fascinating of all histories, and to relate the growth of an important national industry, with its parallels in other lands, in a manner that shall prove neither tedious nor abstruse." Later editions were published in 1901 and 1905. Although American pottery is barely mentioned, this is included because Binns himself was so influential in American ceramics. Solon praised The Story of the Potter: "This small volume may do more than many expensive publications to spread the knowledge of ceramic history. Its modest price places it within everybody's reach, and its intrinsic value renders it equal, if not superior, to the best popular handbooks on the subject."

28. Chaffers, William. The New Keramic Gallery. 3d ed., revised and edited by H. M. Cundall. London: Reeves and Turner, 1926. 2 vol. 8 color, approx. 700 black and white illus. Index.

The third edition of this pictorial supplement to Chaffers' Marks and Monograms on Pottery and Porcelain includes a short chapter on American ceramics with extracts from Barber's The Pottery and Porcelain of the United States. The earlier editions (first edition, 1871; second edition, 1907) had not judged American ceramics important enough for inclusion.

29. Clark, Garth. A Century of Ceramics in the United States, 1878-1978: A Study of Its Development. New York: Dutton in association with the Everson Museum of Art, 1979. 371 p. 40 color, 374 black and white illus. Bibliography: pp. 345-61. Index.

First careful and comprehensive survey of recent American ceramics, "its aesthetic and its influence," published in conjunction with a large exhibition. The text, however, is minimal. The biographies and bibliographical notes for individual potters that are appended are valuable. A Checklist of Marks and Supplementary Information was also published with the exhibition.

30. Clement, Arthur Wilfred. Our Pioneer Potters. New York: Privately printed, 1947. 94 p. 24 black and white illus. Bibliography: pp. 89-91. Index.

Clement produced several authoritative and well-documented studies of early pottery. In this, he discusses "in some

detail a relatively small number of potteries which seemed to me of unusual interest," wishing to establish "an accurate foundation upon which future research and writing may be based." The potteries are organized thus: "Before 1700"; "Redware"; "Stoneware"; "The Moulded Wares"; "The Utility Wares"; "The Decorative Wares"; "Porcelain."

31. Clement, Arthur Wilfred. Preliminary Notes for a Catalogue of Made-in-America Pottery and Porcelain, Assembled for Exhibition at the Brooklyn Museum. New York: Court, 1942. 32 p. 7 black and white illus. Bibliography: p. 32. This catalog was issued although the exhibition could not be held because of the war. The collection touches on most American wares from the early nineteenth century until 1941, including slipware, stoneware, art pottery, and yellowware. Clement's notes, which frequently refer to similar pieces in other collections, are explicit and careful.

32. Cox, Warren E. The Book of Pottery and Porcelain. New York: Crown, 1970. 2 vol. 3,000 black and white illus. Index.
A historical survey of world ceramics which includes American ceramics on pages 979-1008 and 1048-78. The information is detailed; the tone is rather chatty. This edition is only slightly revised from the 1944 edition.

33. Denker, Ellen, and Bert Denker. The Warner Collector's Guide to North American Pottery and Porcelain. New York: Warner Books, 1982. 256 p. 50 color, 270 black and white illus. Bibliography: pp. 250-51. Index.
"The purpose of this book is to provide the collector with a visual identification guide to North American pottery and porcelain." Classifies five hundred pieces of ceramics into fifty categories of redware, stoneware, porcelain, and art pottery subdivided by geography or style. There is a color guide for quick reference while one is in an antique shop or gallery, for instance. Each piece is described and a price range is suggested.

34. Donhauser, Paul S. History of American Ceramics; The Studio Potter. Dubuque, Iowa: Kendall/Hunt, 1978. 260 p. 38 color, 222 black and white illus. Bibliography: pp. 237-40. Index.
The first study of the studio potter from the Arts and Crafts Movement to contemporary work. Nineteenth-century pottery, the china-painters, Art Nouveau, the effects of the Depression, influences from Alfred University, foreign influences, and recent developments are among the topics included. This book is an uncorrected version of the dissertation cited below and unfortunately is marred by carelessness.

35. Donhauser, Paul S. A History of the Development of American

Studio-Pottery. D. Ed. dissertation, Illinois State University, 1967. 268 ℓ. 102 illus. Bibliography: ℓ. 227-34. An effort to document the artistic history of the studio potter. However, the research is sometimes garbled, typographical errors abound, and although sections were added for the Kendall/Hunt publication cited above, the errors remained.

36. Dyer, Walter Alden. Early American Craftsmen. New York: Century, 1915. 387 p. 136 black and white illus. Bibliography: pp. 381-83. Index.
 Chapters on early American potters (pages 273-97) and Bennington pottery (pages 298-319) are included, as well as chapters on furniture, clocks, glass, pewter, and silver. Dyer sketches the lives of some potters and the development of ceramics for "the Collector of Americana." Reprinted, New York: B. Franklin, 1971.

37. Earle, Alice Morse. China Collecting in America. Detroit: Singing Tree Press, 1970. 429 p. 66 black and white illus. Index.
 A charming, personal, and informed account of the passions of a china collector who specialized in the china to be gathered in America. She had found that foreign texts were not helpful in her quest. Although much of the china described is English or Oriental, early American pottery is included. Earle believed that America "has had a larger manufacture of pottery and porcelain than is generally known." This is a facsimile reprint of the 1892 edition (New York: Scribner).

38. Eberlein, Harold Donaldson, and Abbot McClure. The Practical Book of Early American Arts and Crafts. Philadelphia: Lippincott, 1916. 339 p. 232 black and white illus. Bibliography: p. 9. Index.
 "The aim of this book is to present a thoroughgoing, informative, and practical guide to the Arts and Crafts of our forefathers for the use of the collector and general reader." Eberlein and McClure based this book on a series of articles which were the "result of years of first-hand investigation." The only pottery considered is slipware (pages 217-38) and their information is drawn from Barber's work ("To Dr. Barber's efforts, indeed, we owe substantially all we know of the origin and practice of [slipware]"). This was later published (1927, 1936) as The Practical Book of American Antiques, Exclusive of Furniture and reprinted in 1977 (New York: Da Capo Press).

39. Elliott, Charles Wyllys. Pottery and Porcelain; From Early Times down to the Philadelphia Exhibition of 1876. New York: D. Appleton, 1878, © 1877. 358 p. 163 black and white illus. Bibliography: pp. 343-47. Index.
 A worldwide survey written to answer a question then

current in the United States, "What is it that makes 'pottery and porcelain' so attractive to scholars, statesmen, women, and wits?" The final chapter gives some details of porcelain and pottery in the U. S. Solon, in Ceramic Literature, dismisses Elliott's work with a withering comment: "A few volumes of continental works on old pottery, scissors and paste, and a certain degree of confidence, was all that was required.... American handbooks of that period should not be recommended out of America, where they never enjoyed much credit on the part of the true collector."

40. Greer, Georgeanna Hermann. American Stonewares: The Art and Craft of Utilitarian Potters. Exton, Pa.: Schiffer, 1981. 286 p. 16 color, 361 black and white illus. Bibliography: pp. 269-80. Index.
Extensive coverage of historical utilitarian stoneware in America. Greer does not concentrate on potters' biographies but on the work itself. Manufacturing methods, glazing, and firing are described at length; glaze defects and kiln wasters are illustrated. Varying types of necks, rims, handles, feet, and lids are illustrated as are many vessel shapes. She does not include a checklist of potters, feeling that much more research must be done before such a list would be adequate, but she does include a glossary of terms and a good, annotated bibliography.

41. Hillier, Bevis. Pottery and Porcelain 1700-1914: England, Europe and North America. The Social History of the Decorative Arts. London: Weidenfeld and Nicolson, 1968. 386 p. 26 color, 217 black and white illus. Bibliography: pp. 361-68. Index.
This study includes a chapter on North America (pages 164-86). The search for kaolin in America and early efforts to make porcelain are chronicled; several contemporary documents are liberally quoted. Also published: New York: Meredith Press, 1968.

42. Jervis, William Percival. A Pottery Primer. New York: O'Gorman Pub. Co., 1911. 188 p. Many black and white illus.
A survey of ceramics history which originally appeared as a series of articles, "intended as an incentive to further research to those who may be interested either in the ancient history of pottery garnished from the most trustworthy sources, or the original matter first here presented." The final chapter (pages 168-88) discusses early potters, art pottery, and printed dinnerware of the United States.

43. Johnson, Deb, and Gini Johnson. Beginner's Book of American Pottery: Introduction to a Field of Collecting Still Relatively Uncrowded, Easy on the Pocketbook, and Full of Delightful Adventures. Des Moines, Iowa: Wallace-Homestead Book Co., 1974. 119 p. 8 color, 53 black and white illus.

Hundreds of pieces of art pottery and commercial pottery, such as McCoy, Hull, Fulper, Van Briggle, and Red Wing, are illustrated. Beginning collectors are shown the ropes and cautioned about fakes. Scores of marks are reproduced. A guide to pricing is also available.

44. Ketchum, William C. The Pottery and Porcelain Collector's Handbook: A Guide to Early American Ceramics from Maine to California. New York: Funk & Wagnalls, 1971. 204 p. 36 black and white illus. Index.

Redware, stoneware, brownware, yellowware, whiteware, and porcelain are included. Ketchum concentrates, laudably, on obscure potteries from the southern and western U.S., arguing that Ohio and the northeastern potteries have been overworked in the literature. He warns the collector that "until other areas are researched for books such as Lura Watkins' [New England] ... and my own [New York] ... it will be necessary for you to do most of the work yourself." His effort to cover the entire country is unusual. A list of early American potteries is appended.

45. McKearin, George. Loan Exhibition of Early American Pottery and Early American Glass; The Examples Shown Are Selected from the Private Collection of George S. McKearin. Hoosick Falls, N.Y., 1931. 55 p. 41 black and white illus.

Noting that there is "practically nothing" of American pottery in American museums except for Barber's and Pitkin's work, McKearin selected about two hundred pieces from his collection of fifteen hundred for this exhibition at the Third International Antiques Exposition. The pottery catalog is on pages 4-22.

46. Maclay, Alfred B. The Alfred B. Maclay Collection of Early American Glass and Ceramics. Catalogue written by Helen McKearin. New York: Parke-Bernet Galleries, 1939. 141 p. 64 black and white illus.

Maclay's collection of pottery and glass, assembled over a period of twenty years, was sold March 23-25, 1939. McKearin states that "the ceramics far excel anything previously offered at auction. Never before has so important a group of American stoneware domestic utensils come before the public." Her essay "Early American Pottery and Porcelain" discusses the redware, slipware, sgraffito-decorated ware, stoneware, Bennington Rockingham and flint enamel, and porcelain that were auctioned. There are 210 pieces of pottery described in the catalog.

47. Mills, Flora Rupe. Potters and Glassblowers. San Antonio, Texas: Naylor, 1963. 113 p. 15 black and white illus.

Seven Americans are included in the brief biographies of twenty-nine potters and glassblowers who lived from 1640 to 1886. Some popular wares are described. This book is directed to collectors.

48. Newark Museum. Classical America, 1815-1845. Newark,
N.J., 1963. 212 p. 187 black and white illus. Bibliogra-
phies: pp. 161-63, 211-12.
Catalog from an exhibition which was the museum's "first
effort to define a period in the history of American decora-
tive and fine arts." Berry Tracy's essay points out that
very few Empire style ceramics were made in America (six
examples are illustrated) because the European imports were
of fine quality and relatively cheap. "Ceramics" are in-
cluded on pages 108-15.

49. Orlando, Philip, and Bob Gino. Pottery: 1880-1960. Encino,
Calif.: Orlando Gallery, 1973. 87 p., mostly illus.
Catalog from an exhibition of art pottery and commercial
pottery sold from 1880 to 1960. The catalog notes are scat-
tered and cannot be considered adequate.

50. Palovich, George W. Early American Pottery: Its Background
and Relationship to Contemporary Pottery. Master's thesis,
Kent State University, 1964. 65 ℓ. 34 black and white illus.
Bibliography: ℓ. 63-65.
Palovich's purpose is to explore "the possibility of an im-
portant American tradition and to stimulate further investiga-
tion." The history of European, English, and American pot-
tery is summarized, followed by "a discussion of possible re-
lationships between contemporary and Early American pot-
tery." He concludes that stylistically such a relationship
does not seem to exist. There is only a "likeness in spirit
and a carry through of old practices and techniques."

51. Persick, William Thomas. Three Concepts of Pottery. Ph.D.
dissertation, Ohio State University, 1964. 124 p. 12 black
and white illus. Bibliography: pp. 119-22.
A study of the writings and thought of three important pot-
ters who were also influential teachers: Charles F. Binns,
Arthur E. Baggs, and Bernard Leach. Persick wished to
investigate "the ideas and purposes that guide the potter.
With these potters it led to a consideration of their ideas
that extended beyond their notions on pottery and into their
life philosophies."

52. Prime, William Cowper. Pottery and Porcelain of All Times
and Nations; With Tables of Factory and Artists' Marks for
the Use of Collectors. New York: Harper, 1878, © 1877.
531 p. 299 black and white illus. Bibliography: pp. 8-10.
Index.
"Ten years ago there were probably not ten collectors of
Pottery and Porcelain in the United States. To-day there
are perhaps ten thousand." Prime hoped to "relate briefly
those portions of the history which seem most important to
the American public who have not access to, or the time to
read and study, the many learned and valuable works of
Europe." He reviews ancient pottery, modern pottery, por-

celain (Near Eastern, Oriental, and European), the pottery and porcelain of England, and the pottery and porcelain of America (pages 399-432).

53. Ramsay, John. American Potters and Pottery. New York: Tudor, 1947. 304 p. 103 black and white illus. Bibliography: pp. 244-51. Index.

An often-cited study which classifies and surveys the eighteenth- and nineteenth-century pottery and porcelain of the East, South, and Midwest. "I have written from the standpoint of a collector of pottery.... Thus 'collectible' pottery--its types, manufacture and makers--is considered in detail, while other wares, as well as much early and recent ceramic history, are covered only sketchily." At the time Ramsay wrote, he asserts, collectors were not interested in wares made after 1900. Ramsay drew on published works, local histories, newspaper files, and Geological Survey reports. His checklist of hundreds of American potters and potteries is very valuable. "This check-list has been intended to include the location of each pottery, the name of the owner or potter and his successors, the dates of foundation, of any changes in ownership, and of the final closing." Webster, writing in 1971, states that it is "the most extensive ever published" but that "it is also often unreliable, particularly in citations of dates of operation." The Tudor edition is a reprint of the 1939 edition (Boston: Hale, Cushman & Flint). The 1939 edition was also reprinted in 1976 (Ann Arbor, Mich.: Ars Ceramica).

54. Schwartz, Marvin D. Collectors' Guide to Antique American Ceramics. Garden City, N.Y.: Doubleday, 1969. 134 p. 109 black and white illus. Index.

Schwartz's hope is that "the beginning collector and the student will learn to understand the medium and its evolution well enough to be able to identify a ware by its appearance rather than by its marks." This introduction to American pottery covers earthenware, stoneware, and porcelain, touching on art pottery. "The evolution of American ceramic style is emphasized in this survey."

55. Spargo, John. Early American Pottery and China. New York: Century, 1926. 393 p. 64 black and white illus. Bibliography: pp. 373-76. Index.

"This book is expressly designed to meet the needs of the amateur.... Such a collector wants to know what to collect, and why; to be aided in identifying and classifying specimens.... The book is not in any sense a history of American pottery and china." In spite of his disclaimers, Spargo's classification and historical record is an important early study. He is very familiar with earlier writers such as Barber, Jervis, and Pitkin (though he condemns Pitkin as worthless). He admires Barber and offers some corrections to this "indispensable" but "far from careful" writer. Spargo

includes pre-Revolutionary potters, slipware, sgraffito, eighteenth- and nineteenth-century pottery and porcelain, and "grotesqueries, satires, and jests." He also added "several carefully arranged chronological lists of potters" and a selection of marks. Reprinted in 1938, 1948, and in 1974 by Charles E. Tuttle (Rutland, Vt.).

56. Stiles, Helen E. Pottery in the United States. New York: Dutton, 1941. 329 p. 131 black and white illus. Bibliography: pp. 317-24. Index.
 A rather simple introduction which surveys all aspects of pottery in America: its history, early imports, contemporary imports, studio potters, art pottery, brick, tile, and more. Stiles's text is notable because "stress has ... been laid on contemporary products"; many of the pieces illustrated date from the 1930s and are either studio-made or factory-made. A list of prize winners at the National Ceramic Exhibition, Syracuse, is appended.

57. Stradling, Diana, and J. Garrison Stradling. The Art of the Potter: Redware and Stoneware. New York: Main Street/ Universe Books, 1977. 158 p. Many black and white illus. Index.
 A selection of fifty-four of the most authoritative articles on American pottery published in The Magazine: Antiques from 1922 to 1974. Clement, Watkins, Spargo, Noël Hume, and Webster are among the authors. There is a wide variety of articles within the categories of archaeology, redware, stoneware, and techniques. The relationship of the pottery to German and English sources is highlighted.

58. Theus, Will H. How to Detect and Collect Antique Porcelain and Pottery. New York: Knopf, 1974. 249 p. 10 color, 23 black and white illus. Bibliography: pp. 245-49. Index.
 Theus characterizes his book as a "mere outline of the subject for the beginner or novice" in which he has "omitted articles that are not found in any quantity in American shops." Chinese, European, and American ceramics are included. The chapter on American porcelain and pottery (pages 176-99) briefly covers Tucker, Bennington, Belleek, and art pottery. A glossary is appended.

59. Toledo Museum of Art. English and American Ceramics of the 18th and 19th Centuries: A Selection from the Collection of Mr. & Mrs. Harold G. Duckworth. Toledo, Ohio: Toledo Museum of Art, 1968. 53 p. 12 black and white illus. Bibliography: pp. 52-53.
 Catalog from an exhibit of a representative selection of a private collection, "most of which has never before been publicly exhibited." American smear glaze, Parian types, and Rockingham wares are discussed in the text. The exhibit consisted of 220 pieces; only a few are illustrated.

60. Vlach, John Michael. The Afro-American Tradition in Decorative Arts. Cleveland, Ohio: Cleveland Museum of Art, 1978. 175 p. 8 color, 100 black and white illus. Bibliography: pp. 169-73.
 It is rare to find analysis of the black influence on American decorative arts. This exhibition revealed that it is a living tradition in many areas. The nineteenth-century ceramist Dave Potter is studied, and African and Caribbean antecedents of black pottery, face jugs, and figural vessels are discussed and illustrated on pages 76-79. Basketry, musical instruments, boat-building, and architecture are among the other topics.

61. Webster, Donald Blake. Decorated Stoneware Pottery of North America. Rutland, Vt.: Charles E. Tuttle, 1971. 232 p. 300 black and white illus. Bibliography: pp. 229-30. Index.
 "This book is essentially a survey both of the extent of North American stoneware forms and types, and geographical areas, and of the range and variety of decoration." The book is organized by the decorative motifs of the salt-glazed wares: flowers, patriotic scenes, birds, figures, relief designs, etc. Webster did a lot of research; each piece is described in detail although the narrative sections of the text are short. A checklist of eighteenth-, nineteenth-, and twentieth-century stoneware potteries is appended with additions to Ramsay's checklist.

62. Williamson, Scott Graham. The American Craftsman. New York: Crown, 1940. 239 p. 344 black and white illus. Bibliography: pp. 219-32. Index.
 A survey of early American crafts which argues for the revival of craftsmanship in the U.S. The bulk of the book is given to the role of crafts in American culture and includes carpenters, clockmakers, ironworkers, and pewterers, among others. The chapter on clay (pages 48-68) has illustrations of several types of pottery: stoneware, slipware, Bennington, and Rookwood. Checklists of artisans are appended, including a "representative sampling" of potters before 1830; however, Ramsay is recommended by Williamson as containing a "far-reaching check-list." Reprinted in 1975 (Detroit: Gale Research).

63. Woodhouse, Charles Platten. The World's Master Potters: Their Techniques and Art. [New York]: Pitman, 1974. 238 p. 83 black and white illus. Bibliography: pp. 224-28. Index.
 A survey of world pottery and porcelain which includes the United States (Colonial to contemporary) on pages 199-223. Woodhouse presents a lucid introduction to the history of American ceramics, touching on Colonial society, early attempts at fine ceramics, art pottery, and some contemporary potters.

64. Young, Jennie J. The Ceramic Art: A Compendium of the History and Manufacture of Pottery and Porcelain. New York: Harper & Brothers, 1878. 499 p. 464 black and white illus. Index.
 A very early history of pottery and porcelain throughout the world for an American audience. "The attempt has here been made to condense the leading points of the subject, to arrange them after a simple and easily intelligible method, and thus to present in one volume a comprehensive history." In the chapter on the United States (pages 442-87), she reviews the difficulties of American potters due to tariffs, cheap imports, and the Americans' lack of confidence in their own artists. She goes on to describe the chief developments in pottery and porcelain; "the history of American porcelain is necessarily brief."

65. Zserdin, (Sister) Mary Carmelle. The Growth of American Ceramic Art: A Brief Summary. Master's thesis, State University of Iowa, 1962. 73 ℓ. 16 black and white illus. Bibliography: ℓ. 51-56.
 "[N]ot a concise history of American pottery [but] a general survey of the development of form, technique and aesthetic value in American ceramics from pre-Revolutionary days to the present." This is a very general and hasty overview which dismisses the past and praises a few contemporary potters for their "individual, aesthetic creativity."

V. SPECIALIZED HISTORY

66. American Crafts Council. Museum of Contemporary Crafts. Salt Glaze Ceramics. New York: American Crafts Council, 1972. 36 p., mostly illus. (black and white). Bibliography: p. 7.
 Catalog of an exhibition which included historical examples of salt glaze pottery as well as contemporary potters who use salt glaze. Short essays were contributed by Marvin D. Schwartz, "Salt Glaze: Some Historical Notes"; Don Reitz, "Salt Glaze Process"; and Charles Hendricks and Don Pilcher, "The Pollution Aspects of Salt Glaze Firing."

67. American Stoneware Pottery. Kinzle Auction Center, Duncansville, Pa.: [n.p.], 1975-1977. 3 vol. Illus.
 Catalogs from auctions of stoneware collections. The collection of Mr. and Mrs. Charles V. Hagler was auctioned in 1975. It included three hundred pieces of redware, stoneware crocks, jugs, pitchers, and other items. The collection of Mr. and Mrs. Dean Reynolds, sold in 1976, included

some George Ohr pottery, which sold in the price range of
$25 to $140. Five small collections were sold in 1977.
The pieces are illustrated and described briefly.

68. Barber, Edwin AtLee. Lead Glazed Pottery. Part First
(Common Clays): Plain Glazed, Sgraffito and Slip-Decorated
Wares. Art Primer. Pennsylvania Museum and School of
Industrial Art, Philadelphia. Philadelphia: Printed for the
Museum, 1907. 32 p. 48 black and white illus. Index.
"The Art Primers ... are designed to furnish, in a com-
pact form, for the use of collectors, students, and artisans,
the most reliable information, based on the latest discover-
ies, relating to the various industrial arts." Barber surveys
the history and processes of lead-glazed ware, concentrating
on European and Pennsylvania German pottery. This was
also published by Doubleday, Page (New York, 1907).

69. Barber, Edwin AtLee. Salt Glazed Stoneware: Germany,
Flanders, England and the United States. Art Primer.
Pennsylvania Museum and School of Industrial Art, Phila-
delphia. New York: Doubleday, Page, 1907. 32 p. 48
black and white illus. Index.
A historical review of the manufacture of salt-glazed
stoneware which includes a section (pages 23-27) on the
United States. "Salt glazed stoneware has been made in
America since early in the eighteenth century" and was im-
ported from Europe since Colonial times. Most American
stoneware shows the influence of the German tradition.

70. Barber, Edwin AtLee. Tin Enamelled Pottery: Maiolica,
Delft, and Other Stanniferous Faience. Art Primer. Penn-
sylvania Museum and School of Industrial Art. New York:
Doubleday, Page, 1907. 51 p. 58 black and white illus.
Index.
A survey for students and collectors of European tin-
enameled pottery with a small section on the United States:
"Stanniferous faience has never been made in the United
States, except in an experimental way." The 1907 edition
includes a section illustrating marks that is not in the 1906
edition (Philadelphia: Pennsylvania Museum and School of
Industrial Art).

71. Callen, Anthea. Women Artists of the Arts and Crafts Move-
ment, 1870-1914. New York: Pantheon Books, 1979. 232
p. 217 black and white illus. Bibliography: pp. 228-29.
Index.
Callen studies the Arts and Crafts Movement in England
and America not through its famous male leaders, but
through "its widespread and enthusiastic adoption by large
numbers of talented but little known artists and amateurs,
many of whom were women." She also considers the social
and economic circumstances of middle-class women in the
nineteenth century through class structure, design education,

and feminism. American women art potters, "far more adventurous" and "more seriously professional" than the English, are discussed on pages 78-92. This book, published in London as Angel in the Studio, places the craftswomen in a broad cultural context.

72. Clark, Eleanor. Plate Collecting. Secaucus, N.J.: Citadel Press, 1976. 243 p. 14 color, 241 black and white illus. Index.
 A history of plate collecting and of individual companies; the first modern collector plate was made in 1895. American firms considered are Boehm Studio, Fenton Art Glass Co., Franklin Mint, Gorham, Lenox, Mallek Studio, Pickard, and Wallace.

73. Clark, Garth, ed. Ceramic Art: Comment and Review, 1882-1977; An Anthology of Writings on Modern Ceramic Art. New York: Dutton, 1978. 197 p. 24 color, 80 black and white illus. Bibliography: pp. 193-97.
 Selection of essays that have stimulated or interpreted American ceramics in the last century, from William Morris (1882) to 1970s criticism. The essays reflect the ideas of the Victorian Arts and Crafts Movement, the influence of Japanese aesthetics through Leach and Yanagi, the influence of Western classicism through Cardew, and the criticism of the Abstract Expressionist period.

74. Harbin, Edith. Blue & White Stoneware, Pottery & Crockery. Paducah, Ky.: Collector Books, 1977. 63 p., mostly illus. (color).
 Collector's guide to blue and white salt-glazed stoneware sold by several commercial potteries (Lee, McCoy, Burley-Winter, and Logan) and Sears Roebuck. The pieces illustrated are not identified by the potteries that produced them. Suggested prices range from $15 to $225.

75. Heaivilin, Annise Doring. Grandma's Tea Leaf Ironstone: A History and Study of English and American Potteries. Des Moines, Iowa: Wallace-Homestead Book Co., 1981. 232 p. Many black and white illus. Bibliography: pp. 225-28. Index.
 "A resumé of those potters who produced our lovely Tea Leaf pattern, limited to those examples I have actually seen and photographed." Heaivilin researched in libraries, historical societies, newspaper files, and trade catalogs, resulting in the histories of twenty-six English and seventeen American companies that made ironstone china in the Tea Leaf design, which became popular at the end of the nineteenth century.

76. Joseph, Mary, and Edith Harbin. Blue and White Pottery. [n.p.]: Privately published, 1973. 44 p., mostly illus. (color).

Collector's guide to pottery made in the late nineteenth and early twentieth centuries with a blue and white glaze that runs together. There is no text and no information on manufacturers. Prices are suggested. "All the pottery illustrated in this book is from our collections."

77. Klamkin, Marian. American Patriotic and Political China. New York: Scribner, 1973. 215 p. 81 color, 259 black and white illus. Bibliography: pp. 210-11. Index.

Curiously, most "patriotic" china was made in England for export to America. "Historically, British potters have understood the American market far better than have American ceramics producers," states Klamkin. Therefore, the bulk of this study is Anglo-American china but there is one chapter on American potters (pages 54-59). Americans made very little tableware for this market; Toby jugs and clay pipes were more popular. It is notable that Klamkin points out: "With very few exceptions, most of the patriotic and political china that has been made is of poor quality from the ceramist's point of view."

78. McNerney, Kathryn. Collectible Blue and White Stoneware. Paducah, Ky.: Collector Books, 1981. 152 p., mostly illus. (color). Index.

An identification and value guide for blue and white stoneware, mostly kitchen articles. The pottery is priced, the illustrations are good, but the factories are not identified.

79. Marks, Mariann K. Majolica Pottery. Paducah, Ky.: Collector Books, 1982, © 1983. 144 p., mostly illus. (color). Bibliography: p. 144.

Colorful collector's guide to Victorian majolica, "related in name only to the 14th-century Italian and Spanish ware," made in Britain and America. Prices are suggested for each piece but the manufacturers are only occasionally identified.

80. National Museum of History and Technology. The John Paul Remensnyder Collection of American Stoneware. [n.p., 1978?] 14 p. 16 black and white illus. Bibliography: p. 14.

John Remensnyder donated his "definitive collection" of over three hundred pieces of stoneware made in the northeast to the Smithsonian Institution. His collection includes pieces that belonged to Robert J. Sim and many marked pieces (of particular value to researchers). This catalog was published with an exhibition of selected pieces. Susan H. Myers' essay outlines the history of stoneware manufacture.

81. Overglaze Imagery: Cone 019-016. Essays by Garth Clark, Judy Chicago, and Richard Shaw. Fullerton: Art Gallery, Visual Arts Center, California State University, Fullerton,

1977. 206 p. 118 illus. (color, black and white). Bibliography: pp. 21-23.
An extensive catalog from an exhibition of "painted images on ceramic form which utilize surface colorants fired at the low ranges." "Painted Porcelain and Faience: 13th Century-Early 20th Century," "World of the China Painter: Late 19th Century-20th Century," and "Beyond the Barriers of Tradition: Late 20th Century" are included. Curiously, a portion of The Ladies, God Bless 'Em (Cincinnati, Ohio: Cincinnati Art Museum, 1976) is reprinted. The second section builds on the work of Judy Chicago, establishing documentation for the lives and work of the china painters. Short biographies were written when possible. Résumés and bibliographies were prepared for the third section also. This is a serious effort to research china painters and low-fire glazes.

82. Powell, Robert Blake. Antique Shaving Mugs of the United States. Hurst, Tex.: Powell, 1972. 272 p. Many black and white illus. Index.
A chatty and informative book which does not limit itself to shaving mugs; it also covers soaps, razors, display cases, and barberpoles. A history of the Koken Barber Supply Company is included. Most of the mugs illustrated are from private collections, including the author's. This must be the definitive work on shaving mugs.

83. Rare Pottery and Porcelain Liquidating the Collection of Mr. Arthur R. Luedders and Mr. Walter Kachelski of Haslett, Michigan; An Important Collection of Pottery and Porcelain Made for the American Market; Together with Property of Several New England Collectors. Hyannis, Mass.: Richard A. Bourne Co., 1976. 68 p. Many black and white illus.
Catalog from an auction of Staffordshire and other English ceramics, northeastern redware and stoneware, Bennington ware, Shenandoah redware and stoneware, and Etruscan majolica. A price list is included; the prices ranged from $5 to $1,300.

84. Raycraft, Donald R., and Carol Raycraft. Decorated Country Stoneware. Paducah, Ky.: Collector Books, 1982. 80 p., mostly illus. (black and white).
A guide for collectors of decorated stoneware, Bennington stoneware, Sleepy Eye, pottery with stenciled decorations, stenciled whiskey jugs, specialty pieces, and molded stoneware. The illustrations are plentiful but poor. Suggested prices range from $12 to $2,000.

85. Sandknop, Stephen S. Nothing Could Be Finer.... A Compendium of Railroad Dining Car China. Edina, Mo.: Sandknop Publications, 1977. 74 p. Many black and white illus.
A guide "to assist collectors, traders, and other individuals to more accurately identify and inventory dining car china." Sandknop does not include prices because "pricing

[in a guide] naturally leads to spiralling costs to both the neophyte and advanced collector." Some European makers are included but most are American. The illustrations are of poor quality.

86. Sotheby Parke Bernet. The Jacqueline D. Hodgson Collection of Important American Ceramics. New York: Sotheby Parke Bernet, 1974. 55 p., mostly illus. (black and white). Bibliography.

Figurines, banks, mugs, pitchers, stoneware crocks, slipware, Bennington, and Parian ware from the northeast and Ohio were sold at auction, January 22, 1974. A list of prices received ($60-$3,100) is attached.

87. Stefano, Frank. Pictorial Souvenirs & Commemoratives of North America. New York: Dutton, 1976. 148 p. 150 black and white illus. Bibliography: pp. 139-40. Index.

"A guide to ceramic, glass and metal souvenir collectables, including World's Fair souvenirs" which includes American manufacturers and decorators of the twentieth century as well as British and German manufacturers of the nineteenth and twentieth centuries. American distributors are listed and the basic types of scenes are classified. It is claimed that this book is the "first to give necessary background information for collectors."

88. Stewart, Regina, and Geraldine Cosentino. Stoneware: A Golden Handbook of Collectibles. New York: Golden Press, 1977. 128 p. 47 color, 54 black and white illus. Bibliography: p. 127. Index.

A survey of the history, manufacture, and decorating techniques of American salt-glazed stoneware for "beginning collectors." Jugs, crocks, jars, bottles, batter jugs, churns, and pitchers from three private collections are illustrated with informative captions. A list of potters and their dates is appended.

89. Stoneware at Auction. Otego, N.Y.: Hesse Auctions and Denlinger, Quality Country Shows, 1981. 26 p., mostly illus.

There were 228 crocks, jugs, and coolers auctioned at prices ranging from $40 to $3,300. All are illustrated.

90. Temple, Jacob Paxson. The Jacob Paxson Temple Collection of Early American Furniture and Objects of Art. To Be Sold ... During the Week of January 23rd to 28th, 1922. New York: Anderson Galleries, 1922. 280 p. 172 black and white illus.

Temple collected many pieces of furniture, pottery, glassware, and utensils in Pennsylvania, particularly in the rural areas. This sale catalog contains 1,688 pieces, including Pennsylvania and New Jersey pottery, Bennington pottery, and Tucker china. This sale was "the first time that New

York and New England collectors have an opportunity of ac-
quiring representatives of these naive wares."

91. Wearin, Otha D. Statues That Pour: The Story of Character
Bottles. Denver, Colo.: Sage Books, 1965. 202 p. 124
black and white illus. Bibliography: pp. 192-96. Index.
Although most of the bottles are glass, ceramic bottles
are also mentioned in this chatty book for collectors. The
illustrations are of poor quality.

92. Wetherbee, Jean. A Look at White Ironstone. Des Moines,
Iowa: Wallace-Homestead Book Co., 1980. 159 p. 105
black and white illus., many drawings. Bibliography: pp.
153-54. Index.
White ironstone was an inexpensive, sturdy dinnerware
made by English factories in Staffordshire for the American
market. It was made from the 1840s until the end of the
nineteenth century when American pottery became more
plentiful. Hundreds of shapes are illustrated in this history.
After much experimentation, some white ironstone was made
in America. "Native White Ironstone" (pages 133-40) lists
American factories of these dishes.

VI. TECHNIQUE: A SELECTION
OF EARLY BOOKS

93. Binns, Charles Fergus, ed. Ceramic Technology, Being
Some Aspects of Technical Science as Applied to Pottery
Manufacture. London: Scott, Greenwood, 1897. 102 p.
Index.
An important attempt to improve the science of pottery in
England, compiled by the energetic and idealistic Englishman
who brought new impetus to ceramic art and technology in
America and who educated hundreds of American potters at
the New York State College of Ceramics at Alfred University.
Binns published this because he felt that "since the days of
Simeon Shaw [1837] nothing dealing with the technical science
of pottery has been published in England." Later editions
were published in 1898 and 1901.

94. Binns, Charles Fergus, ed. The Manual of Practical Potting.
4th ed. New York: Van Nostrand, 1907. 204 p. Index.
An early comprehensive reference manual for ceramists,
"specially compiled by experts," edited by Binns and pub-
lished by the Pottery Gazette in London. Many formulas
were published for the first time here; the publishers hoped
it would become "the chief text-book for reference wherever
the manufacture of ceramics is followed." The second edi-
tion appeared in 1898; the fifth in 1922. The date of the
first edition is unknown.

95. Binns, Charles Fergus. The Potter's Craft; A Practical Guide for the Studio and Workshop. New York: Van Nostrand, 1910. 206 p. 46 black and white illus. Index.

A pioneering book of instruction in forming and glazing for individual craftsmen, written by Binns ten years after he started the New York State College of Ceramics at Alfred University. The preface states, "Twenty years ago [this book] would have been impossible, for the science of ceramics was not then born. Ten years ago it would have been wasted for the Artist-potter in America had not arrived, but now the individual workers are many and the science is well established." The second edition was published in 1922 by Van Nostrand, the third in 1947, and the fourth in 1967.

96. Bowman (George H.) Co. White China for Decorating. Catalogue No. 5. Cleveland, Ohio: Geo. H. Bowman Co., [n.d.]. 22 p., mostly illus. (black and white).

A catalog of the "blanks" purchased and then decorated by the china painters. Dinnerware and vases from Bavaria, France, "Nippon," and Ohio are illustrated.

97. Campana, Dominic Mathews. Designs and Color Schemes. Chicago: Campana, 1909-10.

Campana sold his designs on a subscription basis, published periodically with firing directions. Large tracings of the designs (fruit, flowers, and fish, natural or stylized) were available.

98. Campana, Dominic Mathews. The Teacher of China Painting. 3d ed., corrected and enlarged. Chicago: Campana, [192-?] 148 p. 21 black and white illus. Index.

Campana published many small guides and sold paints as well. This is a practical manual for beginning china painters which teaches principles of design, firing, ground-laying, and flower painting. Many editions of this were printed. The dates of the earliest editions are unknown. The most recent edition was published in 1959.

99. Cox, George James. Pottery for Artists, Craftsmen & Teachers. Technical Art Series. New York: Macmillan, 1914. 200 p. 75 black and white illus. Bibliography: pp. 198-99.

A specific and quite thorough book of instruction on molding, throwing, firing, glazing, and decorating. Cox also prescribes the equipment for a studio or school pottery. The text is illustrated by the author's firm, clear drawings. Reprinted in 1923, 1926, and 1933.

100. Doat, Taxile. Grand Feu Ceramics; A Practical Treatise on the Making of Fine Porcelain and Grès. Translated from the French by Samuel E. Robineau. Notes on the Use of American Clays for Porcelain and Grès by Charles Binns.

Syracuse, N. Y.: Keramic Studio, 1905. 207 p. 151 black
and white illus.
An important book on porcelain technique originally pub-
lished as a series of articles in Keramic Studio, which was
edited by Adelaide Alsop Robineau. Doat and Binns strived
to encourage the making of fine porcelain in the U. S. A.,
feeling that "the making of artistic porcelain ... has been
but slightly attempted in this country" and that the difficul-
ties, but not the rewards, of high-fire work were appreci-
ated. Even the leaders among American potters, Rookwood
and Grueby, stayed with lower-fired pottery.

101. Frackelton, Susan Stuart. Tried by Fire: A Work on China-
Painting. New York: Appleton, 1886, © 1885. 110 p.
12 color, 24 black and white illus.
Frackelton was an influential early china-painter who
founded a large china decorating firm and later organized
the National League of Mineral Painters. She wrote this
to help the many women who had written for advice "since
my exhibits in the West, at the International Cotton Exposi-
tion South, and the Republic of Mexico." In a spirited, in-
formal tone, she describes the "different methods of paint-
ing and decorating finished pieces of ware." Her views on
the condition of art in America are expressed with indigna-
tion. The third edition was published in 1895.

102. Harris, W. S. The Potter's Wheel, and How It Goes Around.
A Complete Description of the Manufacture of Pottery in
America. Trenton, N. J.: Burroughs & Mountford, Printed
by Crockery & Glass Journal, [1885?] 63 p. 31 black and
white illus.
A fictitious group of American women are guided through
the various rooms of an American pottery to view the oper-
ations of manufacture and decoration and to gain "an idea of
the manner in which their plates and dishes are made."
The narrative is simple but charming and very detailed.

103. Janvier, C. A. Practical Keramics for Students. New
York: Henry Holt, 1880. 258 p. Bibliography: pp. 230-
35. Index.
An early example of a general introduction to ceramics
which was published in America. Materials, manufacture,
and decoration are described, followed by classification of
pottery and porcelain and some instruction for china-
painters. Janvier's book is based on such standard Euro-
pean works as Shaw, Brongniart, Jacquemart, and others.

104. Langenbeck, Karl. The Chemistry of Pottery. Easton, Pa.:
Chemical Pub. Co., 1895. 197 p. Index.
The first American text for the pottery industry suggests
a scientific approach to analysis, testing, glaze and body
composition, and kiln firing with Seger cones. This was
the only American text available to Edward Orton when he

started the Ohio State University ceramics school and
Charles Binns when he started the New York State School
of Clay-Working and Ceramics. Langenbeck, who had ex-
perience at the Mosaic Tile Co., Rookwood, and the Amer-
ican Encaustic Tiling Co., states in the preface: "The pot-
tery industries of England and America have afforded chem-
ists little opportunity for systematic work, so that they have
remained largely on an empirical basis and have supplied
nothing of moment to chemical technology." Within a few
years the American Ceramic Society was formed; its mem-
bers began to make a serious effort to put the chemistry of
pottery on a rational basis.

105. McLaughlin, Mary Louise. The China Painter's Handbook.
Cincinnati, 1917. 30 p. 6 black and white illus.
An introduction to the principles of design and the appli-
cation of colors. She states, "Within comparatively recent
years American china has been produced and ... it is grat-
ifying to know that it has met the tests of the decorators
most satisfactorily."

106. McLaughlin, Mary Louise. China Painting; A Practical Man-
ual for the Use of Amateurs in the Decoration of Hard Por-
celain. New ed. Cincinnati, Ohio: Robert Clarke Co.,
1904. 140 p. 4 black and white illus. Index.
This manual must have been useful since it was pub-
lished in several editions (1877, 1883, 1889, 1914).
McLaughlin describes the preparation of the outline, the
use of colors, the critical importance of drawing skill
("The best foundation for any artwork is a thorough knowl-
edge of drawing"), and the "lessons to be derived from
Japanese art."

107. McLaughlin, Mary Louise. Pottery Decoration Under the
Glaze. 3d ed., rev. Cincinnati, Ohio: Robert Clarke,
1885. 102 p.
After two years of experiments in methods of under-
glaze decoration, McLaughlin wrote "from an unprofes-
sional, yet practical standpoint," for those who wanted to
try that more difficult and unpredictable art. She de-
scribes painting on pottery, modeling, and carving of clay.
This book was very popular and influential. Trapp (Maria
Longworth Storer, ℓ. 32) asserts that her technique "be-
came [Rookwood's] standard procedure of decorating and
glazing." First published in 1880.

108. McLaughlin, Mary Louise. Suggestions to China Painters.
Cincinnati, Ohio: Robert Clarke, 1883. 94 p. 4 black
and white illus. Index.
McLaughlin characterized this as "a supplementary
treatise to the little book on 'China Painting' published by
the writer several years ago. It is less elementary in
character, and contains the results of later experience."

She discusses drawing, design, Japanese art, metallic paints, relief colors, firing, and other subjects. Another edition appeared in 1886 and a revised edition in 1890.

109. Mason, George Champlin. The Application of Art to Manufactures. New York: Putnam, 1858. 344 p. 150 black and white illus.

"[I]n no one work, treating of Metals or Ceramics, will all the materials here brought together be found. The object has been to collect such facts connected with their history ... the various processes of converting the raw materials into the finished goods ... and the importance of a higher development of art in our manufactures.... The refining influence of Art is much needed.... At present it suffers from constant abuse on the one hand, and utter neglect on the other." According to Mason, ceramists must "bring the art products of America to a level with those of France and Great Britain."

110. Miller, Fred. Pottery-Painting: A Course of Instruction in the Various Methods of Working on Pottery and Porcelain; With Notes on Design and the Various Makes of Colours and Glazes. 2d ed. London: E. Menken, 1885. 147 p. 55 black and white illus. Index.

An unusually lengthy and advanced work on china-painting; "a complete course of instruction in Pottery Painting to those who desire a more extended knowledge of the subject." He quotes approvingly from Miss McLaughlin, noting her high reputation and stating that "the Americans have taken up Pottery-painting very thoroughly." The date of the first edition is unknown.

111. Nichols, George Ward. Pottery: How It Is Made, Its Shape and Decoration: Practical Instructions for Painting on Porcelain and All Kinds of Pottery with Vitrifiable and Common Oil Colors, with a Full Bibliography of Standard Works upon the Ceramic Art. New York: G. P. Putnam's Sons, 1878. 142 p. 42 black and white illus. Bibliography: pp. 124-38. Index.

The author, husband of Maria Longworth Nichols (later Storer), wished to encourage ceramic art in America: "It is the object of this Book to show that the manufacture of Pottery may become one of the great art industries in the United States; to describe the laws which govern the form and decoration of Pottery; and to give practical instruction." The Japanese designs were created by his wife.

112. O'Hara, Dorothea Warren. The Art of Enameling on Porcelain. New York: Madison Square Press, 1912. 45 p. 22 black and white illus.

"The aim of this book is to help the Keramic Decorators of America, by presenting a correct kind of decoration by which even the young student can express some beauty with

comparatively small effort." The technique is outlined. Most of the designs are Mrs. O'Hara's; she sold the enamels in forty-seven colors.

113. Osgood, Adelaide Harriet. How to Apply Royal Worcester, Matt, Bronze, LaCroix and Dresden Colors to China; A Practical Elementary Hand-Book for Amateurs, Containing Reliable Methods for Gilding, Mixing of Colors, Ground-Laying, Relief-Paste, Firing, Etc. 18th ed. New York: A. H. Osgood, 1905. 209 p. 23 black and white illus.
 The author ran an art school in New York City. She specifies the colors for many flowers, birds, and fish, but reproduces only a few designs. Many editions were printed; the twelfth appeared in 1896. The first edition was published in 1891.

114. Paist, Henrietta Barclay. Design and the Decoration of Porcelain. Syracuse, N.Y.: Keramic Studio, 1916. 103 p. 42 black and white illus.
 A series of lessons and exercises in design for china-painters, based on correspondence courses that the author gave. Rhythm, balance, tone, and color harmony are discussed. Many designs, some reminiscent of Newcomb and Dedham, are illustrated.

115. Piton, Camille. A Practical Treatise on China-Painting in America, with Some Suggestions as to Decorative Art. New York: Wiley, 1878-80. 3 albums, entirely illus.
 Oversize albums containing large line drawings of Persian, Japanese, Italian, and other designs for china-painters. There is no text.

116. Rhead, Frederick Hurten. Studio Pottery. University City, Mo.: Peoples University Press, 1910. 83 p. 78 black and white illus. Bibliography: p. 8.
 Rhead, editor of The Potter (1916-17), worked at many potteries: Weller, Roseville, Jervis, Arequipa, Rhead, American Encaustic, and Homer Laughlin. He also joined Taxile Doat and the Robineaus at the short-lived University City Pottery. The instruction included a correspondence course for which Rhead wrote this book "to present to the beginner a concise and authoritative description of those processes which may be worked out in the average pottery studio." The text, which is detailed and practical, covers clay preparation, casting, throwing, firing, and glazing. Students lacking a kiln could send their work to the University to be fired!

117. Sparkes, John Charles Lewis. Hints to China and Tile Decorators. Edited and revised by an American decorator. Boston: S. W. Tilton, 1877. 85 p. 4 black and white illus.
 This manual was originally published in England. Tilton

published an American edition with the addition of some Wedgwood designs and a list of materials. Tilton had already published a manual for decorating unglazed pottery and wished to follow it with "a more advanced treatise." The introduction notes: "With their characteristic enthusiasm (stimulated by the Centennial Exposition) our people are beginning to emulate the older nations of the world in their pursuit of this form of art."

118. Stratton, Mary Chase. Ceramic Processes. Ann Arbor, Mich.: Printed by Edwards Bros., 1940, © 1941. 77 p. Many black and white drawings.

Presents a simple introduction to pottery technique, for "most treatises pertaining to clay and glazes are either quite technical or cover so large a field that the uninformed student despairs at the start." Casual drawings illustrate the text. Stratton concludes: "The ceramic field is still one grand question mark inviting all who have a flair for experiments to reply in terms of form, color and types of glaze."

119. Tilton, Stephen Willis. Designs and Instructions for Decorating Pottery in Imitation of Greek, Roman, Egyptian and Other Styles of Vases. Boston: S. W. Tilton, 1876. 74 p., mostly illus. (black and white).

In response to demand from china-painters, Tilton brought out this book of designs that were stylized versions of classic designs. He felt that American women, if only they were taught properly, could paint as well as the English women who painted china and whose wares were displayed at the Centennial Exhibition. Tilton sold all necessary materials. The fourth revised edition was published in 1877.

120. White, Mary. How to Make Pottery. New York: Doubleday, Page, 1904. 179 p. 83 black and white illus.

An early handbook for the beginning potter, for those "who would start clay-working, with no other qualification than the wish to learn how to make pottery." The book is notable in that it describes the whole process from forming the clay body and wedging to glazing and firing. Forming tools, wheels, and kilns are also described. The final chapters are concerned with American Indian and modern American pottery; White praises the influence of Indian, French, and Japanese pottery traditions. Among the potteries considered are Rookwood, Teco, Grueby, Volkmar, and Newcomb.

VII. EARLY MUSEUM COLLECTIONS

PHILADELPHIA MUSEUM OF ART

121. Barber, Edwin AtLee. Illustrated Catalogue of China, Pottery, Porcelains and Glass.... Philadelphia: Samuel T. Freeman, Auctioneers, 1917. 102 p. 13 black and white illus.

Barber's collection was sold after his death. The preface to this catalog explains: "The Collection was on exhibition for many years in the Pennsylvania Museum and it is profoundly to be regretted that the Institute with which Dr. Barber was so long connected did not have the means to acquire it, and it therefore must be dispersed at Public Auction." There are 692 pieces described, including 106 pieces of American pottery, Bennington "flint enameled" ware, and Bennington Parian. Decorators' tools, Rookwood ware, American faience, tiles, and Phoenixville (Pa.) majolica were also sold as well as European porcelains and pottery. "This Catalogue is compiled from the Manuscript left by Dr. Barber and the Specimens herein described served Dr. Barber for study and illustrating his many works on Ceramic Art and Glass." The Philadelphia Museum of Art was known as the Pennsylvania Museum and School of Industrial Art until 1929.

122. Barber, Edwin AtLee. Pottery: Catalogue of American Potteries and Porcelains. Philadelphia: Pennsylvania Museum and School of Industrial Art, 1893. 43 p. 17 black and white illus.

The Pennsylvania Museum made a unique effort to build a complete collection of American ceramics, based on its core collection gathered by Barber for his Pottery and Porcelain of the United States. "So far as is known, no similar effort has ever been made by any American or foreign institution.... Persons who possess specimens of pottery or porcelain of American manufacture are earnestly requested to deposit them permanently or temporarily in the Museum." Nearly three hundred pieces of porcelain, pottery, pipes, and tiles are described.

123. Pennsylvania Museum and School of Industrial Art. General Guide to the Collections of the Pennsylvania Museum and School of Industrial Art.... Philadelphia: Printed for the Museum, 1907. 112 p. 84 black and white illus.

Pages 74-81 describe the collection of American pottery and porcelain, "the only considerable and really representative collection of historical American Ceramic manufactures that has ever been gathered together," begun in 1890 by Barber to illustrate his book. Barber signed the preface.

BROOKLYN MUSEUM

124. Clement, Arthur Wilfred. Notes on American Ceramics,
1607-1943. Brooklyn, N. Y.: Brooklyn Museum, Brooklyn
Institute of Arts and Sciences, 1944. 36 p. 56 black and
white illus. Bibliography: pp. 35-36.
A guidebook, "which contains some heretofore unpub-
lished material on American ceramics," to the museum's
collection of American ceramics. "With the opening of
this new gallery, a collection of American ceramics takes
its rightful place...." Early redware shards, stoneware,
sgraffito, art pottery, and porcelains are included, with
explanatory notes by Clement.

METROPOLITAN MUSEUM OF ART

125. Metropolitan Museum of Art. Handbook for the Use of Visi-
tors Examining Pottery and Porcelain in the Museum. New
York, 1875. 138 p. 36 black and white illus.
Notes that "America has hitherto possessed" no collec-
tions of ceramics; much of this collection is European,
Oriental, or classical. Pages 118-27 outline the history of
pottery use and manufacture in the U. S. Twenty-two Amer-
ican pieces (from Bennington, Vt.; Jersey City, N. J.; Phil-
adelphia, Pa.; and Norwalk, Conn.) are listed as being in
the museum's collection. "Information is desired in refer-
ence to the history of all potteries in the United States,"
solicits the handbook.

VIII. EXPOSITIONS: A SELECTION

EXHIBITION OF THE INDUSTRY OF
ALL NATIONS, 1853-54, NEW YORK

126. Greeley, Horace., ed. Art and Industry as Represented in
the Exhibition at the Crystal Palace, New York, 1853-4,
Showing the Progress and State of the Various Useful and
Esthetic Pursuits from the New York Tribune. Revised
and edited by Horace Greeley. New York: Redfield, 1853.
The Exhibition of the Industry of All Nations was held in
New York before the burst of American creativity produced
by the 1876 Philadelphia Centennial Exhibition. "Porcelain"
(pages 112-24) points out that "the porcelain and earthen-
ware in the Fair is almost exclusively foreign; there being
no articles of fine manufacture in the American Department
which are native." Bennington pottery and Cartlidge por-
celain were exhibited; they are described in some detail
and praised.

INTERNATIONAL EXHIBITION, VIENNA, 1873

127. Blake, William P. Ceramic Art; A Report on Pottery, Porcelain, Tiles, Terra Cotta, and Brick, with a Table of Marks and Monograms, Notices of the Distribution of Materials for Pottery, Chronicle of Events, Etc., Etc. International Exhibition, Vienna, 1873. New York: Van Nostrand, 1875. 146 p. Few black and white illus. Bibliography: pp. 144-46.

Blake was the United States Centennial Commissioner. This report, from the volume of reports of the Massachusetts Commission to Vienna, concentrates on European manufacture but includes discussion of pottery, brick, and clays in the U.S.: "The industry has increased rapidly of late years" but "there are those who think ... that we should send our clay, our sand, and our coal, over the ocean to be worked into objects for our daily use." Imports were still quite high.

PHILADELPHIA CENTENNIAL EXHIBITION, 1876

128. The Masterpieces of the Centennial International Exhibition. New York: Garland, 1977. 3 vol. Many black and white illus.

Reprint of the 1876-78 edition (Philadelphia: Gebbie & Barrie) which was a well-illustrated analysis of the exhibits. Fine Arts (vol. 1) was written by Earl Shinn under the pseudonym Edward Strahan. Industrial Art (Vol. 2) was written by Walter Smith. History, Mechanics, Science (Vol. 3), by Joseph Wilson, includes a history of the international exhibitions before 1876. Smith calls for improved art education in America: "Intelligent training and familiarity with the best models would in a few years make the work, which already has the technical excellence necessary, compare favorably with that of foreign nations."

129. National Museum of History and Technology. 1876: A Centennial Exhibition. Washington, D.C.: National Museum of History and Technology, Smithsonian Institution, 1976. 223 p. 344 black and white illus. Bibliography: p. 215.

To celebrate "the centennial of the Centennial," the Smithsonian put on a very large exhibit of the sort of objects that were displayed at the Philadelphia Centennial Exhibition of 1876. This book, edited by Robert C. Post, which accompanied the exhibit is broad and interesting, with contributions by many of the museum's curators. The impact of the Centennial is explained and the principal original exhibits are described and illustrated; this is "an attempt to recapture the total ambience" of the Centennial. In the section on ceramics (pages 108-13), Susan Myers states that American pottery was profoundly affected by the exhibition and argues that "while American ceramics often were less

sophisticated than foreign, harsh criticism seems unwar-
ranted."

130. Sandhurst, Phillip T., et al. The Great Centennial Exhibi-
 tion, Critically Described and Illustrated. Philadelphia:
 P. W. Ziegler, 1876. 544 p. Many black and white illus.
 A thorough, although disorganized, critical survey of the
 exhibits: "fine arts," "industrial arts," machinery, bridges,
 horticulture, and agriculture. The international exhibitions
 preceding 1876 are described. The ceramics exhibits play
 a small role. As for American ceramics, "in our own
 country especially, the pottery of the people, which is the
 truest indication of the good or bad taste of a nation, is
 now far from what we should wish it to be, whilst in the
 higher walks of the art we stand lower than any other
 civilized nation."

WORLD'S COLUMBIAN EXPOSITION,
CHICAGO, 1893

131. Badger, Reid. The Great American Fair: The World's
 Columbian Exposition & American Culture. Chicago: Nel-
 son Hall, 1979. 177 p. 47 black and white illus. Bibli-
 ography: pp. 165-71. Index.
 Useful as background, even though pottery is not included
 in this study, which is "a general consideration of the great
 world's fairs within the context of nineteenth-century West-
 ern culture, their relationship to American culture" and
 "the overall psychological or emotional condition of Ameri-
 can society in the 1890s."

132. Elliott, Maud Howe, ed. Art and Handicraft in the Woman's
 Building of the World's Columbian Exposition, Chicago,
 1893. Chicago: Rand, McNally, 1894. 320 p. Over 250
 black and white illus.
 A carefully produced book which describes the exhibits
 contained in the Woman's Building and discusses the Con-
 gressional act and public attitudes that prompted a separate
 woman's exhibit. Also included are individual chapters out-
 lining the historic role of women in art, in science, and in
 literature; women's associations; cottage industries in Scot-
 land and Ireland; and the evolution of women's education in
 the United States. Women's position in many European
 countries, Russia, and South America is described in sep-
 arate contributions. This is a lively and hopeful survey of
 women at the end of the nineteenth century. Elizabeth W.
 Perry's essay describes "The Work of Cincinnati Women in
 Decorated Pottery," the pottery clubs, and Rookwood.
 Earlier editions were published in Paris (Goupil & Co.,
 1893) and Paris and New York (Boussod, Valadon & Co.,
 1893).

IX. MANUFACTURING: A SELECTION

133. The American System of Manufactures. The Report of the
Committee on the Machinery of the United States 1855 and
the Special Reports of George Wallis and Joseph Whitworth
1854. Edited by Nathan Rosenberg. Edinburgh: Edinburgh
University Press, 1969. 440 p. Index.
 The modern introduction describes this as "one of the
most detailed, and certainly one of the most reliable, de-
scriptive accounts of American manufacturing methods in
the middle of the nineteenth century" and it marks Amer-
ica's emergence as a world economic power. "Porcelain,
and Other Ceramic Manufactures" (pages 291-93) will un-
dergo rapid and effective progress in Wallis's view; he men-
tions the Queen's Ware Pottery Works, Liverpool, Benning-
ton, and others. First published, London: T. Harrison,
1854.

134. Argument Before the U.S. Tariff Commission at Long Branch,
N.J., August 22d, 1882, on Behalf of the Pottery Manufac-
turers of the United States. Trenton, N.J.: John L. Mur-
phy, Printer, 1882. 28 p.
 J. H. Brewer, Homer Laughlin, and Joseph Willets
testified before the Commission to the inadequacy of the
tariff protection of the manufacturers of "white and deco-
rated crockery and china ware of the United States." They
argued that "simply for want of governmental protection"
against cheaper foreign goods which were deliberately un-
derpriced, the imports were rising each year and American
potters were threatened with "unroofing." Decorated wares
had "grown wonderfully since 1876" and English potters
were consciously cutting prices "to keep the growth and
the increase of the make in the States in check."

135. Bishop, J. Leander. A History of American Manufactures
from 1608 to 1860. 3d ed. Philadelphia: Edward Young
& Co., 1868. 3 vol.
 An early and still valuable documentation of technology
in America. Brickmaking, earthenware, and porcelain are
briefly included; the earliest brick kiln recorded was built
in 1629. The first edition was published in two volumes
(Philadelphia: Edward Young, 1861-1864). The third edi-
tion has been reprinted recently in the Reprints of Econom-
ic Classics series (New York: A. M. Kelly, 1966) and by
Johnson Reprint Corp. (New York, 1967).

136. Clark, Victor S. History of Manufactures in the United
States, 1607-1860. Contributions to American Economic
History from the Department of Economics and Sociology
of the Carnegie Institution of Washington. Carnegie Insti-
tution of Washington, Publication no. 215B. Washington,
D.C.: Carnegie Institution of Washington, 1916. 2 vol.

A pioneering and comprehensive study, prepared as part of an important effort to document American economic history, which includes short sections on the pottery industry, bricks, and tiles. The revised three-volume edition published in 1929 covers the period 1860-1928.

137. Coxe, Tench. A Statement of the Arts and Manufactures of the United States of America for the Year 1810. Philadelphia: Printed by A. Cornman, 1814. 278 p. Index.

Following a resolution of Congress in 1812, Coxe prepared this "collection of facts" on American art and industries; Congress wished a study of their relationship to American economic strength and defense. "Potteries" is listed among other industries in the tabular statements: "I. By State, Territory and District; II. By Counties, Cities and Towns." Coxe introduces these tables with his own analysis and conclusions concerning American industries, noting that "the manufacture of ordinary ware of common potters' clay is very much extended" and that "there is no manufacture, for which this country is more perfectly prepared, than those of potters and glass wares." Reprinted: Elmsford, N. Y.: Maxwell Reprint Co., 1971.

138. Crewson, Harry Bernarr. The Pottery Dinnerware Industry of the United States and the Tariff--1860-1948. Master's thesis, Ohio State University, 1948. 98 ℓ. Bibliography: ℓ. 98.

Examines "the domestic pottery tableware industry, tariff history, imports of similar ware, and principal sources, in order to determine the economic advisability of continuing high tariff rates." The tariff had been an important influence for ninety years. "The conclusion will be reached that the policy of protection has been an utter failure." A good, critical history.

139. Davenport, S. W. The Nation's Obligations and Duty to Its Domestic Manufacturers. New York: "Commercial World" Print, 1882. 23 p.

Subtitled "A Protectionist's Reply to Some Recent Criticisms by a Foreign Importer to Which Is Appended an Article on the Tariff on Earthenware; The Pottery Industry; Domestic Competition Reduces Prices." Prepared for the "Commercial World" in response to a 90-percent tariff proponent.

140. Directory of the Pottery and Glass Trades of the United States and Canada, Containing a List of the Plants, Officials, Head of Sales Department, List of Sample Rooms, Traveling Representative and Lines Manufactured. Pittsburgh: Compiled for China, Glass and Lamps by J. G. Kaufmann and Roy D. Schooley, 1905. 37 p.

The type of ware produced by each factory is also indicated.

141. Middleton, Jefferson. Statistics of the Clay-Working Industries in the United States. Washington, D. C.: Government Printing Office, 1894-1914.
 Detailed statistics on production of brick, tile, pottery, clay products, and building operations state by state were published annually in Mineral Resources of the United States by the Geological Survey. Mineral Resources of the United States was published from 1882 to 1931 and then replaced by Minerals Yearbook.

142. Ries, Heinrich, and Henry Leighton. History of the Clay-Working Industry in the United States. New York: Wiley, 1909. 270 p. 11 black and white illus. Bibliography: pp. 241-45. Index.
 This research was compiled for the Carnegie Institution's series, Contributions to the Economic History of the United States, but was published in advance of that use. Ries and Leighton's copious and detailed work contains a "resume of the clay-working industry by products" and a "history of the clay-working industry by states." They found "such a startling lack of knowledge of the subject in nearly all quarters that the authors venture to hope that the gathering together of what scattered information there is may prove of value." The value of clay products in each state is also listed by categories: brick, paving, pottery, etc.

143. Shotliff, Don A. The History of the Labor Movement in the American Pottery Industry: The National Brotherhood of Operative Potters--International Brotherhood of Operative Potters, 1890-1970. Ph.D. dissertation, Kent State University, 1977. 442 ℓ. Bibliography: ℓ. 435-42.
 "Over the years there has been a paucity of historical literature dealing with the pottery industry and its labor organization.... this study examines the spectrum of events from the Knights of Labor beginnings to the affiliation with the Seafarers' International Union in 1975." He traces the growth of the ceramics industry to the introduction of favorable tariff laws in 1890 and makes a very detailed study of union issues through the twentieth century.

144. Smith, Harry Bradley. A Survey and Analysis of the Pottery Industry, June 1921. Bulletin no. 67. Trade and Industrial Series, no. 20. Washington, D. C.: Federal Board for Vocational Development, 1921. 88 p.
 Smith visited eight potteries which manufactured china, "semiporcelain," and art tiles and classified the production jobs by department. For each job, he gave a description, assigned skill level, and suggested educational and physical requirements. Smith's examination is very thorough.

145. Stratton, Herman John. Factors in the Development of the American Pottery Industry, 1860-1929. Ph.D. dissertation, University of Chicago, 1929. 360 ℓ. Bibliography: ℓ. 355-60.

Study of the types, quality, and prices of pottery manufactured in America between 1860 and 1929. Stratton also investigates the raw materials, labor costs, and technological developments in that period. The struggle against imports and the fight for tariff protection are also described.

146. U. S. Bureau of Foreign and Domestic Commerce. The Pottery Industry: Report on the Cost of Production in the Earthenware and China Industries of the United States, England, Germany, and Austria. Miscellaneous Series, no. 21. Washington, D. C.: Government Printing Office, 1915. 709 p.
An extensive study undertaken by the Bureau in cooperation with the Bureau of Standards. Pages 67-388 contain "Earthenware and vitreous china industry in the United States." Costs, profits, wages, and working hours were studied as well as production figures and imports. Methods and conditions of manufacturing are described for pottery, whitewares, and china. Potters' organizations are also discussed. Pottery production in the U. S. increased 62. 5 percent from 1901 to 1912.

147. U. S. Potters' Association. Shall the Pottery Industry of the United States Be Destroyed? Washington, D. C. , 1888. 12 p.
The executive committee of the U. S. Potters' Association submitted a protest against reducing the tariff on earthenware imports, backing up their arguments with figures on the salaries of American workers and comparative costs of production.

148. U. S. Tariff Commission. Pottery and Reciprocal Trade Agreements. Washington, D. C. : United States Tariff Commission, 1940. 15 p.
"One of a series of reports on industries affected by the trade agreements program" which summarizes the production of pottery in the U. S. from 1929 to 1938. Figures for imports, exports, and the rates of duty are also listed.

149. U. S. Tariff Commission. Pottery: Household Table and Kitchen Articles of Earthenware and of China, Porcelain and Other Vitrified Wares. Report no. 102, 2d series. Washington, D. C. : Government Printing Office, 1936. 114 p.
Under the National Recovery Act, the Commission was ordered to investigate pottery tariffs. The report summarizes the history of the industry, imports (particularly Japanese), and the economic conditions of the pottery industry.

X. HISTORICAL ARCHAEOLOGY

150. Baker, Vernon G. Historical Archaeology at Black Lucy's
 Garden, Andover, Massachusetts: Ceramics from the Site
 of a Nineteenth Century Afro-American. Papers of the
 Robert S. Peabody Foundation for Archaeology, vol. 8.
 Andover, Mass.: Robert S. Peabody Foundation for Ar-
 chaeology, Phillips Academy, 1978. 122 p. 115 black and
 white illus. Bibliography: pp. 117-22.
 Report based on one of the earliest excavations in Amer-
 ican historical archaeology and one of the earliest efforts
 at research on black Americans. Although most of the
 ceramic shards were from imported ware, some local pot-
 tery was found. The research by Ripley Bullen and Adel-
 aide Bullen in 1943 (reanalyzed and written up by Baker)
 was a meticulous attempt to illuminate cultural history
 through pottery; it was "one of the first attempts to devise
 cultural chronology and hypotheses about the late eighteenth
 and early nineteenth century American social system from
 the study of pottery."

151. Barka, Norman F. The Archeology of Kiln 2 Yorktown Pot-
 tery Factory, Yorktown, Virginia. The College of William
 and Mary Yorktown Research Series, no. 4. Williamsburg,
 Va., 1979.
 Not seen.

152. Caywood, Louis Richard. Excavations at Green Spring Planta-
 tion. Yorktown, Va.: Colonial National Historical Park,
 1955. 29 p., 23 ℓ. of maps and plates. Bibliography:
 pp. 26-28.
 Report prepared for the Virginia 350th Anniversary Com-
 mission and the Jamestown-Williamsburg-Yorktown-
 Celebration Commission of the excavation of the seventeenth-
 century home of Virginia's Governor Sir William Berkeley,
 three miles from Jamestown. A pottery kiln, "probably
 built by Governor Berkeley about 1665," was completely
 excavated. "The importance of the Green Spring Kiln can-
 not be overstressed; to date [it] is the only seventeenth
 century pottery kiln which has been found in the State."
 Crude utilitarian wares were made. C. Malcolm Watkins
 helped in identification of the pottery. The cover title is
 Green Spring Plantation Archaeological Report.

153. Conference on Historic Site Archaeology. Papers. Stanley
 South, editor. Columbia, S. C.: Institute of Archaeology
 and Anthropology, University of South Carolina, 1965- .
 The published papers of the sixth through the nineteenth
 conferences have included a variety of useful topics: "The
 Ceramic Ware of the Potter Rudolph Christ at Bethabara
 and Salem, N. C., 1786-1821" by Stanley South (vol. 3);
 "Preliminary Information on the Use of the Alkaline Glaze

for Stoneware in the South, 1800-1970" by Georgeanna
Greer (vol. 5); "Preliminary Investigations of Atlanta's
Folk Potteries" by Linda F. Carnes (vol. 12). Other
relevant papers are in the series.

154. Cotter, John L. Archaeological Excavations at Jamestown
Colonial National Historical Park and Jamestown National
Historical Site, Virginia. Archeological Research Series,
no. 4. Washington, D. C.: National Park Service, 1958.
299 p. 121 black and white illus. Bibliography: pp. 195-
99. Index.
Describes the results of extensive archaeological excava-
tions made between 1954 and 1956 and summarizes the re-
sults of earlier digs. The emphasis is on physical remains
and dating of objects. Several brick, lime, and pottery
kilns were unearthed. An appendix discusses the types of
ceramics found at Jamestown. The University of Pennsyl-
vania accepted this study as Cotter's dissertation in 1959.

155. Deetz, James. In Small Things Forgotten: The Archaeology
of Early American Life. Garden City, N. Y.: Anchor
Press/Doubleday, 1977. 184 p. 20 black and white illus.
Bibliographic notes. Index.
Deetz, an anthropologist and past president of the Society
for Historical Archaeology, demonstrates for a popular au-
dience what artifacts and refuse of past ages can reveal
about their owners' lives and culture. The preponderance
of English pottery is explained and the origins of some
African earthenwares are pondered.

156. Miller, J. Jefferson, II and Lyle M. Stone. Eighteenth-
Century Ceramics from Fort Michilimackinac: A Study in
Historical Archaeology. Smithsonian Studies in History and
Technology, no. 4. Washington, D. C.: Smithsonian Insti-
tution Press, 1970. 130 p. 56 black and white illus.
Bibliography: pp. 102-10. Index.
Few ceramic shards of North American origin have been
found in this excavation of a French fort founded around
1715, then turned over to the British in 1761. Most of the
14,407 shards were European and Oriental. The objectives
of this scholarly study were to describe in detail the cer-
amic artifacts (manufacture, importation, use, and dating)
and to "illustrate the interpretative value of historical sites
ceramics." This is a fine, thorough investigation. The
annotated bibliography is very helpful.

157. Noël Hume, Ivor. A Guide to Artifacts of Colonial America.
New York: Knopf, 1970. 323 p. 100 black and white
illus. Index.
An analysis of design and manufacturing clues that re-
veal the date of excavated items. Arranged alphabetically
from "Armor" to "Wig Curlers," this book is useful for
historical archaeologists and collectors. Entries relevant

to ceramics are "Pottery Bottles," Bricks and Brickwork,"
"American Ceramics," "Chamber Pots, Bedpans, and Close-
stool Pans," "Flower Pots," "Roofing Tiles," and "Tobac-
co Pipes." This is a companion volume to Historical Ar-
chaeology, published in 1969, which is a good introduction
to the field with a fine bibliography. Historical Archaeol-
ogy does not contain much information on pottery however.

158. Noël Hume, Ivor. Here Lies Virginia; An Archaeologist's
View of Colonial Life and History. New York: Knopf,
1963. 317 p. 129 black and white illus. Bibliography:
pp. 309-17. Index.
Noël Hume here demonstrates for a general audience
that archaeology and recorded history can combine to write
the story of the history and culture of Colonial Virginia.
Pages 208-25 contain a good discussion of the early kilns
that have been excavated.

159. Noël Hume, Ivor. Pottery and Porcelain in Colonial Wil-
liamsburg's Archaeological Collections. Colonial Williams-
burg Archaeological Series, no. 2. Williamsburg, Va.:
Colonial Williamsburg Foundation, 1969. 46 p. 44 black
and white illus.
An introduction to the pottery fragments that have been
excavated at Williamsburg since 1929. The archaeologists
have found American-made pottery and a full range of Eng-
lish domestic wares. Some Rhenish, Iberian, and Chinese
wares were also found but only in small quantities because
English law prohibited the importation of non-English pot-
tery. Some pieces from William Rogers' Yorktown pot-
tery are illustrated.

160. Pogue, Dennis J. The Trees Point Stoneware Pottery,
Charles City County, Virginia: An Archaeological Exam-
ination. Master's thesis, George Washington University,
1981. 145 ℓ. (or more; copy seen was defective). Many
black and white drawings. Bibliography: ℓ. 145.
Close study of the wares excavated from Moro Phillips'
pottery at Trees Point, Virginia, which produced common
utilitarian salt-glazed stoneware for the storage of chemi-
cals (an unusual enterprise). Pogue also summarizes the
history of American utilitarian pottery, the chemical stone-
ware industry, and the Trees Point pottery.

161. Smith, Samuel D., and Stephen T. Rogers. A Survey of
Historic Pottery Making in Tennessee. Research Series,
no. 3. Nashville: Division of Archaeology, Tennessee
Department of Conservation, 1979. 159 p. 47 black and
white illus. Bibliography: pp. 151-59.
An important report of extensive archival research and
field site survey which identified 132 family potteries and
31 industrial potteries which operated in Tennessee before
the 1940s. The foreword notes the great need for research

in southern ceramics and the occurrence of errors in the
little that has been written, errors repeated from early
authors such as Ramsay and Barber.

162. South, Stanley, ed. Research Strategies in Historical Ar-
cheology. New York: Academic Press, 1977. 345 p.
Tables. Bibliographies. Index.
A collection of essays, written for graduate students and
archaeologists in the field, which links empirical data to
theory and moves historical archaeology closer to anthro-
pology's "evolutionary and systems theory." Ceramics are
included in these essays for their role in dating and culture
analysis.

163. Thompson, Erwin H. The Poor Potter of Yorktown: Colonial
National Historical Park, Virginia. Historic Structure Re-
port. Denver, Colo.: Denver Service Center, Historic
Preservation Team, National Park Service, U. S. Depart-
ment of the Interior, 1974. 112 p. 13 black and white
illus. Bibliography: pp. 83-89.
An extensive "modified historic structure report for the
archeological remains of William Rogers' pottery shop,"
based on Norman Barka's excavation of the site. The ex-
cavation was stimulated by Watkins' The "Poor Potter" of
Yorktown, described by Thompson as "an important study
that brought attention to the Yorktown pottery befor arche-
ology was carried out." The history of Colonial pottery is
summarized, a partial listing of Colonial kilns is given,
and prototypes for Rogers' kiln are discussed. Contempo-
rary documents are quoted at length and the possible origin
of the term "poor potter" is analyzed. Thompson also
summarizes the archaeological evidence.

164. Watkins, C. Malcolm, and Ivor Noël Hume. The "Poor Pot-
ter" of Yorktown. United States National Museum Bulletin,
249. Contributions from the Museum of History and Tech-
nology. Paper 54, pages 73-112. Washington, D. C.:
Smithsonian Institution Press, 1967. 36 p. 20 black and
white illus. Bibliographic notes.
Watkins and Noël Hume collaborated on this study which
brought forward new information on a previously nameless
"poor potter," William Rogers of Yorktown. Watkins stud-
ied the documentary records and Noël Hume conducted an
archaeological excavation. They found that the "Yorktown
potter was neither poor nor nameless" and that "his ware
was of sufficient quantity and quality to offer competition to
English imports." This is an important example of the
role of historical archaeology.

165. Winterthur Conference, 18th, 1972. Ceramics in America.
Winterthur Conference Report, 1972. Edited by Ian M. G.
Quimby. Charlottesville: Published for the Henry Francis
du Pont Winterthur Museum by the University Press of

Virginia, 1973. 374 p. 122 black and white illus. Bibliographies.
Papers delivered at the eighteenth annual Winterthur Conference which studied ceramics in the context of early American culture. Several report on archaeological digs at Plymouth, Mass.; St. Mary's City, Md.; Louisbourg, Nova Scotia; Yorktown, Va.; and Williamsburg, Va. The written records of Tucker China are studied. Spanish ceramics and Staffordshire ware are also included. The conferees feel that only "rarely have studies of ceramics been devoted to enriching social history.... It was the purpose of this conference, therefore, to bring together students from many areas of ceramic research to focus on and to interpret the cultural information with which all ceramic objects are invested."

166. Winterthur Conference, 20th, 1974. Arts of the Anglo-American Community in the Seventeenth Century. Winter-thur Conference Report, 1974. Edited by Ian M. G. Quimby. Charlottesville: Published for the Henry Francis du Pont Winterthur Museum, by the University Press of Virginia, 1975. 299 p. 106 black and white illus. Bibliographic notes.
The twentieth conference, devoted to the decorative arts of the seventeenth century, includes a paper by C. Malcolm Watkins, "Ceramics in the Seventeenth-Century English Colonies." He summarizes the evidence from kiln excavations that have been carried out, pointing out that "very little kiln evidence has been recovered in America." He also describes the great variety of imported wares that were used in early Colonial days.

XI. ANTIQUES: A SELECTION

167. Bishop, Robert, and Patricia Coblentz. The World of Antiques, Art, and Architecture in Victorian America. New York: Dutton, 1979. 495 p. 45 color, 635 black and white illus. Bibliography: pp. 486-91. Index.
A copiously illustrated and lively work which shows the relationship of the now antique material objects of the Victorians to their daily life and culture. "Ceramics" (pages 190-223) includes an essay on American ceramics, Victorian taste, and foreign influences.

168. Boger, Louise Ade, and H. Batterson Boger. The Dictionary of Antiques and the Decorative Arts; A Book of Reference for Glass, Furniture, Ceramics, Silver, Periods, Styles, Technical Terms, &c. 2d ed. New York: Scribner, 1967. 662 p. 20 color, many black and white illus. Bibliogra-

phies: pp. 559-66, 661-62.
This comprehensive reference work with succinct, in-
formative entries includes a few dozen terms from Ameri-
can ceramics. In lieu of an index, there is a "classified
list of subjects and terms." The second edition contains a
supplement of seven hundred terms from "the English Arts
and Crafts Movement, l'Art Nouveau and the Modern Move-
ment and the Twentieth Century, with selected terms of the
American Victorian period."

169. Bond, Harold Lewis. An Encyclopedia of Antiques. Detroit:
Gale Research, 1975. 389 p. Many black and white illus.
Bibliography: pp. 359-89.
Reprint of the 1945 edition published by Tudor in New
York. Primarily concerned with antiques, but "because of
the tardy development of fine earthenware products in the
United States many late 19th-century potteries are here in-
cluded." Bond also includes biographies of early craftsmen,
hoping to rescue them from neglect.

170. Butler, Joseph T. American Antiques, 1800-1900: A Collec-
tor's History and Guide. New York: Odyssey Press, 1965.
203 p. 8 color, 170 black and white illus. Bibliography:
pp. 187-95. Index.
Furniture, glass, lamps, textiles, and silver are in-
cluded. The chapter on ceramics (pages 93-107) gives a
brief introduction to porcelain and pottery. Butler states:
"Since the ceramics of the nineteenth century have for so
long been derided and lampooned by twentieth century crit-
ics, they offer a vast field as collectibles today."

171. The Connoisseur Complete Encyclopedia of Antiques. 2d ed.
London: The Connoisseur, 1975. 704 p. Many illus.
(color, black and white) Bibliography: pp. 669-78. Index.
Pages 403-15 of this massive encyclopedia contain the
entry for American pottery and porcelain. It is an inter-
esting, informed, and very concise survey.

172. Cooper, Wendy A. In Praise of America: American Decora-
tive Arts, 1650-1830/Fifty Years of Discovery Since the
1929 Girl Scouts Loan Exhibition. New York: Knopf, 1980.
280 p. 52 color, 308 black and white illus. Bibliographic
notes. Index.
In 1929, an important exhibition of American decorative
arts was held at the American Art Association's galleries
as a benefit for the Girl Scouts of America. The fiftieth
anniversary of that exhibition was celebrated with an exhi-
bition at the National Gallery of Art and this extensive,
scholarly book which surveys discoveries of the past fifty
years. It is notable that the only ceramics shown in 1929
were foreign-made imports which were "high-style" then.
That is remedied in this book which, in its brief discus-
sion of American-made ceramics (pages 45-51), is valuable
for its highlighting of recent discoveries and new studies.

173. Davidson, Marshall B. , ed. Three Centuries of American
Antiques: American Heritage. By the editors of American
Heritage; author and editor in charge, Marshall B. David-
son. New York: Bonanza Books, 1979. 384, 416, 415 p.
Many illus. (color, black and white) Indexes.
Ceramics are scattered through this massive volume
which is included for its rich array of antiques and their
integration with American history and culture. The cul-
tural context of the development of ceramics can be under-
stood. Originally published by American Heritage (1967-69)
in three volumes: The American Heritage History of Colo-
nial Antiques, The American Heritage History of American
Antiques from the Revolution to the Civil War, and The
American Heritage History of Antiques from the Civil War
to World War I. Also published by Crown in 1979 in three
volumes.

174. Ketchum, William C. , Jr. The Catalog of American Antiques.
New York: Rutledge Books, distributed by Scribner, 1977.
382 p. , mostly illus. (over 2, 000; color, black and white)
Bibliography: pp. 372-73. Index.
An extensive, fully-illustrated, and reputable guide to a
wide variety of antiques. A range of prices is given for
each antique, which is identified, when possible, by region
and date of production. Pottery (redware, stoneware, yel-
lowware, whiteware, and spongeware) is included on pages
112-33. Issued in 1980 as The New and Revised Catalog of
American Antiques (New York: Rutledge Books, distributed
by Mayflower Books).

175. McClinton, Katharine Morrison. Antique Collecting for Every-
one. New York: Bonanza Books, 1951. 252 p. Many
black and white illus. Bibliographies. Index.
A survey of collecting antiques that were most popular at
the time of writing. American stoneware pots and jars,
Rockingham ware, and American Tobies are included in
short chapters. Also published by McGraw-Hill (1951) and
reprinted by Bonanza Books in 1981.

176. McClinton, Katharine Morrison. Collecting American Victorian
Antiques. New York: Scribner, 1966. 288 p. Over 200
black and white illus. Bibliography: pp. 282-83.
Describes the types of Victorian furniture, glass, silver,
and decorative arts that are most popular with collectors.
Parian ware, majolica, Belleek, art pottery, and tiles are
discussed on pages 220-47. Hand-painted china is also in-
cluded (pages 270-81).

177. McClinton, Katharine Morrison. A Handbook of Popular An-
tiques. New York: Random House, 1946. 244 p. Many
black and white illus. Bibliographies. Index.
An authoritative, documented guide for the antique col-
lector. The pottery described is primarily English and

Anglo-American. However, the chapters on Tucker china, Parian ware, and American Victorian shaving mugs are mostly on American pottery. Ironstone china, Gaudy Dutch and Welsh, Spatterware and Roseware were produced in a few American potteries.

178. Mebane, John. New Horizons in Collecting: Cinderella Antiques. South Brunswick, N.J.: A. S. Barnes, 1966. 280 p. 116 black and white illus. Bibliography: pp. 267-75. Index.

John Rogers' "Groups" and Weller, Roseville, and Dedham pottery are briefly discussed in this investment guide for collectors. Mebane identifies a variety of antiques that were "under-collected" in 1966 and whose prices, in his opinion, were bound to go up.

179. Shull, Thelma. Victorian Antiques. Rutland, Vt.: Charles E. Tuttle, 1963. 421 p. 220 black and white illus. Bibliography: pp. 409-12. Index.

This survey for collectors includes chapters on "The Robertson Family and Dedham Pottery," "Rookwood Pottery," "The Stockton Art Pottery," "The Pauline Pottery," "Victorian Majolica," "Belleek China," "Parian," "Rockingham Ware," and "Pottery Jugs, Mugs, and Shoes."

180. Stillinger, Elizabeth. The Antiques Guide to Decorative Arts in America, 1600-1875. New York: Dutton, 1972. 463 p. 192 drawings, 434 photographs. Bibliography: pp. 459-63.

"This book aims to bring out historical and stylistic relationships among the major types of decorative arts made and used in America." This introductory work surveys the development of the arts every twenty-five years. Thus the Queen Anne period is considered, followed by Chippendale, and so on. American and imported ceramics are included in each period.

XII. ART EDUCATION

181. Ceramic Education: Past, Present, and Future. Alfred, N.Y.: New York State College of Ceramics, 1951. 68 p. 4 portraits.

Papers presented at a symposium held on the fiftieth anniversary of the founding of the N.Y.S. College of Ceramics at Alfred University. The history, present condition, and future of ceramic education was discussed in three talks. The fourth, "Changing Styles in Design and Manufacture--Ceramic and Otherwise," was given by Charles Harder.

182. Clarke, Isaac Edwards. Art and Industrial Education. Department on Education for the U. S. Commission to the Paris Exposition of 1900. Monographs on Education in the United States, 14. Albany, N. Y.: J. B. Lyon Co., 1900. 63 p. Surveys the history of art education in the U. S., noting the rapid development since 1870, spurred by the English art education movement and the 1876 Centennial. He summarizes the contents of his four-volume study, Art and Industry: Education in the Industrial and Fine Arts in the United States (Washington, D. C.: Bureau of Education, 1885-98), authorized by Congress in 1880.

183. Miller, Leslie William. The Lesson of the Hour for American Potters. An Address Delivered by Invitation of the Committee on Design Before the U. S. Potters' Association, at Its Annual Meeting Held in Washington, D. C., Jan. 22, 1890. East Liverpool, Ohio: U. S. Potters' Association, 1890. 24 p.
 A plea to manufacturers for increased art education and cooperation with artists in order to improve the quality of American pottery, by the principal of the Pennsylvania Museum and School of Industrial Art.

184. Nichols, George Ward. Art Education Applied to Industry. New York: Harper & Bros., 1877. 211 p. 130 black and white illus. Bibliography: p. 203. Index.
 Nichols laments the lack of art education in the United States and the effect of this on American crafts industry. Published just after the 1876 Centennial Exhibition at Philadelphia, which Nichols clearly hopes will have "incalculable influence for good upon the art education and art industry in the United States." He deplores the ceramic industry: "Of the art of the potter in the United States there is not much to be said.... Concerning the decoration of pottery ... our manufacturers at Trenton, Cincinnati, Sciotoville, and elsewhere, know but little. It is to be hoped that the magnificent display of ceramics which came from foreign countries will teach them, and inspire them with emulation." He surveys contemporary art education in Europe and proposes a course of instruction for the United States.

185. Norwood, John Nelson. 50 Years of Ceramic Education. Alfred, N. Y.: New York State College of Ceramics, 1950. 80 p. 9 black and white illus.
 Norwood, President of Alfred University from 1934 to 1944, wrote an institutional history of the development of the College of Ceramics from its founding in 1900 by Charles Binns until 1950. The teachers during that period are listed in an appendix as well as all the graduates from 1904 to 1950 and the master's degrees conferred from 1932 to 1950. The cover title is Ceramics at Alfred University, 1900-1950.

186. Perkins, Dorothy Wilson. Education in Ceramic Art in the United States. Ph.D. dissertation, Ohio State University, 1956. 324 ℓ. Bibliography: ℓ. 302-23.
 "The present study is concerned with formal education in ceramic art, particularly at the college level, as that education has evolved in this country from the turn of the century." This is a broad study, including events in Cincinnati and New Orleans before 1900 as well as chapters on Charles Binns, Arthur E. Baggs, and Adelaide Alsop Robineau. Ceramics literature before 1900 and from 1900 to 1925 is also covered. The appendixes list winners of the Binns Medal and of the Ceramic Nationals.

XIII. FOLK POTTERY

187. Barons, Richard I. An Exhibition of 18th and 19th Century American Folk Pottery. New Paltz, N.Y.: College Art Gallery, State University College at New Paltz, 1969. 35 p. 46 black and white illus.
 Catalog from an exhibition of primarily northeastern pottery, although some southern pieces were included. A brief essay precedes the illustrations of pots which "were chosen for they were eye catching, but still retained their domesticity of purpose."

188. Bishop, Robert Charles. American Folk Sculpture. New York: Dutton, 1974. 392 p. 726 illus. (color, black and white). Bibliography: pp. 388-89. Index.
 This well-illustrated visual appreciation includes pottery on pages 214-25. Unusual heads, figures, face jugs, cabin scenes, and extravagently ornamented jugs are illustrated. Bishop notes that "the rediscovery of folk painting and sculpture began in Maine in the late 1920s where artists, dealers, and collectors gathered like mayflies in summer."

189. Christensen, Erwin Ottomar. Early American Designs: Ceramics. New York: Pitman, 1952. 48 p., mostly illus. (black and white). Index.
 Reproductions in large scale of designs from the Index of American Design. "It is hoped that familiarity with these designs will help you get satisfaction and enjoyment from decorating your own pots." Sgraffito, slip, and spatterware designs are included.

190. Christensen, Erwin Ottomar. The Index of American Design. New York: Macmillan and National Gallery of Art, Washington, D.C., 1950. 229 p. 378 illus. (color, black and white) Bibliography: pp. 219-21. Index.
 The Index of American Design resulted from a nationwide

project of the Federal Art Project under the WPA. From 1935 to 1941 artists in thirty-five states documented (in careful watercolors) the creations of American design and craftsmanship. It was "the largest and most nearly comprehensive collection of its kind in the world." Hundreds of artists worked on this task and nearly 17,000 illustrations were made. Figureheads, wooden Indians, toys, glass, furniture, and fire-fighting equipment were included in the wide scope of this enormous project. Holger Cahill's introduction is a knowledgeable history of the index and of earlier research on American folk art and crafts.

191. Guappone, Carmen A. United States Utilitarian Folk Pottery: Price Guide. McClellandtown, Pa.: Guappone Pubs., 1977. 64 p., mostly illus. (black and white)
 Collector's guide to stoneware and tanware of Pennsylvania and other eastern states. Preliminary essays describe the kilns, and illustrate glaze testers, stilts, saggers, and maturity bars. The photographs, which lack definition, are organized by method of decoration: slip cup quill, freehand, or stencil. A price is suggested for each piece.

192. Guilland, Harold F. Early American Folk Pottery. Philadelphia: Chilton, 1971. 321 p. Many black and white illus. Bibliography: pp. 293-309. Index.
 Guilland, "a good potter and a layman historian," wished to arouse the interest of studio potters in the designs of early pottery, to inform on the function of each type of pot, and to inspire more research on country potters. Pages 87-289 are entirely illustrations, all taken from the Index of American Design at the National Gallery, with explanatory comments. His introductory text describes Colonial culture and the traditions of earthenware and stoneware.

193. Historical Society of York County (Pennsylvania). Regional Aspects of American Folk Pottery. York, Pa.: Historical Society of York County, 1974. 56 p., mostly illus. (black and white)
 Catalog from an exhibition which was organized to investigate the regional variations in form and decoration of folk pottery; it was intended "to draw some very broad conclusions to provide a set of cumulative evidence to identify a piece of pottery found out of context." William C. Ketchum, Jr. apparently wrote the essay, which describes the decorations and forms of redware and stoneware and their variations through the country.

194. Hornung, Clarence. Treasury of American Design: A Pictorial Survey of Popular Folk Arts Based upon Watercolor Renderings in the Index of American Design, at the National Gallery of Art. New York: Abrams, [1972]. 2 vol. Over 2,900 illus., 850 in color. Index.

A lavish publication which illustrates over 2,900 of the 17,000 watercolors that comprise the Index of American Design. Holger Cahill's introduction is reprinted from Christensen's The Index of American Design (New York: Macmillan, 1950). Hornung wrote an essay for each category: pottery includes "Jars & Jugs; Crocks & Churns" (pages 346-61), "Rockingham & Bennington" (pages 362-77), and "To a Bit of Clay They Added Beauty" (pages 668-79).

195. Index of American Design. Teaneck, N.J.: Somerset House, 1978- .
The complete Index has been published on color microfiche. More than 15,000 illustrations may be purchased, in full or in part. The categories are as follows: Textiles, Costumes and Jewelry; The Art and Design of Utopian and Religious Communities; Architecture and Naive Art; Tools, Hardware, Firearms and Vehicles; Domestic Utensils; Furniture and Decorative Accessories; Wood Carving and Weathervanes; Ceramics and Glass; Silver, Copper, Pewter and Toleware; Toys and Musical Instruments. A catalog is provided for each part. This is the first time the entire Index has been available to researchers outside the National Gallery.

196. Johnson, Randy J. Early American Folk Pottery. St. Paul, Minn.: Visual Arts Gallery, College of St. Catherine, 1977. 42 p., mostly illus. (black and white).
Catalog from an exhibition of seventy pots, crocks, and churns (mostly stoneware) and slip decorated plates. The captions give insufficient information; there is no text.

197. McClinton, Katharine Morrison. The Complete Book of American Country Antiques. New York: Coward-McCann, 1967. 224 p. 155 black and white illus. Bibliography: pp. 203-09. Index.
"Small country antiques are among those most sought-after by present-day collectors, yet they have never been covered in a book of their own" (book jacket). Tinware, woodenware, iron, copper, brass, and homespun antiques are included as well as "country pottery" (pages 99-130). Redware, stoneware, Rockingham, yellowware, clay pipes, monkey or slave jugs, grease lamps, and sewer tile pottery are surveyed quickly for the collector.

198. Raycraft, Donald R., and Carol Raycraft. American Country Pottery. Des Moines, Iowa: Wallace-Homestead Book Co., 1975. 51 p. 24 color illus.
Illustrates a variety of stoneware crocks and a little Rockingham and yellowware; the pieces are selected from three private collections of "country pottery." The text is confined to short descriptions of the illustrated pieces. The Raycrafts' The Collector's Guide to Kitchen Antiques (Paducah, Ky.: Collector Books, [1980?]) includes on

pages 60-72 crocks and jars not illustrated here. A price guide to American Country Pottery was published in 1977.

199. Raycraft, Donald R., and Carol Raycraft. Wallace-Homestead Price Guide to American Country Antiques. 3d ed. Des Moines, Iowa: Wallace-Homestead Book Co., 1982. 165 p., mostly illus. (color, black and white). Bibliographies.
Furniture, kitchenware, baskets, stoneware (pages 123-40), and Shaker antiques are included. Each item is illustrated and assigned an approximate value. Unfortunately, the illustrations are fuzzy and lack contrast. Redware and yellowware were included in the second edition (1981). First published in 1978.

XIV. ART POTTERY

200. Anscombe, Isabelle, and Charlotte Gere. Arts & Crafts in Britain and America. New York: Rizzoli, 1978. 232 p. 334 illus. (color, black and white) Bibliography: pp. 226-29. Index.
The aesthetic and political implications of the Arts and Crafts Movement in Britain and its importation to America are studied in detail, with many fine illustrations. American pottery is included in only a small way, but the thorough explanation of the context of the art pottery movement is valuable.

201. Clark, Robert Judson, ed. The Arts and Crafts Movement in America, 1876-1916. Princeton, N.J.: Princeton University Press, 1972. 190 p. 295 black and white illus. Bibliography: pp. 187-90.
An extensive and carefully researched catalog published with a large exhibition at the Art Museum, Princeton University, the Art Institute of Chicago, and the National Collection of Fine Arts, which represented the first significant retrospective of American art pottery. Furniture, stained glass, and printing were also included. The captions accompanying each illustration are very informative. Contributions include "The Eastern Seaboard" by Clark and others, "Chicago and the Midwest" by David A. Hanks, "The Pacific Coast" by Clark, "The Arts and Crafts Book" by Susan Otis Thompson, and "Art Pottery" by Martin Eidelberg (pages 119-86). Eidelberg discusses the topics of early development in Ohio and elsewhere, Grueby, Newcomb, Van Briggle, Losanti, Tiffany, Robineau, crystalline glazes, and matt glazes.

202. Elzea, Rowland, and Betty Elzea. The Pre-Raphaelite Era,

1848-1914: An Exhibition in Celebration of the Nation's Bi-
centennial. Wilmington: Delaware Art Museum, 1976.
233 p. Many black and white illus. Bibliography: pp.
230-33.

Rookwood and Grueby are the only American potteries
represented in this fine, scholarly exhibition catalog which
naturally focuses on English arts. The essays and notes
are lengthy and informed. Most of the 469 paintings and
art objects exhibited are illustrated. Pre-Raphaelites, the
Aesthetic Movement, the Arts and Crafts Movement, and
Art Nouveau are among the subjects of this large exhibition.

203. Evans, Paul. Art Pottery of the United States: An Encyclo-
pedia of Producers and Their Marks. New York: Scribner,
1974. 353 p. Many black and white illus. Bibliography:
p. 345. Index.

Evans seeks to "establish an accurate and reliable his-
tory of the various art pottery operations." The many bib-
liographical footnotes document his corrections of errors
that had persisted in the literature. He presents histories
of over one hundred potteries and illustrates at least one
mark for each, noting that Barber's Marks of American
Potters has not been updated by any researcher. Evans
does not include art schools (except Newcomb), folk ware,
"non-art pottery" factory ware, or tiles. His research is
much more extensive than Henzke's, whose book, though
useful, is regrettably undocumented. Evans corrects
Henzke in several footnotes but he does not otherwise re-
fer to her work. Kovels' Collector's Guide, also published
in 1974, has coverage similar to Evans; Kovels' guide has
more entries because tile companies and architectural
terra-cotta companies are included. Evans' work stands
as the most accurate comprehensive guide to art potteries.

204. Garner, Philippe, ed. The Encyclopedia of Decorative Arts,
1890-1940. New York: Van Nostrand Reinhold, 1979.
320 p. Many illus. (color, black and white) Bibliography:
pp. 310-12. Index.

This lavishly illustrated work seeks to convey the "over-
all picture and the fluidity of design history" for the period
in question, "from the dual viewpoints of style and theory
and of actual production." The predominant styles are out-
lined by contributing scholars; following that, the designs
and designers of individual Western countries are discussed.
Connections with literature, painting, and photography are
also illustrated. The section on U.S. ceramics (pages
190-93) is very short, but this book gives a good picture
of the cultural and aesthetic milieu.

205. Henzke, Lucile. Art Pottery of America. Exton, Pa.:
Schiffer, 1982. 368 p. 480 illus. (color, black and
white) Bibliography: p. 361.

A heavily-illustrated survey of forty-four art potteries

(with a chapter on tile companies) that is a revision of
Henzke's American Art Pottery (Camden, N.J.: Thomas
Nelson, 1970). Henzke hopes her readers will be influ-
enced "to enjoy what they collect." Valuable histories of
each pottery and its lines are given. Henzke has added
about fifteen art potteries to her 1970 edition; many of the
original entries remain unchanged, although illustrations
have been added. The history of the Cowan Pottery con-
tained errors in the 1970 edition; that entry has now been
corrected. Other entries have been corrected or expanded.
Her work must be compared with Evans' Art Pottery of the
United States. Evans' research enabled him to write
lengthier histories and correct errors of earlier writers.
The authority of Henzke's work would be increased if she
had indicated her sources, but she does not. Also Evans
restricts his coverage to the art pottery movement (1870-
1920) while Henzke includes several companies which began
in the 1930s, 1940s, even 1965; these fall into the category
of "recent collectible pottery," not art pottery. However,
Henzke's text includes information that is not in Evans and
she illustrates different and often more marks.

206. John and Mable Ringling Museum of Art. The Arts of Louis
Comfort Tiffany and His Times. Sarasota, Fla., 1975.
36 p. 43 illus.
 Art pottery of the contemporary period is included in
this catalog from an exhibition of Tiffany's glass, drawings,
photography, and furniture. The Tiffany pieces were on
loan from the Hugh and Jeannette McKean collection at the
Morse Gallery of Art. Art potteries represented include
Fulper, Wheatley, Grueby, Weller, and seven more.

207. Keen, Kirsten Hoving. American Art Pottery, 1875-1930.
Wilmington: Delaware Art Museum, 1978. 84 p. Many
black and white illus. Bibliography: pp. 83-84.
 This thorough catalog is from an exhibition which pre-
sented "a comprehensive overview of American art pot-
tery," seen here as a vigorously experimental forerunner
to the modern studio pottery movement. Most of the 178
pieces exhibited are illustrated. The catalog notes and
essays are based on wide research and the bibliography is
extensive. The work of many art potteries is represented
and placed in social and artistic context through Keen's de-
tailed essays.

208. Kovel, Ralph M., and Terry H. Kovel. The Kovels' Collec-
tor's Guide to American Art Pottery. New York: Crown,
1974. 378 p. 80 color, many black and white illus.
Bibliographies. Index.
 Published the same year as Evans, the Kovels' guide
has more entries (over 180) because tile companies, ar-
chitectural terra-cotta companies, and little-known firms
are included (sometimes with scanty information). Some

entries are longer than Evans'; some are shorter. The
bibliographies are very helpful and the entries are informa-
tive. However, Evans' research is superior; for example,
Byrdcliffe and Brush Guild are "little-known" here but have
full entries in Evans. More problematical, Grotell and
Natzler are listed as "probably studio potters" and the
Kovels do not appear to realize that the Biloxi Art Pottery
was George Ohr's. Still there are many illustrations, the
"lines" are detailed, and many marks are shown.

209. New York Society of Keramic Arts. The Arts of the Fire.
Exhibition at the National Arts Club, April 19th to May
10th, 1905. New York: G. W. Buskirk Press, 1905.
31 p.
Catalog of an exhibition which included work by Robineau,
Binns, Fry, Frackelton, Van Briggle, Dedham Pottery,
Low Tile, Rookwood, and Newcomb College students. The
sponsors sought to show "a representative collection of the
products of our American potters, glass-blowers and enam-
elers together with the best work of the members of the
Society." None of the pieces are illustrated.

210. Pennsylvania Museum and School of Industrial Art. Pottery
and Porcelain Exhibition, Including a Competition for Amer-
ican Workmen. Awards and Report of the Judges. Phila-
delphia, 1888. 4 p.
This exhibition of American ceramics, held October 16-
November 13, 1888, was "the first of its kind" and rushed
in execution; however the judges gained "a very favorable
impression of the advance of American pottery in recent
years." Prizes were awarded to Rookwood, Burroughs &
Mountford, and several individuals. The judges criticized
the scanty numbers of porcelain and "the lack of serious
effort for qualities of form."

211. Pennsylvania Museum and School of Industrial Art. Exhibi-
tion of American Art Industry of 1889, Including a Compe-
tition for American Workmen. Pottery and Porcelain;
Glass-ware; Terra Cotta; Tiles; Stained Glass; Mosaic
Work. Awards and Reports of the Judges. Philadelphia,
1889. 37 p.
The second exhibition of American ceramics at the mu-
seum (October 8-November 18, 1889) was judged a gratify-
ing improvement over the previous year, a "really remark-
able display," particularly when contrasted to the "mortify-
ing showing" at the Centennial Exhibition in 1876. The
ceramics displayed are analyzed at length; McLaughlin and
Rookwood are singled out for praise.

212. Rebert, M. Charles. American Majolica, 1850-1900. Des
Moines, Iowa: Wallace-Homestead Book Co., 1981. 86 p.
40 color, 72 black and white illus. Bibliography: p. 84.
Index.

American majolica, a "misnomer" because not historically accurate, is here defined as "all mid-19th century pottery with raised designs, imitative of nature's creations, richly painted with vitreous colors and topped off with a clear, lead glaze." Edwin Bennett, Taft of Hampshire, N. H., Griffen and Smith of Phoenixville, and David Haynes of Baltimore are among the producers whose histories are recounted. Majolica fell out of favor about 1900. Marks and many pieces of pottery are illustrated. "The first major book published on the subject of 19th century American majolica" (book cover).

213. Schwartzman, Paulette. A Collector's Guide to European and American Art Pottery. Paducah, Ky.: Collector Books, 1978. 104 p. 258 color illus. Bibliography: p. 103. Index.
 The text briefly outlines the appearance of art pottery in America, Belgium, Holland, France, Great Britain, Austria, Bohemia, Czechoslovakia, and Hungary. Most of the book is taken up by illustrations (of good quality) of pieces from the author's collection. Some marks and signatures are listed and a range of prices is given for some wares.

214. Society of Arts and Crafts, Boston. Exhibition of the Society of Arts & Crafts Together with a Loan Collection of Applied Art, February 5 to 26, 1907. Boston: Heintzemann Press, 1907. 108 p. 8 black and white illus.
 A broad exhibition which commences with a defense of the Arts and Crafts Movement. "Pottery" (pages 51-59) includes the work of Baggs at Marblehead, Binns, Grueby, Markham, Mercer, Mary Chase Perry, Robertson, Robineau, Van Briggle, Volkmar, and Newcomb College, plus some painted china.

215. Society of Arts and Crafts, Boston. Tricennial Exhibition of the Society of Arts & Crafts in Celebration of the Thirtieth Anniversary of Its Organization. Boston: Museum of Fine Arts, 1927. 56 p. 16 black and white illus.
 This varied exhibition (baskets to needlework to wood carvings) included pottery and porcelain (pages 19-26). Among the exhibitors are the Cowan Studio, Fulper Pottery, Marblehead Potteries, Newcomb College, Paul Revere Pottery, and Robineau. The pottery of Cowan, Baggs, and Robineau is illustrated.

216. Smith, Philip S. Porcelain, Pottery and Glass of China, Japan, Europe and America, Collected by Philip S. Smith. New York: Anderson Art Galleries, 1911. 60 p.
 An early sale catalog which includes American pottery. Among the potteries represented are Newcomb College, Volkmar, Chelsea, Grueby, Brouwer, and Rookwood.

XV. DINNERWARE

217. American Vitrified China. Washington, D.C.: Vitrified
China Association, 1946. 31 p. 23 black and white illus.
Publicity pamphlet put out by members of the associa-
tion. The production process of dinnerware is described
and illustrated.

218. Cunningham, Jo. The Collector's Encyclopedia of American
Dinnerware. Paducah, Ky.: Collector Books, 1982. 319
p., mostly illus. (color, black and white). Index.
Cunningham summarizes the history and illustrates a
selection of wares for forty-five companies (a few of them
California companies), including advertising pieces and
children's pieces. Although she points out that East Liver-
pool, Ohio, was the area where the dinnerware industry be-
gan, she includes companies from many parts of the coun-
try. A price guide was also issued.

219. Dallas, Sada. The Romance of Chinaware. Los Angeles:
DeVorss, 1940. 78 p.
"A short interesting history for the Women of Today."
This introductory guide for selection of dinnerware in-
cludes descriptions of Syracuse China, Lenox, Homer
Laughlin, and California pottery as well as European china.

220. Eaklor, Thomas W. Collector's Guide to Russel Wright.
Washington, D.C.: Privately printed, 1978.
Not seen.

221. Gatchell, Dana King. Know Your Tablewares; Their Bodies,
Their Shapes, Their Designs, Some Old, Some New.
American, Bavarian, Danish, English, French, Irish in
Belleeks, Bone Chinas, Chinas, Porcelains, Earthenwares.
Auburn, Ala.: Printed by Edwards Brother, Ann Arbor,
Mich., 1945. 156 p. Bibliography: pp. 153-56.
Gatchell, a professor of home economics, compiled a
classification of tableware designs based on his own col-
lection and china catalogs. American chinas are Castle-
ton, Cumbow, Haviland, Lamberton, Lenox, Lunning,
Pickard, and Syracuse. The patterns are described but
not illustrated. The designs are classified by color and
pattern.

222. Klein, Benjamin. The Collector's Illustrated Price Guide to
Russel Wright Dinnerware. Smithtown, N.Y.: Exposition
Press, 1981. 30 p., mostly illus. (color).
Russel Wright was a designer who worked for many
companies. His "radical, innovative" American Modern
dinnerware line, introduced in 1938, became "the most
widely accepted and, later, copied style ... ever mass-
produced." Klein seeks to "highlight some of the ceramic

lines that were the most successful ... and which have
become favorites among collectors. "

223. Kovel, Ralph M. , and Terry Kovel. The Kovels' Illustrated
Price Guide to Depression Glass and American Dinnerware.
New York: Crown, 1980. 214 p. Over 200 illus. (color;
black and white) Bibliographies: pp. 5 and 137.
"American dinnerware" (pages 133-214), also known as
"Depression dinnerware, " was made from the 1930s through
the 1950s. The price list is organized by pattern name
rather than company. "A partial list of patterns, makers,
shapes and dates" is appended.

224. Lehner, Lois. Complete Book of American Kitchen and Din-
ner Wares. Des Moines, Iowa: Wallace-Homestead Book
Co., 1980. 240 p. 137 black and white illus. Bibliogra-
phy: pp. 220-28. Index.
The author found that very little information on American
dinnerware was available in an organized form and wished
to write a "comprehensive history of the industry in the
United States" that would be "a great aid to the collector"
and "a well-documented historical recording. " She has
concentrated on the marks and history for this book, leav-
ing pattern information for another book. She gives broad,
good coverage (which is well-documented) of many companies,
listed alphabetically, and illustrates hundreds of marks.
Cross-references are included. A list of shapes, decora-
tions, lines, and types of wares is appended.

225. McKee, Floyd W. The Second Oldest Profession: A Century
of American Dinnerware Manufacture. Salem, Ohio: Lyle
Printing & Publishing Co., 1966. 63 p. Index.
An "informal history of the American production of semi-
vitreous chinaware (table-ware) on a commercial basis"
from 1850 to 1950. Written by a former president of the
United States Potters' Association, this history briefly de-
scribes the manufacturing process and scores of individual
companies in a casual but informed tone.

226. Pickel, Susan E. From Kiln to Kitchen: American Ceramic
Design in Tableware. [n. p. , 1980]. 14 p. 21 black and
white illus.
Catalog from an exhibition (held September 7-November
16, 1980, at the Illinois State Museum, Springfield) which
was "perhaps the first of its kind. It encompasses the
development of design in American ceramic tableware and
kitchenware from colonial times to the present. " Pickel
feels that "scholarly interest in the history of American
tableware is relatively new, and research has only skimmed
the surface. " This neglect is due to "an undeserved inferi-
ority [which] has often been ascribed to tableware, perhaps
not so much because it was mass-produced as because it
was produced for the masses. " The exhibition included

early American and Victorian tableware, the wares of the china-painting movement, and the streamlined, colorful wares of the twentieth century.

XVI. PORCELAIN

227. Barber, Edwin AtLee. Artificial Soft Paste Porcelain: France, Italy, Spain and England. Art Primer. Pennsylvania Museum and School of Industrial Art, Philadelphia. New York: Doubleday, Page, 1907. 40 p. 42 black and white illus. Index.
 A condensed survey for students and collectors of European artificial (or fritted) soft paste porcelain which includes a small section on the eighteenth-century Bonnin & Morris factory in Philadelphia. This was also published by the Pennsylvania Museum (Philadelphia, 1907).

228. Clement, Arthur W. Notes on Early American Porcelain, 1738-1838. New York: Court Press, 1946. 38 p.
 Clement's narrative begins with Andrew Duché and his proposal of 1739 to make "true porcelain"; it ends with Tucker China and Smith, Fife & Co. in the 1830s. Twelve individual firms are discussed. Clement published fifty copies of these notes of "forgotten or new material" as preliminary to his "projected History of Earthenware and Porcelain of the United States." Contemporary letters and newspaper articles are quoted.

229. New Jersey State Museum. The American Porcelain Tradition. Trenton: New Jersey State Museum, 1972. 8 p. 5 black and white illus.
 Catalog from an exhibition of American porcelain from 1825 to the present. The catalog is brief, almost a checklist. All seventy pieces are part of the collection of the New Jersey State Museum.

230. R. W. Norton Art Gallery. The American Porcelain Tradition: 18th, 19th, and 20th Centuries. Shreveport, La.: Printed by Cy Young, 1972. 32 p. 5 color, 14 black and white illus. Bibliography: pp. 29-30. Index.
 Catalog from an exhibition of the same seventy pieces as cited in the entry above, now on loan from the New Jersey State Museum. However, more pieces are illustrated in this catalog and an introductory essay sketches the history of porcelain in America in considerable detail. Several little-known companies as well as southern porcelain factories are discussed.

231. Schwartz, Marvin D., and Richard Wolfe. A History of

American Art Porcelain. New York: Renaissance Editions, 1967. 93 p. 7 color, 68 black and white illus. Bibliography: p. 93. This book was published concurrently with a traveling historical exhibition. It covers porcelain in America from the eighteenth century to the present and was "the first to be devoted exclusively to the subject of American porcelain." There are more illustrations here than in the R. W. Norton Art Gallery's American Porcelain Tradition but the texts are comparable, although fewer firms are considered by Schwartz.

XVII. WHITE HOUSE CHINA

232. Detweiler, Susan G. American Presidential China: Exhibition Catalog. Washington, D. C.: Smithsonian Institution Traveling Exhibition Service, 1975. 96 p. Many illus. (color, black and white) Bibliography: pp. 95-96.
A meticulous

Catalog accompanying an exhibition of china used by presidents from Washington to Ford which illustrated "one aspect of the evolution of taste and culture in American society as modified by the personalities of the individual presidents and their First Ladies." Both official and family china were exhibited. Most White House china was imported; only recently has American china been used.

233. Klamkin, Marian. White House China. New York: Scribner, 1972. 184 p. 100 color, 39 black and white illus. Bibliography: pp. 165-69. Index.
A meticulous and interesting study of state china ordered for American presidents. Klamkin laments the lack of research: "There is, today, a great deal of confusion concerning the china of our early Presidents." Because of the late development of fine American porcelain, Woodrow Wilson was the first president to buy American-made china for the White House. Lenox was chosen; it was the first domestic pottery that could produce fine quality in large quantity. The china used by every president from Washington to Nixon is discussed.

234. Klapthor, Margaret Brown. Official White House China: 1789 to the Present. Washington, D. C.: Smithsonian Institution Press, 1975. 283 p. 97 color, 101 black and white illus. Bibliographic footnotes. Index.
This study was published by the Smithsonian three years after Klamkin's White House China. Klamkin pinpointed the need for thorough research: "It is at the Smithsonian that one would expect to untangle some of the mysteries ... it was to be hoped that information on the collection would

also be available for study at the national museum." How-
ever, "a concerted effort to find out if more definite infor-
mation was available at the Smithsonian Institution led no-
where." Perhaps Klamkin's disappointment was due to the
fact that Klapthor's research was ongoing and as yet unpub-
lished. Klapthor, in her publication, chose to ignore Klam-
kin's work.

Klapthor studied vouchers, inventories, and treasury ac-
counts from the National Archives and the White House to
document china purchases; her research took fifteen years.
She asserts that her book contains "the most complete in-
formation available at the present time, but that it is by no
means the final story." The sequence of presidents is or-
ganized by "The Period of French Influence, 1789-1845,"
"The Nationalistic Period, 1845-1893," and "The Contempo-
rary Period." Klapthor's research is intensive and valuable.
Her book is better illustrated than Klamkin's, yet the latter
remains useful.

XVIII. TILES

235. Barnard, Julian. Victorian Ceramic Tiles. Greenwich,
Conn.: New York Graphic Society, 1972. 184 p. 115
illus. (color, black and white) Bibliography: p. 179.
Index.
The concentration is on the production of, decoration of,
and stylistic influences on British tiles, but pages 84-88
and 109-16 describe art tile companies in America. Bar-
nard believes that these companies showed "great initiative
and originality." The styles and innovations of significant
tile companies are explained. Thirty-eight American tile
companies are listed in the appendix. In 1979, this was
reprinted by Mayflower Books (New York) in Christie's In-
ternational Collectors Series.

236. Bruhn, Thomas P. American Decorative Tiles, 1870-1930.
Storrs: The William Benton Museum of Art, University of
Connecticut, 1979. 48 p. 53 black and white illus. Bib-
liography: p. 14.
Catalog from an exhibition of nearly two hundred tiles
from thirty-nine factories; a capsule history of each factory
is given. Bruhn's essay states that "in American ceramics
there is only one period, 1870 to 1930, when tiles played a
significant role in the decorative arts" and that "the history
of American tiles is relatively unexplored." The captions
are quite informative and have bibliographic notes.

237. Bucks County Historical Society. The Mercer Mile: The
Story of Dr. Henry Chapman Mercer and His Concrete

Buildings. Doylestown, Pa.: Bucks County Historical So-
ciety, 1972. 28 p. 23 black and white illus.
Pamphlet which describes Mercer's idiosyncratic home,
pottery works, and museum for his collection of 30,000 arti-
facts. Pages 7-10 discuss Moravian tiles and pages 18-19,
the Moravian Pottery and Tile Works. Mercer wished to
revive the Pennsylvania Dutch methods and designs; he imi-
tated many of the stove plate designs.

238. Dieter, Gerald W., and John Cummings. The Bible in Tile:
The Story of the Mercer Biblical Tile in the Sanctuary of
Salem Church. Doylestown, Pa.: Consistory, Salem United
Church of Christ, 1957. 34 p. 26 color, 2 black and white
illus.
The altar walls of the church were decorated by tiles
made by Mercer in 1928 from his collection of decorated
stove plates. This pamphlet describes the making of stove
plates and the significance of the designs used by Mercer.

239. DiStefano, Albert B., Jr. A Historical Study of Dr. Henry
Chapman Mercer's Revival of Decorative Tile Making.
Master's thesis, Millersville State College, Pa., 1969.
74 ℓ. 1 color, 24 black and white illus. Bibliography:
ℓ. 70-72.
Through archival research and interviews, DiStefano
studied Mercer's years of frustrating experiments under-
taken to discover the lost glaze recipes of the Pennsylvania
Dutch. From 1898 on he developed tile making and in 1912
constructed the Moravian Pottery and Tile Works. The
sources of his many fanciful designs, the tile making pro-
cess, and construction of the Tile Works are described.

240. Furnival, William James. Leadless Decorative Tiles, Faience
and Mosaic; Comprising Notes and Excerpts on the History,
Materials, Manufacture & Use of Ornamental Flooring Tiles,
Ceramic Mosaic, and Decorative Tiles and Faience, with
Complete Series of Recipes for Tile-Bodies, and for Lead-
less Glazes and Art-Tile Enamels. Stone, Staffordshire:
W. J. Furnival, 1904. 2 vol. 37 color, 340 black and
white illus. Index.
This massive study, covering the manufacture and use
of decorative tiles throughout the world, contains only small
sections on the United States but it can be useful as an
early and thorough study.

241. Low, John, and J. G. Low. Illustrated Catalog of Art Tiles
Made by J. G. & J. F. Low, Chelsea, Mass.: U.S.A.
Boston: C. A. Wellington, 1884. 34 p., mostly illus.
Hundreds of the tiles available from Low are illustrated
in this catalog, "the most expensive in manner of produc-
tion, and most beautiful in its results, ever issued, so far
as we are aware, to illustrate the results of any branch of
manufacture." Earlier editions were published in 1881,
1882, and 1883.

242. Low, John, and J. G. Low. <u>Plastic Sketches.</u> Boston:
C. A. Wellington [1882]. 15 plates.
 A catalog of "alto and bas reliefs," "a new phase of
Art somewhere between sculpture and painting," produced
by Low Tile Co. Landscapes and genre scenes were deli-
cately worked and glazed as tiles and panels; "the number
of reproductions will be very limited."

243. Low, John, and J. G. Low. <u>Plastic Sketches of J. G. and</u>
<u>J. F. Low.</u> Boston: Lee & Shepard, 1887. 6 p., 46 ℓ.
of plates.
 Excellent photographic reproductions of the "plastic
sketches" by Arthur Osborne which were made in tile. The
scenes (bucolic, classical, or genre) were made in limited
quantities because of their expense; this book brought them
to a wider audience. It was believed that this was "the
first time that such fascinating effects as were produced by
the use of artistic glazes over a low-relief surface had
been attained."

244. Mercer, Henry Chapman. <u>The Tiled Pavement in the Capitol</u>
<u>of Pennsylvania.</u> Revised and edited by Ginger Duemler.
State College: Pennsylvania Guild of Craftsmen, 1975.
83 p. 350 black and white illus. Index.
 The tiled pavement contains over four hundred mosaics,
made by Mercer, formed in an irregular pattern like stained
glass. The arrangement is chronological, depicting the his-
tory of Pennsylvania and the life of its inhabitants from the
Indians to the automobile. Mercer illustrates and explains
each mosaic. This pamphlet was first published in 1908.

245. Mosaic Tile Company. <u>Catalogue No. 3, 1905 for Floor Tile,</u>
<u>Ceramic, Vitreous, Encaustic.</u> Zanesville, Ohio: Mosaic
Tile Co., [190-]. 50 plates.
 Full-color catalog of their damask designs. This is one
in a series of publicity catalogs.

246. Pennsylvania Museum and School of Industrial Art. <u>Exhibi-</u>
<u>tion of Tiles.</u> Philadelphia: Pennsylvania Museum, 1915.
52 p. 25 black and white illus.
 The tiles of many countries were included in this exhi-
bition, compiled by Edwin AtLee Barber. American tiles
are listed on pages 41-48; roofing tiles, ridge tiles, painted
tiles, and tile panels are included. Barber points out that
"the manufacture of decorative tiles was not seriously at-
tempted in the United States until after the Centennial Ex-
hibition of 1876" although "earthenware roofing tiles were
produced to a considerable extent in eastern Pennsylvania
through the eighteenth century."

247. Purviance, Evan, and Louise Purviance. <u>Zanesville Art Tile</u>
<u>in Color.</u> Des Moines, Iowa: Wallace-Homestead Book Co.,
1972. 48 p., mostly illus. (color, black and white)
 "Until 1875, all decorative tile had been imported into

America." The Purviances' book, based on their collection, contains tiles from the American Encaustic Tiling Co. (1875-1935) and the Mosaic Tile Co. (1894-1967), the largest tile factories in the U.S. in their times. A price guide was issued separately.

248. Rubin, Ronnie. The Tile Club, 1877-1887. Master's thesis, New York University, 1967. 41 ℓ. 99 black and white illus. Bibliography: ℓ. 40-41.
The Tile Club was founded in 1877, stimulated by the European art world and the Philadelphia Centennial Exhibition. It soon grew to a compatible, cosmopolitan group of important artists. They met weekly to decorate tiles, sketch, and converse. Rubin studies the activities of the club and its relationship to American art history.

249. Tile Club, New York. A Book of the Tile Club. Boston: Houghton Mifflin, 1886. 105 p. 113 black and white illus.
A rambling narrative of the travels and adventures of members of the Tile Club, formed by artists who found tile decoration more satisfying than oil or watercolors. There is little discussion of the tiles but the illustrations are very nice.

250. Wires, E. Stanley; Norris F. Schneider; and Moses Mesre. Zanesville Decorative Tiles. Zanesville, Ohio, 1972. 32 p., mostly illus. (black and white) Bibliography: p. 32.
The histories and wares of the American Encaustic Tiling Co. and the Mosaic Tile Co. are outlined. Weller and Owens tiles are mentioned. "The Zanesville plants pioneered in the production of decorative tile in the United States. This account will relate the industrial history and illustrate the artistic products of Zanesville tile plants." Wires's collection of tiles is now in the Smithsonian Institution.

XIX. MODERN CERAMICS

251. American Craftsmen's Council. Museum of Contemporary Crafts. The American Craftsman. New York, 1964. 14 p. 2 black and white illus.
Catalog from an exhibition of thirty American craftsmen and a selection of American Indian and Eskimo craftsmen. There were 320 pieces exhibited. Potters included are Ferguson, Mason, the Natzlers, Ng, Sperry, Takaezu, Voulkos, and Frans Wildenhain. The American Craftsmen's Council, founded in 1943 as the American Craftsmen's Cooperative Council, was known as the American Craftsmen's

Educational Council from 1950 to 1955, when the name was changed to American Craftsmen's Council. In 1969, it took its present name of American Crafts Council.

252. American Craftsmen's Educational Council. Amerikanische Keramik: eine Ausstellung des U. S. Informationsdienstes. [n. p.], 1955. 14 p. 9 black and white illus. An exhibition of thirty-seven American potters, all of whom participated in the International Ceramics Exhibition in Cannes, June 1955. There is a brief essay.

253. American Craftsmen's Council. Museum of Contemporary Crafts. Collector: Object/Environment. [n. p.], 1965. 26 p. 19 black and white illus. "This exhibition has been assembled to illustrate the important recent growth of collecting contemporary art in the United States and to show, through photo murals, the successful use of these works in the homes of several major American collectors." Twenty-one collections were selected, most of which included contemporary American ceramics.

254. American Craftsmen's Council. Museum of Contemporary Crafts. Contemporary Craftsmen of the Far West. New York, 1961. 16 p. 13 black and white illus. "Inaugurates an important series of regional surveys of contemporary American craftsmanship" (see also Craftsmen of the Central States and Craftsmen of the Eastern States). The exhibits were designed to show regional variations and bring regional craftsmen to prominence. There were 326 objects shown.

255. American Craftsmen's Council. Museum of Contemporary Crafts. Craftsmen of the Central States. New York, 1962. 20 p. 10 black and white illus. Catalog from an exhibition which was second in a series of three regional competitive shows (see also Contemporary Craftsmen of the Far West and Craftsmen of the Eastern States). On exhibition were 236 pieces of ceramics, weaving, jewelry, and other crafts, although only a few are illustrated here.

256. American Craftsmen's Council. Museum of Contemporary Crafts. Craftsmen of the Eastern States. New York, [1964?]. 44 p., mostly illus. (black and white). Catalog from an exhibition which completed the regional surveys of American designer-craftsmen (see also Craftsmen of the Central States and Contemporary Craftsmen of the Far West). Three hundred pieces from the northeast and the southeast were shown. Francis S. Merritt of the northeastern exhibition committee felt that "during the past eight years the new designer-craftsmen and artist-craftsmen have taken a position of importance equal to that of painters and sculptors" in the northeast.

257. American Craftsmen's Council. Craftsmen of the Southwest. [n. p., 1966?] 238 p., mostly illus. (black and white) "Contains bio-bibliographical information together with photographs of 151 professional designer-craftsmen living in Arizona, California, Hawaii, Nevada, New Mexico, and Utah." Metal, clay, textile, wood, glass, and architecture are included. The clay section contains forty-five entries.

258. American Craftsmen's Council. Museum of Contemporary Crafts. Craftsmen USA 66. New York: Museum of Contemporary Crafts, 1966. 27 p. 32 black and white illus. Only 268 pieces were selected for this exhibition from over six thousand submitted to earlier regional competitions. Fourteen pieces of pottery, mostly expressionistic, are illustrated; the catalog also includes glass, fiber, wood, and silver.

259. American Craftsmen's Council. Museum of Contemporary Crafts. Designer-Craftsmen, U. S. A. 1953. New York, 1953. 72 p. 104 black and white illus. Exhibition catalog from a national, juried show that tried to present the first "comprehensive idea of what is being done in the craft field in the United States." The show traveled for a year under the auspices of the American Federation of Arts. Exhibited were 243 pieces by 203 artisans. Anna Wetherill Olmsted, director of the Syracuse Museum of Fine Arts, briefly surveys recent American developments in ceramics.

260. American Craftsmen's Council. Museum of Contemporary Crafts. Designer-Craftsmen, U. S. A. 1960. New York, 1960. 35 p. 84 black and white illus. The second Designer-Craftsmen Competition was on the theme, "Designed and Handcrafted For Use." The pottery illustrated includes pieces by David Shaner, Henry Takemoto, Bob Turner, Karen Karnes, Harvey K. Littleton, and others.

261. American Craftsmen's Council. Museum of Contemporary Crafts. New Ceramic Forms. New York, 1965. 2 p. 9 black and white illus. Catalog from an exhibition of ceramic sculpture of "ten young artists from California," which reveals "the strength of these new influences ["pop," "op," and "hard-edge"] on ceramic art, and the diversity of expressive forms they have made possible."

262. American Craftsmen's Council. Proceedings of the Annual Conference. New York: American Craftsmen's Council, 1957-1961. 4 vol. Illus. Individual volumes are Asilomar (1957), Dimension of Design (1958), The Craftsman's World (1959), and Research in the Crafts (1961). Potters participated in these discus-

sions of professional practices, design, creativity, education, and their relationship to society. "Media discussions" (including ceramics) followed each conference.

263. American Craftsmen's Council. Museum of Contemporary Crafts. Young Americans 1962. New York, 1962. 30 p. 29 black and white illus.
 Catalog from an exhibition based on a national competition for craftsmen thirty years old and under. Pottery, jewelry, furniture, and textiles were shown; the "variety and wide range of ceramics," many showing the influence of abstract expressionism, are praised.

264. American Federation of Arts. Catalogue: International Exhibition of Ceramic Art. [n. p.]: American Federation of Arts, 1928. 60 p. 31 black and white illus.
 This exhibition of European and American ceramic art was first in a series of "industrial art exhibitions" and traveled from the Metropolitan to Philadelphia, Minneapolis, Cleveland, Baltimore, Detroit, Newark, and Pittsburgh. The introduction notes that "no branch of decorative art responded to the call of the modern spirit and turned in revolt against the lifeless and sterile copies of the nineteenth century so quickly as pottery." Binns, Poor, Robineau, and Walters were among the exhibitors.

265. Baltimore Museum of Art. An Exhibition of Contemporary American Crafts. Baltimore, Md.: Baltimore Museum of Art, 1944. 31 p. 13 black and white illus.
 Catalog from a large exhibition of "rural" artisans, "artist-designers," and Indian artists which heralded the "renewed and vital interest in handwork." There are nearly seventy exhibitors in the artist-designer section alone, including the Natzlers, Wildenhain, Poor, Andreson, and Bogatay. It is a broad survey, although only a few pieces are illustrated.

266. Baltimore Museum of Art. Modern Crafts. Baltimore, Md.: Baltimore Museum of Art, 1938. 26 p. 10 black and white illus.
 Catalog from an exhibition which included textiles, pottery, metal, prints, and furniture that had been on display at L'Exposition Internationale, Paris, 1937. Fifty-nine pieces of American pottery were included; three sets of figurines are the only illustrations.

267. Beard, Geoffrey W. Modern Ceramics. New York: Dutton, 1969. 167 p. 4 color, 122 black and white illus. Bibliography: p. 163. Index.
 "Discusses developments in ceramics over the past sixty years, with particular emphasis on the most notable achievements of contemporary ceramists in the United States, England, Germany, Japan, and Scandinavia." The brief look at

twentieth-century American pottery must be suspect because
of careless errors of dates and names.

268. California University, Irvine. Art Gallery. Abstract Expres-
sionist Ceramics. Text by John Coplans. Irvine, Calif.,
1966. 54 p. 8 color, 47 black and white illus. Bibliog-
raphy: p. 49.
Catalog from an important exhibition which surveyed the
expressionistic mode of ceramic sculpture in California.
The work of Bengston, Frimkess, Mason, McClain, Mel-
chert, Nagle, Neri, Price, Takemoto, and Voulkos was at
the time "relatively little-known." Coplans was particular-
ly prominent as critic of the new sculptural movement; here
he points out Voulkos' influence on the group and their re-
definition of ceramic art.

269. Cantini, V. D. Contemporary Ceramics in the United States.
Master's thesis, University of Pittsburgh, 1948.
Not seen.

270. Cary, Elisabeth Luther. Critical Comments on the Interna-
tional Exhibition of Ceramic Art. By Elisabeth Luther
Cary, Royal Cortissoz, and Helen Appleton Read. New
York: Reprinted through the courtesy of the New York
Times, New York Herald-Tribune, The Brooklyn Daily
Eagle for the American Federation of Arts, 1928. 20 p.
Critical essays which originally appeared in three New
York newspapers on the pieces shown in the 1928 exhibi-
tion. Cary singles out the work of Poor, Walters, and
Robineau for praise. She also explains that "this exhibi-
tion was formed for the special purpose of encouraging our
public to diligently compare our own productions with those
of Europe."

271. Collier, William Lewis. Representative Potters of Northern
California; Their Work and Philosophy. Master's thesis,
University of California, 1956. 92 ℓ. Bibliography:
ℓ. 32-34.
Interviewed nine northern California potters to discover
"what potters themselves, distinct from critics and cura-
tors, set as a criteria [sic] for judging pottery" and "what
traditions Northern Californian potters drew upon and how
this affected their work." Responses to Bernard Leach's
complaint that American pottery lacks a "tap-root" are also
discussed with the nine potters: Irene Hamel, Frank Ham-
ilton, Edith Heath, Elena Netherby, Anthony Prieto, Harold
Riegger, Herbert Sanders, Paul Volckening, and Marguerite
Wildenhain.

272. Collins, Ruth A. Contemporary Ceramic Sculpture: A Brief
Survey of Ceramic Sculpture in the United States and Europe
Since 1900. Master's thesis, Texas Woman's University,
1949.
Not seen.

273. Cook, Mary H. Contemporary Ceramics in the United States. Master's thesis, Texas Woman's University, 1944. Not seen.

274. Counts, Charles. Encouraging American Handcrafts: What Role in Economic Development? Washington, D.C.: Department of Commerce, 1966. 48 p. Bibliography: pp. 43-48.
 Counts, in his role as crafts consultant at the Smithsonian, prepared this study for the Economic Development Administration, for "until now, there has been little analysis of the handcraft industry in this country as it relates to economic development." He includes an overview of handicraft, analyzes some problems, and makes recommendations to local communities.

275. Eaton, Allen Hendershott, and Lucinda Crile. Rural Handicrafts in the United States. U.S. Department of Agriculture Miscellaneous Publication no. 610. Washington, D.C.: U.S. Department of Agriculture and Russell Sage Foundation, 1946. 40 p. 39 black and white illus.
 The U.S.D.A. Extension Service completed a study of the handicrafts of rural areas, "the most comprehensive survey of its kind ever made," just before World War II. The place of handicrafts in rural life and the results of that nationwide study of the arts, the sources of designs, and marketing are reported. The resurgence of rural arts is noted.

276. Everson Museum of Art of Syracuse and Onondaga County. Ceramic National Exhibition. Syracuse, N.Y., 1932-1972. Illus.
 The "Ceramic Nationals" were a very significant series of juried, national exhibitions which included established potters and new talent; they have no equal as a document of twentieth-century ceramic art. Anna Wetherill Olmsted began the exhibitions as a memorial to Adelaide Alsop Robineau in 1932. They continued until 1972 as an important, continuing stimulus to ceramic art. By 1972, the number of potters had grown so large that the judges felt it was not feasible to continue the juried show. The Museum has not lapsed in its commitment to ceramic art; it has since sponsored many exhibitions focused on ceramics. The Ceramic Nationals (the first exhibit was restricted to New York State ceramics) were held annually until 1954 when they became biennial. The catalogs grew from small leaflets to well illustrated publications as the importance and sponsorship of the Nationals grew. The Everson Museum of Art was established in 1949. It merged with the Syracuse Museum of Fine Arts (established in 1896) in 1959 to form the Everson Museum of Art of Syracuse and Onondaga County.

277. Foundations in Clay. Curated by Robert Smith. Los Angeles:

Los Angeles Institute of Contemporary Art, 1977. 13 p.,
73 cards in portfolio. 78 black and white illus.
Catalog of an exhibition tracing the relationships between
potters at the Otis Art Institute (1954-1960) and Berkeley
(1960-1964) which produced the aesthetic breakthrough of
Abstract Expressionist Ceramics. Frimkess, Mason, Nagle,
Price, Soldner, and Voulkos were included. Essays by Jim
Melchert and John Coplans are reprinted and the card file
lists "most ceramic artists who are currently working or
exhibiting in Southern California."

278. Garber, Ken. Abstract Expressionist Ceramics. Master's
thesis, University of California at Los Angeles, 1974.
Not seen.

279. Grossmont College. Viewpoint: Ceramics 1979. [n. p.]:
Grossmont College Gallery, 1979. 25 p. 34 black and
white illus. Bibliography: p. 7.
The exhibited pieces in this catalog were made in 1979,
but Garth Clark's introductory essay traces the history of
ceramic sculpture in the United States over the past cen-
tury.

280. International Minerals & Chemical Corporation. Ceramic
Arts U. S. A. 1966. [n. p.], 1966. 31 p., mostly illus.
Catalog from an invitational exhibition, February 7 to
February 20, 1966, sponsored by the International Miner-
als & Chemical Corporation, Skokie, Illinois in cooperation
with the Smithsonian Institution. More than one hundred
potters were included. Thirty-two pieces were selected for
exhibition at the Smithsonian, May 2-June 30. The prepara-
tion for this exhibition marked the emergence of the National
Council on Education for the Ceramic Arts from the Design
Division of the American Ceramic Society.

281. Jensen, Carl G. The Cross-Currents of Influence in the
Backgrounds of Twelve Chosen American and Japanese Pot-
ters As Related to the Emergence of a New Ceramic Pres-
ence in the Late Fifties. Master's thesis, University of
New Mexico, 1971. 91 ℓ. 11 illus. Bibliography:
ℓ. 89-91.
"The central theme of this study is the American inter-
pretation, adaptation, and selection of vitalizing influences
found in Japanese folk art pottery and the role of these in-
fluences as seen in the energizing of an American attitude
toward clay as a major creative material during the late
fifties." The American potters studied are Warren Mac-
Kenzie, Daniel Rhodes, Paul Soldner, Hui Ka Kwong, Peter
Voulkos, and Marie Woo.

282. Kaufmann, Edgar, Jr. What Is Modern Design? Introductory
Series to the Modern Arts--3. New York: Museum of
Modern Art, 1950. 32 p., mostly illus. (black and white)

Bibliography: p. 32.
This small book approaches two questions: Why is design important? What is good design? Home furnishings, including some pottery, illustrate the precepts of modern design. Industrial design was an important component of ceramics aesthetics for several decades. Many books on design were published that considered pottery to some extent and Kaufmann's book is included as an example of those. This was reprinted by Arno Press (New York, 1979).

283. Kiln Club of Washington. International Exhibition of Ceramic Art. Washington, D.C.: Smithsonian Institution, 1950-
The Kiln Club sponsored an annual show from 1950 until 1955 when the first biennial show was held. They were juried for local artists; other American and foreign artists were invited to submit pieces. Most were for sale. For each show since 1952, the "Best of Show" piece was presented to the Smithsonian. Pamphlets list exhibitors and illustrate the prize winners.

284. Lang Art Gallery. Scripps College Ceramics Invitational. Claremont, Calif., 1944-.
This series of exhibits has surveyed contemporary ceramics annually since 1944. The title has varied: Scripps College Invitational Ceramic Art Annual (1954); Scripps College Annual Treasury of Ceramic Art (1965). Some of the catalogs have been issued in portfolio form. Many California artists have been included, as well as other Americans and some European and Oriental artists. The catalog for the thirty-fourth annual exhibit, 1978, noted: "In its early years, the Scripps College Ceramic Invitational exhibit featured only the work of well known 'big name' artists. Fifteen years ago, we changed that format to one which emphasized a yearly search for new people of proven quality."

285. McKinnell, James, and Abner Jonas. Clay Today. Ames: New Gallery, Iowa State University, 1962.
Not seen.

286. Metropolitan Museum of Art. Contemporary American Industrial Art. New York, 1917-1940.
"A series of comprehensive exhibitions ... that began at the Museum in 1917." A committee of architects and designers selected the work of as many designers of house furnishings as possible; pottery was included in most of the exhibitions. The original idea was "to prove by a few selected examples that the Metropolitan Museum is directly useful in a practical way in a score of industries"; the designs were based in some way on a study of the museum collection.

287. Nickerson, John H. , Jr. An Incomplete History of the Archie Bray Foundation. Master's thesis, New York State College of Ceramics at Alfred University, 1969. 31 ℓ. 12 illus.
The Archie Bray Foundation is a pottery and art center built in 1951 by Archie Bray "to make available for all who are seriously and sincerely interested in any of the branches of the ceramic art, a fine place to work." Peter Voulkos and Rudy Autio managed it in the early years; later Ken Ferguson took over. Nickerson summarizes Bray's biography, the events at the Foundation from 1951 to 1969, and its struggle to become self-supporting.

288. Nordness, Lee. Objects: USA. New York: Viking Press, 1970. 360 p. Many black and white illus. Index.
"A pictorial survey of the art objects being created in the United States" which illustrates the crafts collections of S. C. Johnson and Co. The "Ceramic" section (pages 37-139) includes the work of eighty-six American potters and a short biographical statement for each. The opening essay analyzes the recent history of crafts in America and the attitude toward crafts as seen in Craft Horizons.

289. Petterson, Richard B. Ceramic Art in America: A Portfolio. Columbus, Ohio: Professional Pubs. , 1969. 4 p. 32 illus.
A portfolio of thirty-two illustrations of contemporary pottery, dating from 1949 to 1968. The text is limited to captions. The pieces were selected from the Scripps College exhibit, "Twenty-five Years of Art in Clay, USA," and "represent most of the developments and achievements that have marked this postwar quarter-century as a period of almost explosive growth and change."

290. Seely, Edith P. A Survey of Contemporary Ceramics in the United States. Master's thesis, Colorado State College of Education, 1943. 184 ℓ. 58 illus. (color, black and white) Bibliography: ℓ. 173-76.
Studies ceramics in the U. S. during "a period of great expansion and art development." Of the 129 art potteries, 26 china potteries, 40 earthenware potteries, 55 whiteware potteries, and 50 stoneware potteries that she identifies, 75 percent were founded in the twentieth century. Her survey is descriptive rather than analytical and gives brief histories of many potteries, potters, ceramics schools, and national exhibitions.

291. Sloane, W. & J. , firm. Exhibition of Contemporary American Ceramics. Introduction by Charles F. Binns. New York: W. & J. Sloane Co. , [c. 1925].
Not seen.

292. Steinmetz, Rollin C. , and Charles S. Rice. Vanishing Crafts and Their Craftsmen. New Brunswick, N. J. : Rutgers

University Press, 1959. 160 p. 70 black and white illus.
The authors interviewed and photographed individual ar-
tisans (blacksmith, lime burner, candymaker, cigarmaker,
buttonmaker, etc.) who run one-person shops that work suc-
cessfully. The potter (pages 113-22) was Henry Schofield
of Pennsylvania, who worked in an old-time tradition.

293. Syracuse Museum of Fine Arts. Contemporary American
 Ceramics, 1937. Syracuse, N. Y., 1937. 15 p. 1 color,
 17 black and white illus.
 Catalog from "the first exhibition of Contemporary Amer-
 ican Ceramics to be assembled upon invitation from Euro-
 pean countries." The pieces were chosen from the five
 preceding Ceramic National shows at Syracuse (now the
 Everson Museum of Art). Included are Schreckengost,
 Poor, Harder, Bogatay, Cowan, Baggs, Stratton, Winter,
 and others.

294. Wallance, Don. Shaping America's Products. New York:
 Reinhold, 1956. 193 p. 194 black and white illus. Bib-
 liography: pp. 187-88. Index.
 Research sponsored by the Walker Art Center and the
 American Craftsmen's Council resulted in this survey of
 design and craftsmanship in an industrial society. Wallance
 visited many factories and crafts studios, concluding that
 "a trend away from emphasis on the individual designer is
 already evident." Heath Ceramics, Sitterle Ceramics,
 Coors Porcelain, Wildenhain, and the Natzlers are in-
 cluded in this study of design for mass production.

 XX. REGIONAL AND LOCAL HISTORY

NEW ENGLAND

295. Eaton, Allen Hendershott. Handicrafts of New England. New
 York: Bonanza, 1949. 374 p. 4 color, 128 black and
 white illus. Index.
 This extensive study of the history of handicrafts in
 New England is modeled on Eaton's 1937 study of the
 Southern Highlands and was also conducted with the sup-
 port of the Russell Sage Foundation. He investigates the
 backgrounds of New England handicrafts, New England
 handicrafts today, significant influences in the handicraft
 movement, and the value of handicrafts. Contemporary
 pottery is discussed on pages 152-67. Also published by
 Harper (New York, 1949).

296. Society for the Preservation of New England Antiquities. "A
 Choice Sortment": Ceramics from New England Homes.

[n. p.], 1981. 32 p. 37 black and white illus.
Catalog from an exhibition, "the first to survey SPNEA's
extensive ceramic holdings, bringing together objects se-
lected from its study collections as well as its house mu-
seums throughout New England." On exhibition were 136
pieces, categorized as drinking vessels, coffee and tea
wares, tablewares, household embellishments, utilitarian
wares, and toys; most pieces are imports, but several New
England potteries are represented. Essays describe the
drinking and table customs of the times.

297. Watkins, Lura Woodside. Early New England Potters and
Their Wares. Cambridge, Mass.: Harvard University
Press, 1950. 291 p. 141 black and white illus. Bibliog-
raphy: pp. 271-76. Index.
This classic and authoritative study resulted from more
than fifteen years of research through local records, inter-
views, and archaeological digs. Watkins discovered infor-
mation that would have been lost otherwise and compiled it
in this lengthy, detailed work. She concentrated on the
early redware and stoneware, although Bennington pottery
and art pottery are considered at the end. She affirms
the existence of earthenware as early as 1644, then traces
its development in town after town. The check list of New
England potters includes about seven hundred names. Re-
printed in 1968 (Hamden, Conn.: Archon Books).

298. Watkins, Lura Woodside. Early New England Pottery. Old
Sturbridge Village Booklet Series. Sturbridge, Mass.:
Old Sturbridge Village, 1959. 23 p. 14 black and white
illus. Bibliography: p. 23.
A concise discussion by a reliable authority of the earth-
enware and stoneware made in New England in the eighteenth
and nineteenth centuries. At least three hundred potters
were at work in New England before 1800. She emphasizes
the wares made near Sturbridge; some of the pieces illus-
trated are from the Sturbridge collection.

Maine

299. Branin, Manlif Lelyn. The Early Potters and Potteries of
Maine. Middletown, Conn.: Wesleyan University Press,
1978. 262 p. 67 black and white illus. Index.
A study based on lengthy research which gives detailed
information on eighteenth- and nineteenth-century Maine
potters for the first time. "The only earlier intensive
study that included Maine was [Watkins' Early New Eng-
land Potters and Their Wares]"; however, Branin treats
Maine potters "at greater length and in greater depth and
detail." He describes the location of each pottery, its
owners, and the type of ware turned out in a carefully
documented narrative. Marks and a checklist of potters

are included in the appendixes. Also published by the
Maine State Museum, Augusta, 1978, in the Maine Heritage
Series.

300. Maine State Museum. A Tradition in Clay: A Comprehensive
Exhibition of Maine-Made Pottery. [n. p. , n. d.] 14 p.
An exhibition was held December 13, 1978-August 31,
1979, at the Maine State Museum in connection with the
publication of Branin's The Early Potters and Potteries of
Maine. "Pottery articles were not commonly produced or
used in Maine homes before 1800. " This pamphlet is a
checklist of redware potteries and stoneware companies
whose wares were in the exhibit, but the exhibited items
are not listed.

New Hampshire

301. New Hampshire Historical Society. The Decorative Arts of
New Hampshire; A Sesquicentennial Exhibition. Concord:
New Hampshire Historical Society, 1973. 64 p. 115 black
and white illus.
Catalog of an exhibition of crafts from the Society's col-
lection. Many have been seldom exhibited and the introduc-
tion states that "the serious study of the decorative arts of
New Hampshire is still in its infancy. " A few ceramics
from 1792 to 1885 are included.

302. Writers' Program of the Work Projects Administration, New
Hampshire. Hands That Built New Hampshire: The Story
of Granite State Craftsmen, Past & Present. Brattleboro,
Vt. : Stephen Daye Press, 1940. 288 p. 45 black and
white illus. Bibliography: pp. 261-73. Index.
A thorough survey of the arts and crafts of New Hamp-
shire that was accomplished as a WPA project. The empha-
sis is on the craftsmen more than the crafts; the descrip-
tions of modern crafts workers are more detailed than those
of earlier workers. The chapter on pottery (pages 90-104)
dates the earliest known potter to 1756. Many potteries
started up after the Embargo Acts of the War of 1812.
Some nineteenth- and twentieth-century potters are de-
scribed.

Massachusetts

303. Belknap, Henry Wyckoff. Artists and Craftsmen of Essex
County, Massachusetts. Salem, Mass. : Essex Institute,
1927. 127 p. 19 black and white illus.
Strictly an alphabetical listing of architects, engravers,
painters, cabinet makers, glassmakers, etc. , "from the
earliest days down to about 1860. " Summary biographical
data are given for each individual. Fifty-five potters are
listed.

304. Belknap, Henry Wyckoff. <u>Trades and Tradesmen of Essex</u>
 <u>County, Massachusetts, Chiefly of the Seventeenth Century.</u>
 Salem, Mass.: Essex Institute, 1929. 96 p. 11 black and
 white illus. Index.
 Only five potters are mentioned in the index. John
 Pride and William Vincent (Vinson), the earliest, were
 working in the 1640s. Jacob Davis, in the stocks for
 stealing apples on Sunday, was a potter around 1655.
 Belknap found most of his information in court records
 and letters and feels that there must have been more pot-
 ters than are recorded.

305. Chace, Paul G. <u>Ceramics in Plymouth Colony: An Analysis</u>
 <u>of Estate Inventories from 1631-1675.</u> Master's thesis,
 State University College at Oneonta, N.Y., 1974. 21 ℓ.,
 13 color plates. Bibliography: ℓ. 11-12.
 Studies the estate inventories from Plymouth Colony and
 finds earthenware distinguished from stoneware but no vo-
 cabulary for delft or porcelain. Pottery was made in New
 England by 1654, Chace finds. He quotes Noël Hume on
 the state of current knowledge of seventeenth-century cer-
 amics that were available to the colonists: "so slender that
 we can very easily attribute 19th century fragments to the
 17th century." This thesis was also published as No. 3 in
 the series Occasional Papers in Old Colony Studies.

306. Dow. George Francis. <u>The Arts & Crafts in New England,</u>
 <u>1704-1775; Gleanings from Boston Newspapers Relating to</u>
 <u>Painting, Engraving, Silversmiths, Pewterers, Clockmakers,</u>
 <u>Furniture, Pottery, Old Houses, Costume, Trades and Oc-</u>
 <u>cupations.</u> Topsfield, Mass.: Wayside Press, 1927.
 326 p. 39 black and white illus. Index.
 The section on pottery (pages 81-96) gives a sense of the
 pottery being made and sold in eighteenth-century Boston;
 most of the advertised wares were imported. Dow's intro-
 duction outlines the disapproving attitude of the Puritans
 towards art. Reprinted by Da Capo Press (New York,
 1967).

Connecticut

307. Sherman, Frederic Fairchild. <u>Early Connecticut Artists &</u>
 <u>Craftsmen.</u> New York: Privately printed, 1925. 78 p.
 10 black and white illus. Bibliography: pp. xiii-xiv.
 Lists the architects, bookbinders, carpenters, clock-
 makers, combmakers, etc., of Connecticut from 1600 to
 1875. Twenty-five potters are listed on pages 51-52.

308. <u>Three Centuries of Connecticut Folk Art.</u> By Alexandra
 Grave. [New Haven: Art Resources of Connecticut], 1979.
 104 p. 15 color, 103 black and white illus. Bibliography:
 pp. 96-97. Index.

"An exhibition which brings together for the first time a selection from three hundred years of Connecticut folk art." Pages 30-34 illustrate four stoneware pieces and two contemporary pots. Decoys, quilts, gravestones, paintings, and store signs are also included.

MID-ATLANTIC AND SOUTH

309. Counts, Charles. Common Clay. Photographs by Bill Haddox. Atlanta, Ga.: Droke House/Hallux, 1971. 144 p. 29 color, 118 black and white illus.

A casual and poetic book whose thesis is that "the potters crafts is full of basic human values." Counts visited eight southern potteries (including Meaders, Piedmont Potters, and Norman Smith), watched the work and listened to the potters' reflections on their lives and craft. A somewhat reduced version was published in 1977 (Indiana, Pa.: Halldin) as Common Clay: Indiana Revisions.

310. Dupuy, Edward L., and Emma Weaver. Artisans of the Appalachians. Asheville, N.C.: Miller Printing Co., 1967. 123 p. 133 black and white illus. Index.

Dupuy, a member of the Southern Highland Handicraft Guild, took the photographs and Weaver wrote the text based on interviews with individual artisans. Both traditional and contemporary craftsmen of the Southern Appalachians are included, with photographs and a page of text for each. Potters are on pages 48-63: Davis P. Brown, Walter Cornelison, Charles Counts, Douglas Ferguson, Lynn Gault, Don Lewis, Cheever Meaders, and Sara Young.

311. Eaton, Allen Hendershott. Handicrafts of the Southern Highlands. New York: Dover, 1973. 370 p. 112 black and white illus. Bibliography: pp. 347-55. Index.

A thorough study of the history, revival, and future of handicraft in Southern Appalachian folk culture which includes one chapter on pottery. Eaton wished to document and encourage the handicraft movement in the Highlands and throughout the U.S. Pages 209-19 describe contemporary potteries such as Jugtown, Meaders', Omar Khayyam, Pisgah Forest, and others. Reprint of the 1937 edition published by the Russell Sage Foundation.

312. Prime, Alfred Coxe. The Arts & Crafts in Philadelphia, Maryland, and South Carolina, 1721-1800: Gleanings from Newspapers. Da Capo Press Series in Architecture and Decorative Art, vol. 31. New York: Da Capo Press, 1969. 2 vol. 71 black and white illus. Indexes.

Prime studied twenty-two (vol. 1) and twenty-four (vol. 2) eighteenth-century newspapers, copying advertisements for arts and crafts, medicine, printing, ships, slaves, and more. The arts and crafts items were published in these

two volumes. Prime died in 1926 and the publication was completed by his wife. This edition is a reprint of the first edition (New York: Walpole Society, 1929-1933). The "Pottery and Porcelain" section includes notices for Bonnin and Morris.

313. Smith, Elmer L. Pottery: A Utilitarian Folk Craft. Lebanon, Pa.: Applied Arts Pub., 1972. 32 p. 78 black and white illus.

"This booklet, being a sampler of some of the generally unacclaimed pottery products," deals with domestic wares made from about 1830 to 1900. Smith concentrates on wares of Virginia, West Virginia, and Pennsylvania, giving brief mention of fifteen individual potteries.

New York

314. Blue-Decorated Stoneware of New York State: Catalog & Study Guide. Watkins Glen, N. Y.: American Life Foundation, 1966. 32 p. 85 black and white illus. Bibliography: pp. 31-32.

A leaflet published as a catalog for an exhibition of one hundred stoneware crocks and jugs. The exhibitors felt that stoneware had been long neglected, particularly that of western New York; they wished to document "hitherto unrecorded stoneware of this region." An essay on forms and decorations is followed by the catalog, a checklist of manufacturers, glossary, and illustrations of a few early potter's tools. Marks are described but not illustrated. A version with many fewer illustrations was published as Blue-Decorated Stoneware: One Hundred Crocks.

315. Brown, Joshua, and David Ment. Factories, Foundries, and Refineries: A History of Five Brooklyn Industries. A Brooklyn Rediscovery Booklet. Brooklyn: Brooklyn Educational & Cultural Alliance, 1980. 75 p. 36 black and white illus. Bibliography: pp. 72-75.

"The manufacture of pottery was one of Brooklyn's earliest industries." Dutch settlers made pottery from local clays. "The pottery for which Brooklyn achieved a national reputation, however, was high-quality porcelain." The history of Charles Cartlidge & Co. and the Union Porcelain Works is described on pages 21-31.

316. Ceramic Association of New York. New York Ceramic Directory. Alfred, N. Y.: 1936. 72 p. 19 black and white illus. Index.

Lists the ceramic factories in New York State, both industrial and art pottery. Many entries have a description of the company's history and its wares.

317. Everson Museum of Art of Syracuse and Onondage County.

Onondaga Pottery. Syracuse, N. Y. : Everson Museum of Art, 1973. 10 p. 8 black and white illus. Catalog of an exhibition of nineteenth-century stoneware made in Onondaga County, N. Y., which was "to our knowledge ... the most comprehensive exhibit ever presented in this area." Fifty-one marked pieces from potteries in Geddes, Baldwinsville, and Jordan were exhibited. A brief essay sketches the history of pottery in Onondaga County.

318. Gottesman, Rita Susswein. The Arts and Crafts in New York, 1726-1776. Advertisements and News Items from New York City Newspapers. John Watts DePeyster Publication Fund Series, vol. 69. New York: Printed for the New York Historical Society, 1938. 450 p. Bibliography: pp. xv-xvi. Index.
 Before 1750, most craft items were imported from Europe. The growth of home manufactures is documented in this meticulous compilation of extracts from all the papers published in New York City during the period; fifteen newspapers were examined. "Porcelain, Pottery and Earthenware" is found in pages 84-91. Reprinted: New York: Da Capo Press, 1970.

319. Gottesman, Rita Susswein. The Arts and Crafts in New York, 1777-1799: Advertisements and News Items from New York City Newspapers. New York: New York Historical Society, 1954. 484 p. Index.
 Sequel to the entry above. During the war (1776-1783) and the British occupation of New York City, publishing was erratic and paper scarce; many craftsmen left the city. After the war, American-made goods slowly increased in number. Potters are listed on pages 95-96, "Sellers of China, Earthenware and Glass" on pages 99-104.

320. Gottesman, Rita Susswein. The Arts and Crafts in New York, 1800-1804: Advertisements and News Items from New York City Newspapers. New York: New York Historical Society, 1965. 537 p. Index.
 A second sequel to entry no. 318. "China, Earthenware, and Glass" are on pages 127-35. The preface notes the increasing sophistication and national pride of New Yorkers and the increased business and commercial activity.

321. Ithaca College Museum of Art. New York Crafts, 1700-1875: An Historical Survey. Ithaca, N. Y., 1967. 56 p. 26 black and white illus. Bibliography: pp. 55-56.
 Because of the "gradual deterioration of good design and workmanship" and the "plethora of bad taste" in the late Victorian era, this exhibition was limited to the earlier period. Needlework, glass, pewter, and tools were among the crafts exhibited. Twenty-three pieces of ceramics (pages 11-15) were exhibited. A brief essay accompanies the list.

322. Ketchum, William C., Jr. Early Potters and Potteries of
New York State. New York: Funk & Wagnalls, 1970.
278 p. 15 black and white illus. Bibliography: pp. 254-
69. Index.
This is by far the most thorough study of New York pot-
ters. Ketchum focuses on craftsmen who made utilitarian
household wares; art potters of the late nineteenth century
are excluded. The first known potter was Dirck Claesen,
who set up a kiln in Manhattan in the 1650s. Ketchum has
done a great deal of research, yet he regards it as only
"the first step in exploration." The appendix contains a
list of about five hundred New York potters and their marks.

323. Ketchum, William C., Jr. The Pottery of the State. New
York: Museum of American Folk Art, 1974. 13 p. 21
black and white illus.
Catalog from an exhibition celebrating the 1976 bicenten-
nial anniversary, which gives a short introduction to the
redware and stoneware made in New York. Although red-
ware was made as early as the 1650s, stoneware soon be-
came predominant when vast deposits of stoneware clay were
found in the state. Eighty-five pieces were lent for exhibit
from various contributors. The earliest dated (1823), a
slip-decorated pie plate of redware, was exhibited for the
first time.

324. Munson-Williams-Proctor Institute. Made in Utica. Utica,
N. Y.: Munson-Williams-Proctor Institute, 1976. 73 p.
79 black and white illus. Bibliography: pp. 72-73.
Catalog from an exhibition in association with the Oneida
Historical Society which studied the decorative arts and
crafts in Utica from its early days to 1945. Pages 16-19
include pottery: early redware, stoneware, and White's
Pottery.

325. Rochester Museum and Science Center. Clay in the Hands of
the Potter: An Exhibition of Pottery Manufactured in the
Rochester and Genesee Valley Region, c. 1793-1900.
Rochester, N. Y.: Rochester Museum and Science Center,
1974. 56 p. 57 black and white illus. Bibliography:
p. 56.
Catalog from an exhibition of earthenware and stoneware,
based on the Museum's recent historic sites survey and ex-
cavation. The preface states, "This catalogue contains sig-
nificant information about local pottery and pottery manu-
facturing never published, as well as indications that re-
visions of published material are perhaps in order." Ex-
cavated shards and kiln sites are illustrated. "Lead-glazed
earthenwares were produced in the area from about 1793 to
about 1900." Stoneware was made after the opening of the
Erie Canal permitted the shipment of stoneware clays from
New Jersey.

New Jersey

326. Clement, Arthur Wilfred. Notes On American Pottery. New
 York: Court, 1942. Part 1: 11 p.; Part 2: 15 p.
 Part 1, "Some Early New Jersey Potteries," consists of
 "for the most part quotations from W. W. Clayton's History
 of Union and Middlesex Counties, N.J. (Philadelphia, 1882)"
 and from the catalog of the 1915 Newark Museum exhibition
 of pottery and porcelain. Because they were out of print,
 Clement reprinted them for "later writers." Part 2, "More
 Early New Jersey Potteries," appears to have been drawn
 from Robert J. Sim's Some Vanishing Phases of Rural Life
 in New Jersey.

327. Monmouth County Historical Association. New Jersey Stone-
 ware. Freehold, N.J.: Monmouth County Historical So-
 ciety, 1955. 20 p. 16 black and white illus.
 Robert J. Sim and James S. Brown wrote the catalog
 notes for this exhibit which "contains the most complete
 collection of New Jersey Stoneware yet assembled." The
 exhibition, held May 21-June 21, 1955, contained about
 seventy-five pieces of pottery from twenty eighteenth- and
 nineteenth-century potteries. The illustrations are poor.

328. New Jersey State Museum. Early Arts of New Jersey; The
 Potter's Art, c. 1680-c. 1900. Trenton, 1956. 56 p.
 2 black and white illus.
 Catalog from a large exhibition (held January 24-
 September 3, 1956) of 378 pieces of New Jersey pottery.
 Indian and Colonial pottery are included as well as red-
 ware, stoneware, yellowware, Rockingham, earthenware,
 and porcelain. Although no pieces are illustrated, there
 is historical information on potters and factories. The
 equipment for a nineteenth-century potter's shop is listed.
 The cover title is New Jersey Pottery, Exhibition, 1956.

329. New Jersey State Museum. New Jersey Pottery to 1840.
 Trenton: New Jersey State Museum, 1972. 46 p. 92
 black and white illus. Bibliography: p. 45.
 Catalog from an exhibition (held March 18-May 12,
 1972) of "lead glazed redware, salt glazed stoneware, and
 yellow glazed stoneware." Redware was made from the
 first settlements in the seventeenth century; the earliest
 dated piece is from 1704. The pieces are arranged by the
 towns in which they were produced and basic information
 is given about each potter or firm.

330. Newark Museum. The Pottery and Porcelain of New Jersey:
 1688-1900. Newark, N.J., 1947. 100 p. 53 black and
 white illus. Bibliography: p. 76.
 Catalog from an exhibition (held April 8-May 11, 1947)
 which demonstrated the new material discovered after the

1915 exhibition The Pottery and Porcelain of New Jersey
Prior to 1876. The essay and careful catalog notes are by
Arthur Clement and Edith Bishop. Redware, stoneware,
moulded ware, and porcelain are included; the earliest
piece dates from around 1690.

331. Newark Museum Association. The Clay Products of New Jer-
sey at the Present Time. An Exhibition in the Public Li-
brary Building, February 1 to March 20, 1915. Newark,
N. J.: Newark Museum Association, 1915. 20 p.
A pamphlet which surveys industrial wares (brick, pipes,
and crucibles) as well as art pottery and tiles. Factories
which produce the various types of wares are mentioned,
but the exhibited pieces are not listed; see The Pottery and
Porcelain of New Jersey Prior to 1876 for the catalog of
this exhibition.

332. Newark Museum Association. New Jersey Clay: The Story
of Clay. Newark, N. J., 1915. 16 p. 17 black and white
illus. Bibliography: pp. 15-16.
A pamphlet published with the above exhibition at the
Newark Public Library, which sought to educate the public
on the origin and mining of clay as well as on the products
of New Jersey factories and potteries. Reprinted from The
Newarker, November 1914-March 1915. See The Pottery
and Porcelain of New Jersey Prior to 1876 for the catalog
of this exhibition.

333. Newark Museum Association. The Pottery and Porcelain of
New Jersey Prior to 1876. Newark, N. J., 1915. 32 p.
None of the pieces are illustrated but this exhibition
(held February 1-March 20, 1915) was the first "attempt
to bring together a collection of the products of [New Jer-
sey's] pioneer potteries." Many contributors donated a
total of 109 pieces, which were arranged by town and pot-
tery makers. A few sentences of historical information
are included for each maker. The exhibitors hoped to
arouse an appreciation for New Jersey's historic pottery.

334. Robinson, Dorothy, and Bill Feeny. The Official Price Guide
to American Pottery & Porcelain. Orlando, Fla.: House
of Collectibles, 1980. 390 p. Many illus. (color, black
and white). Bibliography: p. 390.
This guide is organized alphabetically, with brief his-
tories, reproductions of marks, and prices given for the
"numerous Trenton based pottery companies." Over five
thousand prices are given for collectible china. Biogra-
phies of Trenton potters precede the company listing. The
emphasis is on Lenox China (pages 75-328); "this started
out as a book on Lenox, and for a variety of reasons ended
up being about the Trenton ceramics industry as a whole....
Companies which were started fairly recently were not
covered in great depth partly because they were not a part

of the basic time period we wanted to cover and partly be-
cause the two biggest ones, Boehm and Cybis, already have
books on them." Ott & Brewer and Willets Manufacturing
Co. also are covered in detail. Scores of Trenton compa-
nies receive briefer mention.

335. Sim, Robert J. Pages from the Past of Rural New Jersey.
Trenton: New Jersey Agricultural Society, 1975. 121 p.
65 black and white illus. Index.
"The aims of this study are to publish illustrations of
things that were used during the earlier days in New Jersey
and to put on record data concerning their origins and uses."
Although Sim had a special interest in pottery, only pages
18-25 are concerned with pottery in this study: spouted
pitchers, a Trenton pie dish, and Old Bridge pottery are
examples. Reprint of the 1949 edition.

336. Sim, Robert J. Some Vanishing Phases of Rural Life in New
Jersey. Matawan, N.J.: Archives Press, 1965. 60 p.
59 black and white illus.
Descriptions of nineteenth-century farm implements and
utensils. Pages 40-53 include stoneware and earthenware,
especially from South Amboy, and adds information to ear-
lier essays on New Jersey pottery. Reprint of the New
Jersey Department of Agriculture Circular no. 327 (Tren-
ton, 1941).

337. Van Hoesen, Walter Hamilton. Crafts and Craftsmen of New
Jersey. Rutherford, N.J.: Fairleigh Dickinson University
Press, 1973. 251 p. 71 black and white illus. Bibliogra-
phy: pp. 242-43. Index.
Van Hoesen spent decades researching local records be-
fore writing this history of craftsmen from early times to
the mid-nineteenth century. There is a chapter on potters
(pages 150-69) and an appendix of 201 New Jersey pottery
marks reprinted from Thomas Maddock's Sons Co.'s Pot-
tery. "The marks used by only a small portion of New
Jersey potters are definitely known. Undoubtedly many of
them did not adopt a distinctive mark, while others copied
those of English potters." The foreword states that he in-
cludes information not dealt with in White's The Decorative
Arts of Early New Jersey; however, he also leaves out in-
formation that is in White's book and other earlier publica-
tions, or differs from them without citing his sources.

338. White, Margaret E. The Decorative Arts of Early New Jer-
sey. New Jersey Historical Series. Princeton, N.J.:
Van Nostrand, 1964. 135 p. 35 black and white illus.
Bibliography: pp. 124-28. Index.
White's overview of New Jersey crafts is the first gen-
eral history on this subject; it contains chapters on glass,
pottery, weaving, silver, clocks, and furniture. The pot-
tery chapter (pages 27-50) highlights the Burlington Pottery

founded in 1688 and D. & J. Henderson (1829-1845); it also includes redware, stoneware, Trenton potteries, and porcelain. White points out the need to use old newspapers, archives, and census records, but her footnotes are to secondary sources. Arts in America; A Bibliography describes this book as an "important one" but "unfortunately, it contains some rather startling errors."

Pennsylvania

339. Bower, Beth Anne. The Pottery-Making Trade in Colonial Philadelphia: The Growth of an Early Urban Industry. Master's thesis, Brown University, 1975. 130 ℓ. Bibliography: ℓ. 125-30.

"Examines the organization, materials, and products of pottery-making in Colonial Philadelphia" from 1685 to 1775, using the results of archaeological research, probate records, deeds, tax lists, and manuscripts. Bower argues that previous studies have dismissed the potter as a "country craftsman"; the evidence shows that "the potters in Philadelphia were a significant presence in colonial times." The appendix contains biographies of forty-two early potters.

340. Breininger, Lester P., Jr. Potters of the Tulpehocken. Robesonia, Pa.: Breininger, 1979. 56 p. 8 color, 22 black and white illus.

"This present treatise, a pioneer study of the potters and pottery of the western part of Berks County located in south-eastern Pennsylvania, documents the existence of some thirty potters." The valley was settled by Germanic people in the 1720s. "Since colonial times, well over fifty men" were redware potters in the area. Most of the potters did not mark their wares consistently.

341. Flower, Milton Embick, and Lenore E. Flower. Newville Pottery. Carlisle, Pa.: Cumberland County Historical Society, 1966. 4 p.

Leaflet published with an exhibition of two earthenware pieces and a stoneware foot-warmer which summarizes the history of the Newville, Pennsylvania, pottery begun by H. H. Zigler which closed in 1877.

342. Guappone, Carmen A. New Geneva and Greensboro Pottery, Illustrated and Priced. McClellandtown, Pa.: Guappones' Publishers, 1975. 48 p., mostly illus. (black and white).

Collector's guide to stoneware of southwestern Pennsylvania. Guappone briefly mentions some nineteenth- and twentieth-century potters, then illustrates, poorly, many of their crocks, pans, and pitchers. A second guide was published in 1980, New Geneva & Greensboro Pottery: Illustrated Price Guide No. II.

343. James, Arthur E. The Potters and Potteries of Chester County, Pennsylvania. 2d ed. Exton, Pa.: Schiffer, 1978. 208 p. Many black and white illus. Bibliography: pp. 205-08.

Originally published in 1945, this revised edition includes new and detailed material on many nineteenth century Quaker and Scotch Irish potters of Pennsylvania who made wares simpler and less adorned than the Pennsylvania Dutch. James states that many potteries of Chester County have been either neglected by historians or classified with the Dutch group, "where obviously they do not belong." James outlines the history and techniques, then reports on forty-three potteries, Tucker China, and Tucker and Hemphill. A checklist of about two hundred potters is added.

344. Lasansky, Jeannette. Central Pennsylvania Redware Pottery, 1780-1904. An Oral Traditions Project, Keystone Books. Lewisburg, Pa.: Union County Oral Tradition Projects, Distributed by the Pennsylvania State University Press, University Park, Pa., 1979. 60 p. 1 color, 80 black and white illus. Bibliography: p. 56. Index.

Identifies "the red earthenware potters of the eighteenth and nineteenth centuries," seeking "to establish the location and dates of as many of these potters' shops as possible, and to learn about those craftsmen, the nature of their pot making and of their ware." Lasansky uses the tax assessment records and other local records to list and describe potteries county by county. Many domestic pottery forms, both common and uncommon, are illustrated. This is a companion study to Lasansky's Made of Mud: Stoneware Potteries in Central Pennsylvania, 1834-1929.

345. Lasansky, Jeannette. Made of Mud: Stoneware Potteries in Central Pennsylvania, 1834-1929. An Oral Traditions Project. [Lewisburg? Pa.], 1977. 59 p. 52 black and white illus. Bibliography: pp. 57-58. Index.

A well-illustrated local study with early photographs, based on research through "early tax assessments, deeds, federal census material, business directories and newspapers" as well as oral accounts. The domestic lives of the potters of the nineteenth century are described. Many crocks and pitchers are illustrated. The first stoneware pottery opened in 1834; the industry expanded as stoneware clays were transported easily on the canals and railroads built in the middle of the century. No earthenware potters are included (see Lasansky's companion volume, Central Pennsylvania Redware Pottery, 1780-1904). Potters and their marks are listed in an appendix. Published in 1979 by Pennsylvania State University Press, University Park, Pa.

346. Myers, Susan H. Handcraft to Industry: Philadelphia

Ceramics in the First Half of the Nineteenth Century. Smithsonian Studies in History and Technology, no. 43. Washington, D.C.: Smithsonian Institution Press, 1980. 117 p. 54 black and white illus. Bibliography: pp. 111-17.

"Outlines the process of early nineteenth-century industrialization in one area of American manufacturing, ceramics, produced in a representative urban center, Philadelphia Between 1800 and 1850, urban potters were confronted with economic and industrial influences that forced drastic change in their trade; the end result was the transformation of a handcraft into an industry." Myers stresses ceramics as "an integral part of the development of American manufactures," pointing out that a thorough analysis of American ceramics will depend on study of many aspects beyond their role as a decorative or folk art. The appendixes contain a biographical list of American potters, statistics on manufacturing and judges' comments on pottery at the Franklin Institute's exhibitions of American manufacturing, 1824-1858. Based on her master's thesis, George Washington University, 1977.

347. Pennsylvania Guild of Craftsmen. Arts and Crafts of Pennsylvania: First State-Wide Exhibition of the Guild. Philadelphia: Pennsylvania Guild of Craftsmen, 1946. 34 p., mostly illus.

The Guild was founded in 1944. This exhibition contained a few pieces of pottery by local craftsmen, including two by Rudy Staffel and a photograph of Isaac Stahl, "the last of the Pennsylvania German potters," at work.

348. Powell, Elizabeth A. Pennsylvania Pottery: Tools and Processes. Doylestown, Pa.: Bucks County Historical Society, 1972. 20 p. Many black and white illus.

The techniques of early potters are described, including clay preparation, throwing, glazing, decorating, and firing. Several processes and pieces of equipment are illustrated, as are pieces of pottery.

349. Schaltenbrand, Phil. Old Pots: Salt-Glazed Stoneware of the Greensboro-New Geneva Region. Hanover, Pa.: Everybodys Press, [1977?] 89 p. 74 black and white illus. Bibliography: p. 89.

A study of the nineteenth-century stoneware of the Monongahela Valley in southwestern Pennsylvania. Thirty potteries flourished there. Based on interviews, deeds, court records, family Bibles, local histories, and his own experience as a potter, Schaltenbrand has written on the history and technique in a vigorous fashion. "I have combined the historical side of the industry with a thorough description of the process by which the pottery was formed, decorated, and fired." Important dates and potters are listed in the appendix. He notes the need for further research, including archaeological excavations.

350. Schiffer, Margaret. Arts and Crafts of Chester County, Pennsylvania. Exton, Pa.: Schiffer, 1980. 285 p., mostly illus. (black and white).
Chester County, one of the three original counties of Pennsylvania, was settled mainly by immigrants from the British Isles and the Pennsylvania Dutch. Many eighteenth- and nineteenth-century pieces from Chester County Histori- cal Society and private collections are shown, interspersed with documentary information from contemporary records and newspapers. "Ceramics" (pages 31-49) includes Arthur E. James's list of Chester County potters with dates and illustrations of earthenware, Vickers porcelain, and majol- ica. Schiffer refers readers to James's The Potters and Potteries of Chester County, Pennsylvania for more infor- mation.

351. Shoemaker, Henry W. Early Potters of Clinton County, with Special Reference to the Work Done in Sugar Valley by the Pioneer Pennsylvania Potters--John Gerstung, Joseph Kem- merer, Joseph Eilert and Reuben McKee. Altoona, Pa.: Altoona Tribune Publishing Co., 1916. 37 p.
"Earthenware was more generally manufactured in Cen- tral Pennsylvania during the first three-quarters of the Nineteenth Century than has been commonly supposed." Shoemaker notes the influence of Indian pottery on the early Pennsylvania potters. Four potters receive a few sentences of biographical data. The romantic story of the parents of Letty Logan, a half-Indian potter, is told at length.

Pennsylvania Dutch: A Selection

352. Barber, Edwin AtLee. Tulip Ware of the Pennsylvania- German Potters: An Historical Sketch of the Art of Slip- Decoration in the United States. Art Handbook of the Penn- sylvania Museum and School of Industrial Art. Philadelphia: Pennsylvania Museum and School of Industrial Art, 1903. 233 p. 2 color, 93 black and white illus. Index.
An extensive description and history of slip-decorated ware based on the Museum's collection. Barber discovered slipware; his usual thorough research is evident in this study: "The writer, after ten years of research and inves- tigation, is enabled to give some account of at least a few of the old establishments where the ware was produced and to fully identify many of the best pieces in the collection." Not restricted to tulip decoration alone, Barber discusses Pennsylvania Dutch history and pottery. Also published: Philadelphia: Patterson & White, 1903. The Museum re- printed its 1903 edition in 1926. Dover reprinted the 1926 edition in 1970 with a new introduction. Some of the illus- trations were rephotographed for the Dover edition.

353. Clarke, John Mason. The Swiss Influence on the Early Pennsylvania Slip Decorated Majolica. Albany, N. Y.:

J. B. Lyon Co., 1908. 18 p. 8 black and white illus.
Clarke, Director of the New York State Museum, ac-
knowledging Barber's "discovery" and study of the Penn-
sylvania Dutch slipware, adds the influence of German-
speaking Swiss to the American development of the ware.
He finds a direct source for the traditional designs of
Pennsylvania Dutch in the Swiss pottery of Basel and
Zurich.

354. Glazer, James, and Nancy Glazer. American Slip Decorated
Earthenware. Philadelphia: American Antiques, 1982.
Portfolio of 10 color plates. Bibliography.
A portfolio of plates of Pennsylvania Dutch pottery issued
with careful notes. An essay by Richard J. Wattenmaker
discusses the pottery, its decoration, and its history of col-
lecting. He states that "a paucity of reliable material ex-
ists about Pennsylvania slip-decorated redware and sgraffito,
the individual artists, and their creations. The basic source
remains Barber's pathfinding study which has not been super-
seded ... the overwhelming majority of early American pot-
tery has never been published, reproduced in any compre-
hensive way and therefore no truly systematic evaluation
has been published."

355. Kauffman, Henry J. Pennsylvania Dutch American Folk Art.
Revised ed. New York: Dover, 1964. 146 p., mostly
illus. (black and white). Bibliography: pp. 145-46.
A survey of the arts of the Pennsylvania Dutch, including
architecture, furniture, pottery, glass, metal, textiles, and
manuscripts. About fifty examples of pottery are shown.
This is an enlarged revision of the 1946 edition published
by American Studio Books, New York.

356. Keyser, Mildred Weekes (Davis). Method of Making Pennsyl-
vania German Pottery. Home Craft Course in Pennsylvania
German Pottery, vol. 2. Allentown, Pa.: Schlecter's,
1943. 27 p. 19 black and white illus.
Brief instructions are given for "home-made" pottery,
rolled out with a rolling pin and formed by molding the
clay around a plate or bowl. Crude line drawings illus-
trate the process and typical designs. A second edition
was published in 1945.

357. Lichten, Frances. Folk Art of Rural Pennsylvania. New
York: Scribner, 1946. 276 p. 47 color, many black and
white illus. Index.
One chapter (pages 9-46) of this book on Pennsylvania
Dutch decorative arts describes the potter's life and art in
Colonial times and the early nineteenth century. The de-
signs of several known potters are illustrated as well as
anonymous wares. The author was State Supervisor of the
Pennsylvania Index of American Design and gathered the
notes and drawings for this book during that project. This

was first published, as a smaller portfolio, by the Pennsylvania Art Project (Philadelphia, 1941). The 1946 edition was reprinted by Scribner in 1963.

358. Robacker, Earl F. Old Stuff in Up-Country Pennsylvania. South Brunswick, N.J.: A. S. Barnes, 1973. 283 p. 16 color, 182 black and white illus. Bibliography: pp. 271-74. Index.
 Concentrates on Monroe County, Pa., where the "up-country" Dutch lived, who have been ignored in many surveys of the Pennsylvania Dutch. Robacker analyzes the "up-country" relationship to the other Dutch and, desiring to preserve knowledge of the past, gathers the artifacts of their material culture. He explains many interesting details of daily life: butter making, egg gathering, tanning, weaving, bee-keeping, music, and more. Pottery is included in a small way. Robacker's Pennsylvania Dutch Stuff: A Guide to Country Antiques (Philadelphia: University of Pennsylvania Press, 1944) also contains a section on pottery.

359. Stoudt, John Joseph. Early Pennsylvania Arts and Crafts. New York: A. S. Barnes, 1964. 364 p. 21 color, 344 black and white illus. Index.
 "The purpose of this book is to explain the cultural and historical meaning of the arts and crafts made in Pennsylvania from its founding in the 1680s to the coming of the industrial revolution." Most of this book is concerned with architecture, furniture, fine arts, and illumination, but there is a short section on pottery (pages 206-19) with several slipware and sgraffito plates illustrated. Reprinted: New York: Bonanza Books, 197-?

360. Stoudt, John Joseph. Pennsylvania German Folk Art: An Interpretation. The Pennsylvania German Folklore Society, vol. 28. Allentown, Pa.: Schlecter's, 1966. 386 p. 7 color illus.; pages 133-385 are mostly illus. (black and white).
 A revision of Stoudt's Pennsylvania Folk Art: An Interpretation (1948) which was itself a revision of his Consider the Lilies, How They Grow (1937). Stoudt studies the designs as non-representational expressions of traditional Christian imagery. Pottery designs are illustrated on pages 305-28.

361. Thevenin, Diana Elena Scott. Pennsylvania German Pie Plates. Master's thesis, Ohio State University, 1951. 22 ℓ. 6 illus. Bibliography: ℓ. 22.
 Briefly describes the decorative tradition of the Pennsylvania Dutch and mentions a few eighteenth- and nineteenth-century potters. Thevenin concentrates on the procedure of making slip and sgraffito wares and the technical problems that arise.

362. Weygandt, Cornelius. The Red Hills: A Record of Good
Days Outdoors and In, with Things Pennsylvania Dutch.
Keystone State Historical Publications Series, no. 7. Port
Washington, N. Y.: Ira J. Friedman, 1969. 251 p. 9
black and white illus. Index.
A reprint of the 1929 publication in Philadelphia by the
University of Pennsylvania Press, this narrative is "chiefly
concerned with those characteristics and habits and modes
of thought that distinguish the Pennsylvania Dutch from their
neighbors in America." He discusses redware, spatterware,
and the work of a traditional potter, as well as the decora-
tive motifs: peacock, tulip, pomegranate, and deer. The
discussion is personal, centering on family life and customs.

Maryland

363. Maryland Historical Society. The Potter's Craft in Maryland:
An Exhibition of Nearly 200 Examples of Pottery Manufac-
tured 1793 to 1890. [n. p.], 1955. 14 p.
A checklist from an exhibition of Indian artifacts, Colonial
and eighteenth-century wares, and the pottery of the Perine
family, Peter Bell, Edwin Bennett, and others.

364. Pearce, John N. The Early Baltimore Potters and Their
Wares, 1763-1850. Master's thesis, University of Dela-
ware, 1959. 150 ℓ. 3 color, 28 black and white illus.
Bibliography: ℓ. 141-50. Index.
A careful study of the early history of Baltimore pot-
tery, designed to lay the groundwork for a full history of
the region's pottery: "The standard works contain practi-
cally nothing on Baltimore pottery." While Barber and
Spargo knew of only two Baltimore potters and Ramsay
knew of twenty-eight, Pearce lists 167 potters' biographies
in the appendix. He also lists the apprenticeships that he
discovered and the contents of the Perine Pottery records.
So little Baltimore pottery has been preserved that he can
illustrate only thirteen pieces of pottery dated before 1850.
He documents the early earthenware, the introduction of
stoneware, the first use of molds, and the decline of the
"handicraft" potters around 1850 as industrialization in-
creased.

Shenandoah Valley

365. Rice, Alvin H., and John Baer Stoudt. The Shenandoah Pot-
tery. Strasburg, Va.: Shenandoah Publishing House, 1929.
277 p. 7 color, 38 black and white illus.
Rice gathered a large collection of over two thousand
pieces of nineteenth-century earthenware pottery from the
Shenandoah Valley. Inspired by Barber's "discovery" of
slipware in Pennsylvania, Rice in 1897 began to collect the

ware and followed the trail to Virginia. The collection is cataloged but only partly illustrated in this book. Several chapters record the history of the Bell family of potters, the Eberly pottery, stoneware in Strasburg, Va., the Keister pottery, and A. W. Baecher; little had been known about these potters before their study. A brief supplement includes documents on early Moravian potteries at Bethabara and Salem, N. C. A facsimile edition was published: Berryville, Va.: Virginia Book Co., 1974.

366. Smith, Elmer Lewis. Arts and Crafts of the Shenandoah Valley. Witmer, Pa.: Published for Shenandoah Valley Folklore Society by Applied Arts, 1968. 43 p., mostly illus. (black and white).

 Painting, weaving, tin, wood, pottery (pages 16-19), fraktur, and music are included in this booklet. Several marks and pieces of pottery are illustrated (the illustrations vary in quality) and nineteenth-century potters, including John G. Schweinfurt, are discussed briefly.

367. Wiltshire, William E., III. Folk Pottery of the Shenandoah Valley. New York: Dutton, 1975. 127 p. 60 color illus. Bibliography: p. 127.

 A selection of sixty special pieces, presentation pieces perhaps, from nineteenth-century Shenandoah potteries is illustrated in fine color. The potters included are the Bell family, the Eberly potters, A. W. Baecher, and John G. Schweinfurt. H. E. Comstock's introduction describes the lives of the potters, their techniques, and glazes. Many of the pieces of Valley earthenware and stoneware have never before been published. The authors consider this a reassessment of the pottery tradition studied by Rice and Stoudt.

West Virginia

368. Hough, Walter. An Early West Virginia Pottery. U. S. National Museum Annual Report, 1899. Washington, D. C., 1901. pp. 511-21, 18 plates.

 An early study of the first pottery established west of the mountains; it was located in Morgantown, W. V., before 1785. Terracottas were made; later, stoneware. Wares, tools, and molds are illustrated.

Virginia

369. Kaufman, Stanley A. Heatwole and Suter Pottery. Exhibit, February 5-March 5, 1978, Eastern Mennonite College. Harrisonburg, Va.: Good Printers, 1978. 47 p., mostly illus. (color, black and white). Bibliographies: pp. 8 and 13.

 Catalog from the first exhibit to study the work of two

Mennonite potters. "It is hoped that this effort will encourage the study of other Rockingham County potters." John D. Heatwole (1826-1907) and Emanuel Suter (1833-1902) made stoneware in Rockingham County, Virginia, from about 1850 to about 1890. The text includes a biography and bibliography for each man and photographs of their marks.

370. Smith, James M. The Pottery and Kiln of Green Spring: A Study in 17th Century Material Culture. Master's thesis, College of William and Mary, 1981. 118 *l*. Illus. Bibliography: *l*. 109-17.
Not seen.

North Carolina

371. Bivins, John, Jr. Moravian Decorative Arts in North Carolina: An Introduction to the Old Salem Collection. Winston-Salem, N.C.: Old Salem, Inc., 1981. 111 p. 191 illus. (color, black and white). Bibliographic notes.
A nicely illustrated survey which includes pottery on pages 35-50. The "study of early pottery in Wachovia has been enormously enhanced by the exacting science of historical archaeology"; more has been learned about pottery than any other trade in Salem. The nineteenth-century potters Aust, Christ, Krause, Holland, Butner, Schaffner, and their apprentices, worked in a "central and eastern European ceramic tradition that survived the emigration to America intact."

372. Bivins, John, Jr. The Moravian Potters in North Carolina. The Old Salem Series. Chapel Hill: Published for Old Salem, Inc., Winston-Salem, N.C., by the University of North Carolina Press, 1972. 300 p. 2 color, 276 black and white illus. Bibliography: pp. 289-90. Index.
"North Carolina [was] the home of a group of master potters whose quality and scope of workmanship was virtually unparalleled in the entire country during the period." Bivins has made a thorough study, based on extensive research, of the pottery and life of the Moravian community in North Carolina from 1750 to 1830. "This book is an attempt to correlate archaeological finds in Wachovia with the Moravian records and existing pieces of pottery identifiable as local ware." Bivins analyzes in detail the potters, their apprentices, the techniques, the pottery, and slip-decoration.

373. Bridges, Daisy Wade, ed. Potters of the Catawba Valley. Journal of Studies, Ceramic Circle of Charlotte, vol. 4. Charlotte, N.C.: History Department, Mint Museum, 1980. 96 p. 103 black and white illus. Bibliographies: p. 9 and p. 92.
Catalog from an exhibition of over two hundred pieces of

alkaline-glazed Catawba Valley pottery; "most of these pieces of Southern pottery are on public view for the first time." Essays by Greer, Zug, Schwartz, Bridges, and other researchers outline the stoneware tradition and the history of several valley potters. "The use of an entirely different stoneware glaze, unmatched by any European counterpart, in the deepest southern states is unique.... The earliest history ... and the original center of its development ... are still undiscovered."

374. Clauser, John W., Jr. The Excavation of the Bethabara Pottery Kiln: An Analysis of Nineteenth Century Potting Techniques. Master's thesis, University of Florida, 1978. 154 ℓ. Illus. Bibliography: ℓ. 149-53. Not seen.

375. Conway. Bob. Traditional Pottery in North Carolina. Waynesville, N.C.: Printed by the Mountaineer, 1974. 36 p., mostly illus. (black and white).
An overview of "traditional" pottery from the Potter's Museum and private collections. The photographs are by Ed Gilreath; the text is minimal.

376. Craig, James H. The Arts and Crafts in North Carolina, 1699-1840. Winston-Salem, N.C.: Museum of Early Southern Decorative Arts, 1966. 480 p. Bibliography: pp. 379-83. Index.
Documentation of early arts and crafts in North Carolina based on contemporary newspaper advertisements and county court minutes (which list indentures of apprentices). The first potter arrived in 1755.

377. Helms, Charles Douglas. An Historical Study of Folk Potters In and Around Alton Community of Union County, North Carolina, from 1800-1950, with Emphasis on the Pottery of "Jug Jim" Broome. Master's thesis, East Carolina University, 1974. 52 ℓ. 23 black and white illus. Bibliography: ℓ. 50-52.
Through interviews and excavation of the abandoned kiln site, Helms studied the pottery of "Jug Jim" Broome, who died in 1957. He documents the history of local potters, including Thomas N. Gay (the first recorded potter), and the methods of folk pottery and kiln construction in Union County.

378. Mint Museum of Art. 1982 Mint Museum Antiques Show. Charlotte, N.C.: Mint Museum of Art, 1982. 112 p., mostly advertisements.
The sixteenth annual antiques show includes comments on collecting early Carolina pottery, "North Carolina Art Pottery" by Daisy Wade Bridges, "The Museum as Collector" by Stuart C. Schwartz, and other contributions. These are brief; this volume is mostly advertising, although several pieces of pottery are illustrated.

379. The Moravian Potters/An Exhibit of the Work of the Moravian
 Potters in North Carolina. Winston-Salem, N.C.: Wachovia
 Museum, Old Salem, Inc., 1973. 12 p.
 Small pamphlet that accompanied an exhibition of the
 wares of Aust, Christ, Ellis, other masters, and appren-
 tices. There were 146 pieces shown; a capsule description
 of each piece is given.

380. Schwartz, Stuart C. North Carolina Pottery: A Bibliography.
 Charlotte, N.C.: Mint Museum of History, 1978. 23 p.
 A substantial bibliography which focuses on the folk pot-
 tery and contemporary potters of North Carolina, while in-
 cluding books on American ceramics generally and on south-
 ern ceramics in particular. Films, catalogs, brochures,
 and bibliographies are listed as well as books and articles.
 This was published on honor of "Raised in the Mud," a
 pottery celebration in 1978.

381. Zug, Charles G., III. The Traditional Pottery of North
 Carolina. Chapel Hill: Ackland Art Museum, University
 of North Carolina, 1981. 66 p. 36 black and white illus.
 Bibliography: pp. 48-49.
 Catalog from an exhibition of nearly 250 pieces of North
 Carolina pottery. Zug did extensive research to prepare
 the lengthy essay and documentation for the catalog. He
 studies the history of the area and the work of individuals.
 "Virtually all of the traditional pottery in North Carolina
 was produced in the Piedmont." The development of earth-
 enware, stoneware, salt-glaze, and alkaline glaze are
 traced by Zug, who asserts that "Southern pottery in
 general--and North Carolina pottery in particular--has been
 too long ignored."

South Carolina

382. Early Decorated Stoneware of the Edgefield District, South
 Carolina. Text by Stephen T. Ferrell and T. M. Ferrell.
 Greenville, S.C.: Greenville County Museum of Art, 1976.
 24 p. 12 black and white illus. Bibliography: p. 16.
 Catalog from an exhibition of the ash-glazed slip-
 decorated stoneware made by nineteenth-century folk pot-
 ters in South Carolina. Several individual potteries are
 discussed. The Ferrells' text "represents one of the few
 published histories of the Edgefield craftsmen."

Georgia

383. Burrison, John A. Georgia Jug Makers: A History of South-
 ern Folk Pottery. Ph.D. dissertation, University of Penn-
 sylvania, 1973. xxxvii, 421 ℓ. 40 black and white illus.
 Bibliography: ℓ. xv-xxxvii. Index.

A lengthy and detailed study which is the first to treat the Georgia folk pottery tradition as a whole. Burrison has used the techniques of oral interviews and archaeological excavation to supplement the scanty information in archives and newspapers. He wished to examine the Georgia pottery tradition, its regional variations, its decline, and the role of the potter in the community in the context of the southern pottery tradition, which has been neglected by historians. The history and methods of many nineteenth- and early twentieth-century potters are included; Burrison is particularly familiar with the Meaders, who offer "a window into the nineteenth century."

384. High Museum of Art. A Thing of Beauty: Art Nouveau, Art Deco, Arts & Crafts Movement and Aesthetic Movement Objects in Atlanta Collections. Atlanta, Ga.: High Museum of Art, 1980. 91 p. 14 color, many black and white illus. Bibliography: p. 90.

Catalog from an exhibition of European and American ceramics, furniture, glass, metalwork, paper, and textiles, drawn entirely from private collections in Atlanta. Although there is not much text, the captions are very informative. The pottery illustrated on pages 15-50 includes such American firms as Marblehead, Paul Revere, Weller, Ohr's, Grueby, Rookwood, and Newcomb.

385. Missing Pieces: Georgia Folk Art, 1770-1976. Exhibition organized by Anna Wadsworth. [n. p.]: Georgia Council for the Arts and Humanities, 1976. 112 p., mostly illus. (color, black and white). Bibliographic notes.

Stoneware jugs, crocks, churns, and face jugs of the late nineteenth and twentieth centuries are illustrated on pages 86-103. John Burrison's essay "Folk Pottery of Georgia" outlines the history of its pottery, which usually had simple decoration or remained unadorned. "One of the most neglected crafts in the South, folk pottery is finally achieving recognition and serious study."

Mississippi

386. Mississippi State Historical Museum. Made by Hand: Mississippi Folk Art. Jackson, Miss.: Mississippi Department of Archives and History, 1980. 120 p. 47 color, 103 black and white illus.

A selection of folk art from an exhibition which identified the unique elements of Mississippi art. Contributed essays analyze black and Choctaw folklife. "The Folk Pottery of Mississippi" (pages 45-54) is discussed by Georgeanna Greer; the potters of 1850, 1860, 1870, and 1880 are listed. Forty-five pieces of pottery were included in the exhibit.

MIDWEST

387. National League of Mineral Painters. Exhibition ... from
October 24 to November 1, 1896. Cincinnati, Ohio: Art
Museum, 1896. 25 p.
Members of local groups, such as the New York Society
of Keramic Arts, Wisconsin Keramic Club, Chicago Ceram-
ic Association, etc., contributed to this large exhibition.
Most items are priced.

Ohio

388. Adamson, Jack E. Illustrated Handbook of Ohio Sewer Pipe
Folk Art. Barberton, Ohio, 1973. 86 p., mostly illus.
(black and white).
Objects from the author's collection of pottery pieces
made from the rough clay used for sewer pipe and bricks
are illustrated, but the illustrations vary in quality. The
collection is largely composed of twentieth-century figurines.

389. Blair, C. Dean. The Potters and Potteries of Summit County,
1828-1915. Akron, Ohio: Summit County Historical Society,
1965, © 1966. 59 p. 52 black and white illus. Bibliogra-
phy: pp. 35-36.
Traces the growth of stoneware potteries in Summit
County, Ohio, and the effects of social changes on the pot-
teries. Sewer pipe production is excluded. A checklist of
potters and potteries, along with a facsimile of the Robin-
son Clay catalog, is included. Reprinted: Akron, Ohio:
Beacon Journal Pub. Co., 1974.

390. Brinker, Lea J. Women's Role in the Development of Art as
an Institution in Nineteenth-Century Cincinnati. Master's
thesis, University of Cincinnati, 1970. 141 ℓ. Bibliog-
raphy: ℓ. 132-41.
The histories of five art organizations in Cincinnati
which were formed through the efforts of the city's upper-
class, educated women are studied: The Ladies Academy
of Fine Arts, The Women's Centennial Committee, The
Women's Art Museum Association, The Cincinnati Pottery
Club, and the Rookwood Pottery. The Women's Art Mu-
seum Association (fund raiser for establishment of the Cin-
cinnati Art Museum) purchased many pieces of American
pottery for the Museum. The author draws on a variety of
contemporary sources for this thorough study.

391. Brunsman, Sue. The European Origins of Early Cincinnati
Art Pottery: 1870-1900. Master's thesis, University of
Cincinnati, 1973. 142 ℓ. 68 black and white illus. Bib-
liography: ℓ. 137-42.
An exploration of the contacts with Europe through the
1851 Crystal Palace Exhibition and the 1876 Philadelphia

Centennial Exhibition. The origins of the Pottery Club and the Rookwood Pottery are discussed and the influence of Haviland and Doulton wares on Cincinnati art pottery is studied in detail.

392. Cincinnati Art Museum. Art Pottery: Cincinnati; The Late 19th Century Women's Ceramic Movement. Cincinnati, Ohio: Cincinnati Art Museum, 1971. 7 p. 3 black and white illus.
Leaflet accompanying an exhibit of ninety-three vases, cups, plates, and decorative objects. The makers include china painters, Fred Dallas, McLaughlin, Storer, and Rookwood decorators.

393. Cincinnati Art Museum. The Cincinnati Crafters Exhibition: All-Ohio Crafts. Cincinnati, Ohio, 1941. 14 p.
A checklist with prices. Exhibitors included Atherton, Bogatay, Burt, Littlefield, Nash, Schreckengost, and the Winters.

394. Cincinnati Art Museum. The Ladies, God Bless 'Em: The Women's Art Movement in Cincinnati in the Nineteenth Century. Cincinnati, Ohio: Cincinnati Art Museum, 1976. 69 p. 51 black and white illus. Bibliographies: p. 13, pp. 61-62.
Catalog from an exhibition of the art of the Cincinnati women who began the art pottery movement, which was "the most extensive, complete publication on this movement and the objects produced by the artists. Museum archives, files, old journals, and records have yielded much information never before recorded or published." The introduction outlines the role of women in Cincinnati arts. There is no essay, but the catalog notes by Deborah D. Long and Kenneth R. Trapp are very specific, careful, and informative. Biographies of thirty-six Cincinnati artists are included.

395. Clara Chipman Newton: A Memorial Tribute. Cincinnati, Ohio: Privately printed, 1938. 40 p. Portrait.
A panegyric occasioned by the death of Clara Chipman Newton, who worked as business secretary and teacher of underglaze painting for Rookwood Pottery. She was also active in the Cincinnati Pottery Club.

396. Clark, Edna Maria. Ohio Art and Artists. Richmond, Va.: Garrett and Massie, 1932. 509 p. 142 black and white illus. Index.
General history of the arts in prehistoric and historic Ohio which includes the ceramics of Rookwood, Cowan, Zanesville, etc. on pages 153-78. Short biographies of the artists are appended. Reprinted: Detroit: Gale Research, 1975 and Richmond, Va.: Garrett and Massie, 1975.

397. Crooksville-Roseville Pottery Festival. Souvenir Program.
[n. p.], 1967. 84 p. Black and white illus.
Leaflet which includes Guy E. Crook's "Brief History of
the Pottery Industry of Crooksville," histories of "today's
operating potteries" (Hull, Brush, Nelson McCoy, Robinson-
Ransbottom, etc.) and miscellany. The 1971 edition con-
tains seventy-two pages.

398. Doty, Robert. American Folk Art in Ohio Collections. New
York: Distributed by Dodd, Mead, 1976. 103 p. 11 color,
56 black and white illus.
A survey of folk art in public and private collections in
Ohio prepared for an exhibition at the Akron Art Institute.
Nine ceramic pieces are illustrated: stoneware crocks, an
effigy jug, and two jugs with bizarre decorations.

399. Garner, George. Posthumous Letter of a Pioneer Potter.
East Liverpool, Ohio: Simms Printing Co., 1934. 15 p.
12 black and white illus.
As part of East Liverpool's centennial celebration, a
letter written in 1844 by Garner, a potter, was reprinted.
He wrote it shortly after he emigrated from England and
described his first experience of America.

400. Gates, William C., Jr. and Dana E. Ormerod. The East
Liverpool, Ohio, Pottery District: Identification of Manu-
facturers and Marks. Washington, D.C.: Society for His-
torical Archaeology, 1982.
Not seen. Also published (Ann Arbor: Braun-Brumfield,
1982) as volume 16, numbers 1 and 2 of Historical Archae-
ology.

401. Lehner, Lois. Ohio Pottery and Glass: Marks and Manu-
facturers. Des Moines, Iowa: Wallace-Homestead Book
Co., 1978. 113 p. Bibliography: pp. 109-13. Index.
The marks of many pottery and glass factories are re-
produced, but no wares are illustrated. Brief histories
are given for the factories, which are arranged alphabeti-
cally by city. More than one thousand factory names are
listed in the index.

402. Purviance, Louise; Evan Purviance; and Norris F. Schneider.
Zanesville Art Pottery in Color. Leon, Iowa: Mid-America
Book Co., 1968. 50 p., mostly illus. (color).
A selection of pieces from the Purviances' collection.
Potteries represented are Weller, Owens, Roseville, Amer-
ican Encaustic, and Mosaic Tile. This book concentrates
on the earlier hand-decorated pieces. The Purviances'
other publications contain expanded coverage of these
wares. Also published by Wallace-Homestead Book Co.,
Des Moines, 1968. Price lists were issued.

403. Ratner, Max. The Clay Products Industry in Ohio. National

Youth Administration in Ohio. Occupational Study no. 2.
[n.p.]: National Youth Administration in Ohio, 1938. 95 ℓ.
19 black and white illus., maps. Bibliography: ℓ. 89-92.
Index.
 Very detailed occupational study of the tasks and working
conditions in factories that manufacture brick, sewer pipe,
tiles, pottery and china, sanitary ware, art pottery, and
other clay products. "Our emphasis has been on what the
worker does rather than processes, and on simple job de-
scriptions" for the use of vocational counselors and young
people.

404. Schneider, Norris F. Zanesville Art Pottery. Zanesville,
Ohio, 1963. 27 p. 11 black and white illus.
 Schneider discusses S. A. Weller, J. B. Owens Pottery
Co., and the Roseville Pottery Co. in this brief history of
art potteries of Zanesville, Ohio. The illustrations are
muddy and dark.

405. Women's Art Museum Association of Cincinnati. A Sketch of
the Women's Art Museum Association of Cincinnati, 1877-
1886. Cincinnati, Ohio: Robert Clarke, 1886. 134 p.
 Hardly a sketch, this is a full record of the goals and
activities of the Women's Art Museum Association, which
was founded when the Women's Centennial Committee (1874-
1877) finished its work. The Association was formed to
encourage the foundation of an art museum in Cincinnati
and disbanded when the Cincinnati Art Museum was estab-
lished. Through museums and art education, Americans
in Cincinnati and elsewhere hoped to improve their dismal
showing in art.

Michigan

406. Arts and Crafts in Detroit 1906-1976: The Movement, the
Society, the School. Detroit: Detroit Institute of Arts,
1976. 296 p. 6 color, many black and white illus. Bib-
liography: pp. 265-93.
 A large exhibition was held to honor the seventieth an-
niversary of the Detroit Society of Arts and Crafts and the
fiftieth anniversary of its school. The admirable essays
and catalog notes are detailed and careful. Most of the
393 pieces exhibited are illustrated. Included in the cata-
log are "The Arts and Crafts Exhibition Era, 1906-1931"
and the "Pewabic Pottery" (essay by Thomas Brunk).

407. Dewhurst, C. Kurt, and Marsha MacDowell. Cast in Clay:
The Folk Pottery of Grand Ledge, Michigan. Publications
of the Museum, Michigan State University, Folk Culture
Series, vol. 1, no. 2. [East Lansing]: The Museum,
Michigan State University in cooperation with the Grand
Ledge Area Historical Society, 1980. 73 p. 115 black

and white illus. Bibliography: p. 73.
Catalog from an exhibition of local pottery which grew
out of the authors' earlier show, "Michigan Folk Art, Its
Beginnings to 1941." Several nineteenth-century potteries
are described and illustrated. The "Grand Ledge lion," a
clay door stop, is prominent, accompanied by many whim-
sical creatures.

408. MacDowell, Marsha, and C. Kurt Dewhurst. Michigan Folk
Art: Its Beginnings to 1941. East Lansing: Kresge Art
Gallery, Michigan State University, 1976. 104 p., mostly
illus. (black and white).
In the belief that folk art had been overlooked in the
Midwest, the Michigan Folk Art Project undertook a two-
year survey to document, photograph, and exhibit the folk
art of Michigan. All 209 exhibits are illustrated in this
catalog. The sewer tile clay figures of Roy Poole and
other artists are on pages 48-52.

Indiana

409. Loar, Peggy A. Indiana Stoneware. Indianapolis, Ind.:
Indianapolis Museum of Art, 1974. 48 p. 94 black and
white illus. Bibliography: pp. 47-48.
Catalog from an exhibition of a "relatively unexplored
field." The lives and works of early potters (the nine-
teenth century is "early" in Indiana) were researched and
the essay outlines the history of the first potteries. Some
contemporary potters whose work is influenced by the tra-
ditional jugs and crocks were included. The author feels
that much more research is needed; the earliest known
stoneware dates from 1830, although there is evidence that
it was made around 1795 to 1805.

Illinois

410. Darling, Sharon S. Chicago Ceramics and Glass: An Illus-
trated History from 1871 to 1933. Chicago: Chicago His-
torical Society; distributed by University of Chicago Press,
1979. 221 p. 5 color, 215 black and white illus. Bibli-
ography: pp. 211-13. Index.
A historical study which is based on very thorough,
original research. It was published simultaneously with an
exhibition of decorative and architectural ceramics and
glass. The exhibition was organized in five sections:
"Handpainted China," "Art Pottery," "Cut & Engraved
Glass," "Stained & Ornamental Glass," and "Architectural
Terra Cotta." Darling has studied each area very care-
fully. This is a well-illustrated, thoughtful work that es-
tablishes the historical context for the decorative arts in
Chicago from the Chicago Fire to the Depression. William

Gates's Teco ware, Susan Frackelton, and Hull House pottery are among the potteries considered.

411. Darling, Sharon S. Decorative & Architectural Arts in Chicago, 1871-1933: An Illustrated Guide to the Ceramics and Glass Exhibition. Chicago: University of Chicago Press, 1982. 90 p. 4 color microfiches (336 images). Bibliography: pp. 83-86. Index.

"The most important objects included in the exhibition Chicago Ceramics and Glass, held at the Chicago Historical Society in 1980, are illustrated here." This guide contains Darling's essays (which give historical background for the pottery, glass, and architectural terra cotta) and a list of the illustrations. The essays have been condensed from her earlier book, Chicago Ceramics and Glass: An Illustrated History from 1871 to 1933.

412. Horney, Wayne B. Pottery of the Galena Area. [East Dubuque?, Ill.], 1965. 48 p., mostly illus. (color, black and white).

Description and history of the lead-glazed earthenware made at various potteries near Galena, Illinois from 1843 to 1899. Horney found information on Galena potteries, an Elizabeth, Illinois pottery, J. B. Goble & Co., Elizabeth, and a pottery in Mineral Point, Wisconsin. A chronology is added.

413. Madden, Betty I. Art, Crafts, and Architecture in Early Illinois. Urbana: Published in cooperation with the Illinois State Museum by the University of Illinois Press, 1974. 297 p. Many black and white illus. Bibliography: pp. 269-79. Index.

The author feels that Midwestern craftsmen and artists have been neglected by historians and that "no book has dealt comprehensively with the cultural history of the Midwest." This broad, well-researched survey includes a chapter on "Jug Towns" (pages 181-94). Potters were working in Illinois by the 1820s; by 1900 their production was second only to that of Ohio artisans. A checklist of about one hundred Illinois potters is included.

Missouri

414. Van Ravenswaay, Charles. The Arts and Architecture of German Settlements in Missouri: A Survey of a Vanishing Culture. Columbia, Mo.: University of Missouri Press, 1977. 533 p. Many illus. (color, black and white). Bibliography: pp. 513-18. Index.

An extensive, in-depth study of the "contributions to the architecture and the arts and crafts of the United States in the period 1830-1860 made by the German colonies established in that period in the Missouri Valley." This project

to photograph the art, conduct oral interviews, and research
local records was sponsored by the Archives of American
Art. Earthenware and salt-glazed stoneware were made by
the German-trained workmen until about 1880, when glass
and metal began to replace pottery. There was some pot-
tery production before 1833 by Anglo-Americans. Pages
459-83 describe the potters and their processes in careful
detail.

Iowa

415. Barglof, Elva Zesiger. The Potteries of Fort Dodge, Iowa:
A Price Guide Identification. [Spencer, Iowa], 1980. 30 p.
19 black and white illus.
Martin White, a German potter, arrived at Fort Dodge
in 1870. He soon began a stoneware pottery with native
clays. The wares of four Fort Dodge potteries connected
with White are described, poorly illustrated, and priced.
"The prices of Fort Dodge pottery have already reached an
unbelievable peak."

416. Reynolds, John D. Coalport and Its Relationship to the Early
Historic Pottery Industry in the Des Moines Valley. Mas-
ter's thesis, Iowa State University, 1970.
Not seen.

417. Schroeder, Allen. The Stoneware Industry at Moingona,
Iowa: Archaeological and Historical Study of Moingona
Pottery Works (13BN120) and Flint Stone Pottery (13BN132).
Master's thesis, Iowa State University, 1974.
Not seen.

418. Schulte, Barbara. The Nineteenth Century Ceramic Industry
at Coal Valley: Archaeology of 13BN111 (Noah Creek Kiln).
Master's thesis, Iowa State University, 1974. 160 ℓ. 50
black and white drawings, 6 photographs. Bibliography:
ℓ. 150-55.
The first pottery in Boone county opened in 1856. By
1900, most of the Iowa stoneware potteries had closed;
stoneware was replaced by tin and glass vessels. Schulte
surveys the pottery industry of the area, then explores the
archaeological evidence of the Noah Creek Kiln which made
salt-glazed and slip-glazed wares either on the wheel or by
jollying. The use of jollying shows the influence of indus-
trialization at the Noah Creek Kiln which operated in the
1860s and 1870s.

Minnesota

419. Newkirk, David A. A Guide to Red Wing Markings. Monti-
cello, Minn.: Newkirk, 1979. 40 p., mostly illus. (black

and white).
Presents an approximate chronology of eight Red Wing
potteries and one potter, Joseph Pohl. The typical decora-
tions and marks are organized and illustrated. "This book-
let is <u>not</u> a precise, minutely detailed chronicle of markings
used on Red Wing products. Nor does it assign specific
dates."

420. Tefft, Gary, and Bonnie Tefft. <u>Red Wing Potters & Their</u>
<u>Wares</u>. Menomonee Falls, Wis.: Locust Enterprises,
1981. 192 p. 68 color, over 600 black and white illus.
Bibliography: p. 187. Index.
"A book for collectors of Red Wing's early pottery" which
presents a "broad but organized" display of the pottery and
a "studied historical account of the events and developments
which formed that industry. For we have found that much
of what has been reported previously has been flawed and
piecemeal." The history of the Red Wing industry from the
early days to the 1900s is discussed very thoroughly and
many pieces of pottery are illustrated. Early documents
and catalogs are reproduced and a price guide was issued.

421. Tyrrell, George V., Jr. <u>New Ulm Potters and Pottery,</u>
<u>1860-1900</u>. Master's thesis, State University College at
Oneonta, N.Y., 1969. 156 ℓ. 48 plates, 72 figures.
Bibliography: ℓ. 152-56.
"This paper concerns the potters and potteries of New
Ulm, Minnesota, between the years 1860 and 1900.... The
primary objectives of this paper are the biographies of the
potters and their firms; the locations and characteristics of
their clays; some of the methods they used in making their
pottery; a listing of their known products. A secondary
objective is the study of nineteenth-century pottery tools,
machines, and methods." Through newspaper accounts and
census records, Tyrrell studies the pottery history of this
German community. He also describes the clays and the
potters' techniques.

422. Viel, Lyndon C. <u>The Clay Giants: The Stoneware of Red</u>
<u>Wing, Goodhue County, Minnesota</u>. Des Moines, Iowa:
Wallace-Homestead Book Co., 1977. 128 p., mostly illus.
(color, black and white).
A collector's guide to the crocks and jugs of the Red
Wing Stoneware Co. (1876-1894), Minnesota Stoneware Co.
(1883-1894), Union Stoneware Co. (1894-1906), North Star
Stoneware Co. (1892-1897), Red Wing Union Stoneware Co.
(1906-1930) and Red Wing Potteries Inc. (1930-1967).
Early catalogs are reprinted as an appendix.

423. Viel, Lyndon C. <u>The Clay Giants, Book 2: The Stoneware</u>
<u>of Red Wing, Goodhue County, Minnesota</u>. Des Moines,
Iowa: Wallace-Homestead Book Co., 1980. 168 p., mostly
illus. (black and white).

"Over 550 all new photographs of Stoneware products and catalogs" further document Red Wing stoneware. Histories, glaze descriptions, newspaper clippings, and other miscellany are included in this loosely organized compilation. Additions and corrections to the first book are listed. A price guide was also issued.

Kansas

424. Arts and Crafts of Kansas; Catalog. Lawrence, Kans.: Printed by The World Co., 1948. 119 p. 1 color, 43 black and white illus.
 The Kansas Art Festival included painters, print makers, sculptors, photographers, writers, and other artists. Each exhibitor receives a brief biographical note. "Ceramics" (pages 66-70) includes six potters then working in Kansas, but no historical review of Kansas pottery.

North Dakota

425. Barr, Margaret Libby; Donald Miller; and Robert Barr. University of North Dakota Pottery: The Cable Years. Fargo, N.D.: Knight Printing Co., 1977. 51 p. 30 color, 13 black and white illus. Bibliography: p. 37.
 History of the University of North Dakota Ceramics Department under the direction of Margaret Cable, 1910-1949. She studied under Rhead and Binns, sent student displays to many exhibitions, encouraged the use of North Dakota clays, and sought local inspiration for designs. She was an influential teacher. Many pieces of pottery are illustrated and the identification marks are explained. A price list was also issued.

SOUTHWEST

Oklahoma

426. Oliver, Zelma Olletta. Crafts in Oklahoma. Master's thesis, University of Oklahoma, 1951. 50 ℓ. 1 color, 4 black and white illus., 7 textile samples. Bibliography: ℓ. 49-50.
 A study of leather, pottery, and weaving "to determine which crafts are still being practiced in Oklahoma and to what extent they have retained their traditions and original techniques." The brief chapter on pottery describes two modern factories but points out that "Oklahoma had no pottery tradition to build on or retain." Indian pottery is mentioned but nineteenth-century Oklahoma pottery is not; apparently, it did not exist.

Texas

427. Humphreys, Sherry B., and Johnell L. Schmidt. Texas Pot-
tery: Caddo Indian to Contemporary. Washington, Texas:
Star of the Republic Museum, 1976. 45 p. 26 color, 28
black and white illus. Bibliography: p. 45.
Catalog from an exhibition which presented Texas-made
pottery over a period of one thousand years. The first
"Anglo-American" potters arrived in the 1840s and 1850s;
they used ash glazes or salt glazes. By the end of the
nineteenth century there were at least twelve potteries in
Texas. The catalog essays are brief; the illustrations are
of good quality.

428. Malone, James M.; Georgeanna H. Greer; and Helen Simons.
Kirbee Kiln; a Mid-19th-Century Texas Stoneware Pottery.
Office of the State Archeologist, report 31. Austin: Of-
fice of the State Archeologist, Texas Historical Commis-
sion, 1979. 60 p. 23 black and white illus. Bibliogra-
phy: pp. 59-60.
Report of a prolonged excavation of the Kirbee Pottery,
which operated from 1850 to 1860 and produced "utilitarian
stoneware of the southern type with an alkaline glaze and a
limited range of forms." It was one of five Texas potter-
ies operating in 1850. The kiln is notable for its extraor-
dinary length of 18 meters. "This is the first reported ex-
cavation of a groundhog-type kiln in Texas"; 32,751 artifacts
were recovered.

429. Steinfeldt, Cecilia, and Donald Lewis Stover. Early Texas
Furniture and Decorative Arts. San Antonio, Texas: Pub-
lished for the San Antonio Museum Association by Trinity
University Press, 1973. 263 p. Many illus. (color, black
and white). Index.
The San Antonio Museum Association sponsored this
"first major exhibition of early Texas furniture and decora-
tive arts." Furniture, mainly nineteenth century, has the
major emphasis, but pages 196-207 illustrate crocks and
jars, for "porcelain and glass were not produced in Texas."
Georgeanna Greer assisted with this section.

430. Steinfeldt, Cecilia. Texas Folk Art: One Hundred Years of
the Southwestern Tradition. Austin: Texas Monthly Press,
1981. 302 p. 205 illus. (color, black and white). Bibli-
ography: pp. 291-95. Index.
Based on an exhibition, "A Survey of Naive Texas Art-
ists," held at the San Antonio Museum, which was "a pio-
neering effort in the exploration of naive Texas art." "The
Potters and Their Wares" are on pages 181-95. The illus-
trations are very good and the captions are unusually infor-
mative.

WEST

Utah

431. Nielsen, Emma Cynthia. The Development of Pioneer Pottery in Utah. Master's thesis, Brigham Young University, 1963. 111 ℓ. 2 color, 52 black and white illus. Bibliography: ℓ. 110-11.
Study of the pioneer pottery industry in Utah, which was encouraged by Brigham Young. The clay beds, methods of making pottery and glazes, and the role of potters in the colonization of Utah are described. Biographical sketches of thirteen potters and a chart of seventy-five pots are included.

Washington

432. Harrington, LaMar. Ceramics in the Pacific Northwest: A History. Index of Art in the Pacific Northwest, no. 10. Seattle: Published for the Henry Art Gallery by the University of Washington Press, 1979. 128 p. 14 color, many black and white illus. Bibliography: pp. 125-26. Index.
Although the emphasis is on contemporary potters, this detailed history begins with the 1930s. "Although some discussion of early, manufactured objects of clay ... is included, the concern is predominately with the individual studio artist making one- or few-of-a-kind functional or sculptural works of artistic interest." The flow of ideas and influences came at first from eastern U.S., followed by the development of a strong group of potters in the Northwest. The importance of the Archie Bray Foundation, Oriental influences, Voulkos, and the universities is stressed. This is the closest study of regional contemporary pottery that has been made.

California

433. Association of San Francisco Potters. 1 Score; Twentieth Anniversary. [n.p.], 1965. 19 p. 11 black and white illus.
The Association was founded in 1945 by a group of students, led by Carlton F. Ball, at the San Francisco School of Fine Arts. It grew to have many members. Sixty-seven members, including Arneson, Ball, Frey, Ng, Rippon, and Sanders exhibited in this show. Most of the pieces were for sale.

434. Bray, Hazel V. The Potter's Art in California, 1885 to 1955. Oakland, Calif.: Oakland Museum, 1980. 87 p. 10 color, 24 black and white illus. Bibliographic notes.

Catalog from an exhibition which included the first sur-
vey of early art pottery in California, as well as recent
studio potters. The extensive research gives much new in-
formation, histories of nineteen potteries, and biographies
for thirty-seven potters. The text is "concerned with doc-
umenting ... regional growth up to the first break with the
tradition of ceramics as craft and the move into the main
stream of contemporary art which occurred here in 1955."

435. California Design 1910. Santa Barbara, Calif.: Peregrine
Smith, 1980. 144 p. Many black and white illus. Index.
"A broad survey of the creative expressions in California
roughly between 1895 and World War I, a germinal period
of cultural consolidation within the State," by California De-
sign, hitherto a department of the Pasadena Art Museum.
Timothy J. Anderson, Eudorah M. Moore, and Robert W.
Winter edited the publication. "Pottery" (pages 64-77) by
Paul Evans describes twelve potteries (including Arequipa,
Stockton, Grand Feu, and Walrich) and gives short biogra-
phies of eleven potters. Originally published in 1974 (Pas-
adena, Calif.: California Design Pubs.) concurrently with
an exhibition.

436. Long Beach Museum of Art. Arts of Southern California--VI:
Ceramics. Long Beach, Calif.: Lewis Printing Co., 1960.
51 p. 66 black and white illus.
A "survey exhibition" of forty-two potters from southern
California which originated at the Long Beach Museum of
Art and traveled through the United States. Thirteen of the
potters briefly comment on their work. Most of the pieces
were for sale: prices are listed.

437. Parker, E. E. Containing and Decorating Forms in California
Pottery. Master's thesis, University of California, 1940.
Not seen.

XXI. INDIVIDUAL POTTERIES

ABINGDON POTTERY

438. Rehl, Norma. Abingdon Pottery. Milford, N.J.: N. Rehl,
1981. 56 p., mostly illus. (black and white).
Abingdon Pottery (Abingdon, Illinois) was founded in
1908. The company made plumbing fixtures until 1934 when
it switched to "Art Pottery"; production was abandoned in
1950. Marks, glazes, and decorations of the wares (kitchen
ware, novelties, lamps, and knick-knacks) are illustrated.

AMERICAN ENCAUSTIC TILING COMPANY

439. American Encaustic Tiling Company. A Modern Tile Factory,
from Clay to Tiles. [Zanesville, Ohio? 1903?] 50 p.,
mostly illus. (black and white).
The manufacturing and decorating processes at the fac-
tory are described in this introductory brochure for visitors.
American Encaustic opened in 1875 and closed in 1935.
Part of it was reopened as the Shawnee Pottery.

440. Flammer, Charles A. Fifty Years of Progress. New York:
American Encaustic Tiling Co., 1928. 7 p.
A brief paper read at a meeting commemorating the
fiftieth anniversary of the company which touches on the
company history and the merits of tile.

J. A. BAUER POTTERY CO.

441. Hayes, Barbara Jean. Bauer, the California Pottery Rain-
bow. Venice, Calif.: Salem Witch Antiques, 1975. 58 p.,
mostly illus. (color, black and white).
The J. A. Bauer Pottery Co. was founded in Los An-
geles in 1914 by a Kentucky potter, John Andrew Bauer.
It closed in 1962. "A long list of imitators made [Ring
Pattern dinnerware] the most widely copied of all Califor-
nia pottery." Some lines are illustrated and several Bauer
catalogs are reproduced.

BENNINGTON POTTERIES

442. Barret, Richard Carter. Bennington Pottery and Porcelain:
A Guide to Identification. New York: Crown Publishers,
1958. 342 p. 7 color, 462 black and white illus. Index.
A brief text describes the history of the Bennington pot-
teries (Norton Pottery, 1793-1894; Fenton Pottery, 1847-
1858) and the recognition of their wares. Barret illus-
trates "every known type of ware and all of the most sig-
nificant production items." About two thousand pieces are
illustrated; they are divided into "functional items," such
as pitchers and tablewares, and "fancy articles," such as
vases, statuettes, and novelty items. Also published: New
York: Bonanza Books, 1958.

443. Barret, Richard Carter. A Color Guide to Bennington Pot-
tery. Manchester, Vt.: Forward's Color Productions,
1966. 28 p. 14 color illus. Index.
Barret, Director-Curator of the Bennington Museum, has
gathered a variety of colored glazes used at the Norton and
Fenton potteries in Bennington. He wishes to dispel the
misconception that all Bennington ware is a spotted, mottled
brown. Most of the approximately 170 pieces illustrated

are from the Fenton period, 1844-1858. Also published:
New York: Crown, 1966.

444. Barret, Richard Carter. How to Identify Bennington Pottery.
Brattleboro, Vt.: Stephen Greene Press, 1964. 71 p. 82
black and white illus. Index.
Identification guide for collectors based on questions re-
ceived by the author as Curator of the Bennington Museum.
This "easy photo guide to detail & variety" is in the form
of questions and answers about the many pieces illustrated.

445. Friedman, Ruth Neabore. The British Influence on Benning-
ton Pottery: Christopher Webber Fenton, 1847-1858. Mas-
ter's thesis, City College of City University of New York,
1966.
Not seen.

446. Osgood, Cornelius. The Jug and Related Stoneware of Ben-
nington. Rutland, Vt.: Charles E. Tuttle, 1971. 222 p.
8 color, 58 black and white illus. Bibliography: pp. 207-
12. Index.
A thorough study of the Bennington jugs by an archaeolo-
gist (Yale University) and collector who has also studied the
dating by means of shape of Chinese blue and white wares.
He begins with the history of pottery in New England, fol-
lowed by the history of the Bennington potteries. He then
traces the changes in shape, decoration, and marks of the
stoneware jugs, building on the previous work of Spargo
and Watkins.

447. Pitkin, Albert Hastings. Early American Folk Pottery, In-
cluding the History of the Bennington Pottery. Hartford,
Conn.: Mrs. Albert Hastings Pitkin, 1918. 152 p. 26
black and white illus. Index.
This early history was the culmination of thirty-five
years of research; Pitkin interviewed men who had worked
at the Bennington Pottery decades earlier. Edwin AtLee
Barber, knowing of Pitkin's work, demanded its publication.
Pitkin's widow completed the book after both Pitkin and
Barber died. It includes histories of Bennington pottery
and folk pottery and catalogs 106 pieces of Bennington pot-
tery and 171 pieces of folk pottery. Pitkin's work is still
admired, although the contents may be disputed by current
researchers; Spargo labeled them "quite worthless."

448. Spargo, John. The A.B.C. of Bennington Pottery Wares: A
Manual for Collectors and Dealers, Illustrated from Photo-
graphs. New and revised ed. Bennington, Vt.: Benning-
ton Historical Museum, 1948. 38 p. 13 black and white
illus.
Illustrates the characteristic products of the Bennington
potteries and explains how to avoid collecting confusion and
pitfalls. Historical background on the potteries is given.

The final section, a forerunner to Barret's How to Identify Bennington Pottery (1964), answers ten questions that recurred frequently at the museum. Spargo restricts his coverage to the years 1844 to 1858, "the only wares made at Bennington that merit the attention of the connoisseur and collector." First published in 1938 by the Bennington Historical Museum.

449. Spargo, John. The Potters and Potteries of Bennington. Southhampton, N.Y.: Cracker Barrel Press, [1969?] 270 p. 44 black and white illus. Index.

Spargo produced this because of his "disappointment resulting from a study of the books and articles previously published on the subject, and comparison of them with such evidence as I had accumulated in the course of my own studies." He covers the history of the Norton and Fenton potteries in interesting, discursive detail. Bennington wares and important craftsmen are also discussed. He corrects some errors of Barber and Pitkin. The introduction to Blue-Decorated Stoneware of New York State states that Spargo is "weak on stoneware" and that he favors the fancy wares; nevertheless, Spargo is considered an important early researcher. Reprint of the 1926 (Boston: Houghton Mifflin and Antiques Inc.) edition. Also reprinted: New York: Dover, 1972.

EDWARD MARSHALL BOEHM INC.

450. Boehm, Helen F. Edward Marshall Boehm and the Edward Marshall Boehm Artists and Craftsmen. Trenton, N.J.: Edward Marshall Boehm, Inc., 1970. 31 p. 15 black and white illus.

A pamphlet published by Boehm's widow shortly after his death. She states that "the increasing numbers of collectors pursuing his work have resulted in an economic market force probably unparalleled in the history of the medium," then reviews his work and introduces the new work of the studio which will carry on in his tradition. Boehm opened his studio in 1949.

451. Cosentino, Frank J. Boehm's Birds: The Porcelain Art of Edward Marshall Boehm. New York: Frederick Fell, 1960. 207 p. 15 color, 85 black and white illus. Bibliography: pp. 159-60.

The life story of Boehm, breeder and veterinarian's assistant turned porcelain sculptor, who got his first big break when the curator at the Metropolitan Museum of Art bought two pieces for the museum. The carving and manufacturing methods are described; many birds, animals, and other figurines which are now collector's items are illustrated.

452. Cosentino, Frank J. Edward Marshall Boehm, 1913-1969. Chicago: Printed by the Lakeside Press, 1970. 264 p. Many illus. (color, black and white). Bibliography: p. 264.
 An extended, personal memoir of Mr. Boehm's life and work by the managing director of the Boehm porcelain factory. Many porcelain birds, flowers, and horses are illustrated. The Edward Marshall Boehm Collection of about 350 sculptures is cataloged and limited editions made since 1961 are illustrated.

453. Palley, Reese. The Porcelain Art of Edward Marshall Boehm. New York: Abrams, 1976. 312 p. Many illus. (color, black and white). Bibliography: p. 312.
 A voluminous study of the dishes, flowers, animals, and especially the birds of Boehm, who raised and bred many animals and birds which he then modeled in porcelain. The text describes his life and personality. The catalog classifies and illustrates hundreds of Boehm's sculptures.

454. Porcelain & Pottery: Bisque Porcelain Bird & Animal Statuettes Modeled by Edward Marshall Boehm; Royal Worcester Bird Statuettes Modeled by Dorothy Doughty; Worcester, Derby, Spode, Wedgwood, Staffordshire, Sèvres, Faience, Meissen. New York: Parke-Bernet Galleries, 1969. 68 p. 30 black and white illus.
 Catalog from an auction which included sixty-five Boehm statuettes, which sold for prices ranging from $50 to $17,500.

BONNIN AND MORRIS

455. Hood, Graham. Bonnin and Morris of Philadelphia; The First American Porcelain Factory, 1770-1772. An Institute Book on the Arts and Material Culture in Early America. Chapel Hill: Published for the Institute of Early American History and Culture at Williamsburg, Virginia by the University of North Carolina Press, 1972. 78 p. 56 black and white illus. Bibliographic notes. Index.
 Detailed investigation of a short-lived but important porcelain factory, based on contemporary records and on-site excavation. The venture failed quickly, in part because of British competition. The Bonnin and Morris factory had been poorly documented until this study. Barber knew of only one Bonnin and Morris piece; Clement knew of five. Hood was able to untangle confusion about the factory, to analyze closely the few known wares already attributed to the factory, and to identify more work from Bonnin and Morris.

BRUSH-McCOY POTTERY CO.

456. Jobbers' Catalogue no. 24-A. "The Lines that Sell." Art, Glazed, Decorative & Utility Ware. Zanesville, Ohio: Brush-McCoy Pottery Co., 1924. 12 ℓ., mostly illus. (color).
One example of the large, colorful catalogs containing many of the lines of the Brush-McCoy (later Brush) Pottery Co. Catalogs were published every year.

457. Huxford, Sharon, and Bob Huxford. The Collectors Catalogue of Brush-McCoy Pottery: An Identification Guide for Over 1,100 Pieces of J. W. McCoy and Brush-McCoy Pottery. Paducah, Ky.: Collector Books, 1978. 80 p., mostly illus. (color). Index.
The Brush-McCoy Pottery was formed in 1911 from a merger of the Brush Pottery and the J. W. McCoy Pottery. The Huxfords have reprinted pages from sale catalogs published from 1910 to 1933. A brief history of the pottery precedes the catalogs.

458. Huxford, Sharon, and Bob Huxford. The Collectors Encyclopedia of Brush McCoy Pottery. Paducah, Ky.: Collector Books, 1978. 190 p. 80 color, 16 black and white illus. Bibliography: pp. 188-89. Index.
Illustrates many examples of the lines of the Brush-McCoy Pottery. A short history is included with a list of the officers and employees.

BUFFALO POTTERY

459. Altman, Violet, and Seymour Altman. The Book of Buffalo Pottery. New York: Bonanza Books, 1969. 192 p. 8 color, 370 black and white illus. Bibliography: p. 187. Index.
Extensive history of the Buffalo Pottery Company (now Buffalo China, Inc.), founded in 1901, and its table wares. The company was begun to produce pottery as premiums for the Larkin Company soaps. It made willow patterns, Deldare ware, Abino ware, historical wares, Christmas plates, and more. Price guides for collectors of the china were issued in 1969, 1973, 1976, and 1981.

CATALINA POTTERY

460. Fridley, A. W. Catalina Pottery: The Early Years, 1927-1937. Costa Mesa, Calif.: Rainbow Pub. Co., 1977. 96 p., mostly illus. (black and white).
Collector's guide to the wares made by the Catalina Pottery in California from 1927 to 1937, when the pottery was sold to Gladding McBean which continued to produce the

Catalina line until World War II. An informal history and reproductions of newspaper articles and price lists precede the illustrations.

H. J. CAULKINS & CO.

461. H. J. Caulkins & Co. Revelation China & Glass Kilns. Detroit, Mich.: [c. 1906]. 52 p. 10 black and white illus.

Sales catalog of the famous Revelation kilns, sold by Caulkins and Mary Chase Perry (Stratton) and used by many china painters and potters. Eight kilns are illustrated and described. Testimonials from all over the continent are included.

CYBIS ART STUDIO

462. Cybis Art Studio. Cybis: A World of Enchantment. Text by Hazel Herman. Trenton, N. J.: Cybis Art Studio, 1978. 96 p., mostly illus. (color, black and white). Bibliography: p. 84.

Boleslaw Cybis (1895-1957) was a Polish artist who came to America just before World War II. Here he began to concentrate on porcelain sculptures. This book depicts many of the porcelain figures made by Cybis: commemoratives, animals, birds, biblical figures, portraits, and fantasia. An alphabetical guide to sculptures (which includes release date, number issued, and price) is appended. An enlarged revision was published in 1979 as Cybis: Porcelains that Fire the Imagination. Cybis Art Studio was formed in 1955, when Cybis's earlier company, Cordey China Co. (1942-1955), was closed.

463. New Jersey State Museum. Cybis in Retrospect. Trenton, N. J., 1970. 92 p. 59 black and white illus.

Catalog of the entire collection of Cybis porcelain at the New Jersey State Museum. The company gave many pieces to the museum that together document the history of the company. Some of Boleslaw Cybis's paintings were also exhibited. A chronology of Cybis's life is included.

DEDHAM POTTERY

464. Dedham Pottery, Formerly Known to the Trade and to the Public as Chelsea Pottery, U. S., but Now Newly Established Under the Style of Dedham Pottery at Dedham, Massachusetts, U. S. A. Dedham, Mass.; 1896. 4 p. 1 illus.

This leaflet was issued when the Chelsea Pottery moved from its damp and unsuitable old site, changing its name

because some people had supposed that "American Chelsea
Ware was an imitation of the English product." The dif-
ference is clarified and the glazes described.

465. Hawes, Lloyd E. The Dedham Pottery and the Earlier Rob-
ertson's Chelsea Potteries. Dedham, Mass.: Dedham His-
torical Society, 1968. 52 p. Many black and white illus.
Bibliography: p. 52.
 This history of the Robertson's potteries (1860-1943) was
published simultaneously with an exhibition of four hundred
pieces of Chelsea and Dedham pottery. The histories of
the family and the potteries are outlined. The production
processes and the rather drastic method of achieving the
famous crackle finish are described. The illustrations con-
tain many Chelsea and Dedham designs.

EXETER POTTERY WORKS

466. Lamson, Everett C., Jr. The Old Exeter Pottery Works.
Barre, Vt.: Privately printed by Modern Printing Co.,
1978. 84 p. 2 color, 47 black and white illus. Bibli-
ography: p. 83.
 The grandson of the last owner of the Exeter Pottery
Works, Exeter, N.H. (1771-1935), wrote these fond "ram-
bling reminiscences" of the pottery and his grandfather's
life "to gather all available information possible concerning
the Pottery's history, and operations along with whatever
photographs could be found of the buildings, men involved,
and samples of the work produced." F. H. Norton's arti-
cle on the processes of making the pottery is reprinted
from The Magazine Antiques.

FRANKOMA POTTERY

467. Cox, Susan N. The Collectors Guide to Frankoma Pottery.
El Cajon, Calif.: Cox, 1979. 126 p. Illus. (color, black
and white).
 Frankoma Pottery was founded in 1933 and is still oper-
ating. Cox describes the history of the company and illus-
trates the dinnerware and figurines produced. Price Guide
and Supplement. Updated Edition for Book One was pub-
lished in 1982; since prices had risen since the publication
of the first book, the supplement, keyed to the first edition,
was published with revised prices. The Collectors Guide
to Frankoma Pottery: Book Two (168 p.) was also pub-
lished in 1982.

FULPER ART POTTERY

468. Blasberg, Robert W., and Carol L. Bohdan. Fulper Art

Pottery: An Aesthetic Appreciation, 1909-1929. New York: Jordan-Volpe Gallery, 1979. 88 p. 13 color, 76 black and white illus. Bibliography: pp. 78-79.
Catalog from an exhibition of Fulper pottery in which many pieces were shown for the first time. Fulper was founded in the nineteenth century; it began producing its famous art line in 1909. In 1929, a disastrous fire destroyed the building and all the records. In 1930, J. Martin Stangl bought the firm and the art pottery was dropped. The accompanying text shows thorough research and the color plates demonstrate the brilliant glazes. Blasberg stresses the influence of Charles Binns on Fulper designs and glazes as well as the importance of Chinese ceramics. This exhibition was "the first attempt to present a comprehensive selection of objects illustrating the breadth of Fulper's artistry with glazes, shapes and colors."

GREEN POINT PORCELAIN WORKS

469. Barber, Edwin AtLee. Historical Sketch of the Green Point (N.Y.) Porcelain Works of Charles Cartlidge & Co. Indianapolis: Reprinted from The Clay-Worker, 1895. 59 p. 37 black and white illus.
 A careful and detailed study of what Barber describes as the first soft porcelain factory in the United States, which operated from 1848 to 1859. (Bonnin and Morris [1770-1772] is now considered the first American manufacturer of soft porcelain.) The factory produced a great variety of wares, from buttons and door knobs to tiles and tableware; it appears to have failed from mismanagement rather than as a victim of foreign competition. Barber relates many events of Charles Cartlidge's life as well as the history of the firm.

GRIFFEN SMITH & CO.

470. Griffen Smith & Co. Majolica; Catalogue. Phoenixville, Pa.: Brooke Weidner, 1960. 14 p., mostly illus. (color).
 A reprint of the company's catalog of Phoenixville Etruscan Majolica, "today ... one of the rarest and most sought after in the field of American manufactured Majolica." The firm lasted from about 1878 to the early 1890s under the name Griffen.

471. Weidner, Ruth Irwin. The Majolica Wares of Griffen, Smith and Company. Master's thesis, University of Delaware, 1980. 89 ℓ. 18 color, 2 black and white illus. Bibliography: ℓ. 63-68.
 "The first in-depth study of the majolica wares produced by the Phoenixville, Pennsylvania, pottery of Griffen, Smith

& Company" includes a history of the pottery (1867-1902),
the manufacturing processes, and an analysis of the vege-
tative, marine, and Oriental designs and their sources.
Weidner traces most of the majolica designs to British
sources. Griffen, Smith was imitating currently popular
British designs; the company "is not considered to be a
part of the art pottery movement."

HALL CHINA COMPANY

472. Duke, Harvey. Superior Quality--Hall China: A Guide for
Collectors. An ELO Book. Otisville, Mich.: Depression
Glass Daze, 1977. 100 p. Many illus. (color, black and
white).
The Hall China Company opened in 1903 and is still pro-
ducing. Duke illustrates the basic shapes, decorations, and
miscellaneous lines. He has "concentrated mainly on lines
that were brought out in the thirties, as these are the most
coveted now, but [has] ranged up through the fifties."

473. Cunningham, Jo. The Autumn Leaf Story. Springfield, Mo.:
HAF-A Productions, 1976. 48 p. 16 color, 78 black and
white illus.
A collector's guide to the Autumn Leaf pattern of the
Hall China Company which has been made since 1933 as a
premium for the Jewel Tea Co., now the Jewel Home Shop-
ping Service. Price "updates" were published in 1978 and
1979, based on information provided by members of the Na-
tional Autumn Leaf Collectors Club. The introduction of
the many different pieces of dinnerware made in this pat-
tern is followed chronologically.

HAMPSHIRE POTTERY CO.

474. Pappas, Joan, and A. Harold Kendall. Hampshire Pottery
Manufactured by J. S. Taft & Company, Keene, New Hamp-
shire. Manchester, Vt.: Forward's Color Productions,
1971. 44 p., mostly illus. (color, black and white).
Illustrates about three hundred items (dishes, vases,
teapots) made by the Hampshire Pottery Co. (1871-1923).
A short history of the firm is given. An English potter
and a Japanese artist who worked for the pottery brought
ideas from their countries. Hampshire Pottery was well
known for its matt glazes; it also made majolica and stone-
ware. The company failed when competition from New Jer-
sey and Ohio increased.

HOMER LAUGHLIN CHINA CO.

475. Berkow, Nancy. Fiesta Ware. Des Moines, Iowa: Wallace-

Homestead Book Co., 1978. 123 p. Many illus. (color,
black and white).
Traces the production of Fiesta ware, a colorful dinner-
ware, by the Homer Laughlin China Co. from its introduc-
tion in 1937 to its discontinuation in 1973. Fiesta was de-
signed by Frederick Hurten Rhead, art director at Homer
Laughlin. A price guide was also issued in 1978.

476. Homer Laughlin China Co. The China Book. Newell, W. Va.:
Homer Laughlin China Co., 1912. 22 p., mostly illus.
Illustrates and describes some of the Laughlin designs
and factory processes; several photographs of the factory and
workers are included. The Homer Laughlin China Co. was
founded in 1871 in East Liverpool, Ohio. In 1905 its fourth
factory, then the world's largest, was built in Newell, West
Virginia.

477. Huxford, Sharon, and Bob Huxford. The Collectors Encyclo-
pedia of Fiesta, with Harlequin and Riviera. 4th ed.
Paducah, Ky.: Collector Books, 1981. 206 p. 146 color
illus. Index.
First published in 1974, this guide has lengthened with
each edition. A history of the company and its lines pre-
cedes the illustrations, which are of good quality. Harle-
quin (1938-1964) was sold exclusively through Woolworth's.
Riviera was made from 1938 to about 1950. A few other
patterns are also illustrated. Suggested prices are listed.
The Huxfords date Fiesta from 1936 to 1971.

478. Riederer, Lahoma, and Charles Bettinger. Fiesta III: A
Collector's Guide to Fiesta, Harlequin and Riviera Dinner-
ware. Monroe, La.: Fiesta Finders [197-?] 32 p.
Illus. (color, black and white).
Not seen. The date of the first volume is unknown.
Fiesta II was published in 1976.

A. E. HULL POTTERY CO.

479. Felker, Sharon Loraine. Lovely Hull Pottery. Des Moines,
Iowa: Wallace-Homestead Book Co., 1974-1977. 2 vol.
47 color illus.
Collector's guides to the hand-decorated pottery made
between 1930 and 1950 at the A. E. Hull Pottery Co.,
Crooksville, Ohio. The company started in 1905 and is
still operating. The pieces shown are from the author's
own collection of over three hundred pieces. The plant
was destroyed by fire in 1950; all records were lost. The
second volume adds briefly to the history of the pottery
and illustrates pieces from eighteen Hull lines.

480. Roberts, Brenda. The Collectors Encyclopedia of Hull Pot-
tery. Paducah, Ky.: Collector Books, 1980. 193 p.,

mostly illus. (color, black and white). Bibliography: p. 192. Index.
A history of the company is followed by many illustrations of its lines. The marks and lines are listed and the numbering system is explained. Old company catalogs are reprinted also. Price Guide No. 1 was issued in 1981.

JUGTOWN POTTERY

481. Crawford, Jean. Jugtown Pottery: History and Design. Winston-Salem, N.C.: John F. Blair, 1964. 127 p. 12 color, 13 black and white illus. Bibliography: pp. 120-27.
Jugtown Pottery was founded in 1921 by Jacques and Juliana Busbee, who wished to revive folk pottery in North Carolina. This detailed history is based on many interviews and historical records. Jugtown Pottery became very successful; the pottery sold well in the Busbee's New York City store. Visitors came from throughout the country and from overseas to view the traditional methods and the characteristic groundhog kiln.

KIRKPATRICKS' POTTERY

482. Denker, Ellen Paul. "Forever Getting Up Something New": The Kirkpatricks' Pottery at Anna, Illinois, 1859-1896. Master's thesis, University of Delaware, 1978. 129 ℓ. 30 illus. Bibliography: ℓ. 116-20.
A thorough study of the Kirkpatricks' pottery, which made "eccentric and humorous novelty wares" such as frog mugs and snake jugs as well as utilitarian stonewares. Denker asserts that "their important contribution to the American pottery tradition has remained largely unrecorded in this century"; Ramsay mentions the pottery but his information is inaccurate. Local newspapers provided Denker with most of her historical information.

KNOWLES, TAYLOR AND KNOWLES CO.

483. Ohio Historical Society. The Brunner Collection of Lotus Ware. The Riley Lustre Collection. Columbus: Ohio Historical Society, 1960. 10 p.
Brochure from an exhibition of ninety-two pieces of Lotus Ware from a private collection. Lotus Ware was a bone china made by Knowles, Taylor and Knowles of East Liverpool, Ohio at the end of the nineteenth century. Knowles, Taylor and Knowles was formed in 1870.

484. Pockrandt, Florence D. Lotus Ware: A Ceramic Product of the Nineties (A Study in Museum Education). Master's thesis, Ohio State University, 1942. 57 ℓ. 2 black and white

illus. Bibliography: ℓ. 55-57.
Study of Lotus Ware and the company that produced it in
the context of the art of the 1890s. The importance of the
1893 Columbian Exposition, where Lotus Ware won an award
of special merit, to America's search for greater freedom
from foreign stylistic influence is explored.

LENOX INC.

485. Ceramic Art Co. The Ceramic Art Co., Potters and Deco-
 rators of Belleek China, Indian China, and Artists' Special-
 ties. New York: E. O. Wagner, Printer, 1891. 40 p.,
 mostly illus. (black and white).
 The Ceramic Art Co. was founded in 1889; Lenox bought
 out his partner in 1894 and reorganized the company as
 Lenox, Inc. in 1906. This catalog includes many drawings
 of the company's fine china wares and sketches of the work-
 rooms.

486. Holmes, George Sanford. Lenox China: The Story of Walter
 Scott Lenox. Trenton, N.J.: Lenox, Inc., 1924. 72 p.
 43 black and white illus.
 An admiring biography of Lenox and description of the
 firm by a Lenox designer. Lenox worked as art director
 of Ott and Brewer before he began the Ceramic Art Co.
 in partnership with Jonathan Coxon. The factory processes
 are described and illustrated in detail. Also published
 privately in Philadelphia in 1924.

487. Lenox Inc. Lenox China. Trenton, N.J.: Lenox Inc.,
 1922. 10 ℓ., 25 plates.
 Catalog of Lenox dinnerware patterns and gold decora-
 tions available in 1922.

488. Lenox China. The Story of Lenox Belleek China. [n.p.,
 n.d.] 18 p. 1 black and white illus.
 A leaflet published after Walter Lenox's death in 1920
 which describes his struggle to produce fine quality Bel-
 leek and the methods of manufacture.

McCOY POTTERIES

489. Coates, Pamela Zimmer. The Real McCoy: A Historical
 Sketch and Buyer's Guide for Collectors of McCoy Pottery.
 Des Moines, Iowa: Wallace-Homestead, 1971-1974. 2
 vol., mostly illus. (color, black and white).
 Coates concentrates on the Nelson McCoy Pottery Co.
 (1910-present). In the first volume, she reproduces (in
 rather poor detail) pieces from catalogs dating from before
 1932 to 1963. The company president lent the only exist-
 ing copies of the old catalogs for these reproductions. The

second volume includes photographs of many McCoy lines,
novelties, cookie jars, steins, and other items. Marks
are included. The illustrations in the second volume are
of better quality than the first. Price guides were also
issued.

490. Huxford, Sharon, and Bob Huxford. The Collectors Encyclo-
pedia of McCoy Pottery. Paducah, Ky.: Collector Books,
1978. 240 p., mostly illus. (color, black and white).
Bibliography: p. 238. Index.
Illustrates about 1,200 pieces of pottery from the McCoy
pottery companies in Zanesville and Roseville, Ohio. These
include the W. Nelson McCoy Pottery (1848-?), J. W.
McCoy Pottery Co. (1899-1925, merged into Brush-McCoy
Pottery Co. in 1911), and the Nelson McCoy Sanitary Stone-
ware Co. (1910-present). Estimated prices are given and
pottery marks are illustrated.

MAYER CHINA COMPANY

491. Mayer China Company. An Ancient Industry in a Modern
Age.... Beaver Falls, Pa.: Mayer China Co., 1935.
33 p. 9 black and white illus.
"A brief history of china together with its present meth-
ods of manufacture and suggestions for its selection." The
manufacturing procedures are illustrated.

MORAVIAN POTTERY AND TILE WORKS

492. Barnes, Benjamin H. The Moravian Pottery: Memories of
Forty-Six Years. Doylestown, Pa.: Bucks County Histor-
ical Society, 1970. 25 p.
Personal reminiscences of life at the Moravian Pottery
by one of the workmen, containing some description of tile
making. He includes several anecdotes of his experiences
with Henry C. Mercer, who started the pottery in 1898.
The pottery has been revived recently.

NEWCOMB POTTERY

493. Mitchell, Jerry Jack. An Analysis of the Decorative Styles
of Newcomb Pottery. Master's thesis, Louisiana State
University, 1972. 71 ℓ. Bibliography: ℓ. 58-64.
The evolution of Newcomb pottery from 1895-1940 is
studied relative to the Arts and Crafts Movement and Art
Nouveau. Ellsworth Woodward's formative influence on the
art school is also examined.

494. Newcomb College. Department of Art. Two Decades of New-
comb Pottery: Pieces from the Period of 1897 to 1917.

New Orleans, 1963. 15 p. 14 black and white illus.
Bibliography: p. 15.
Catalog from an exhibition of pieces made in the period
that is most typical of the "Newcomb style." Most of the
pottery was formed on the wheel by Joseph Fortune Meyer,
then decorated by the students. Twenty-one of the 103
pieces in the exhibition are illustrated.

495. Ormond, Suzanne, and Mary E. Irvine. Louisiana's Art
Nouveau: The Crafts of the Newcomb Style. Gretna, La.:
Pelican Pub. Co., 1976. 182 p. 56 color, 191 black and
white illus. Bibliography: pp. 175-77. Index.
A detailed, well-documented history of Newcomb College,
which opened in 1887, and the Newcomb Guild, which made
and marketed the pottery for fifty years. While pottery was
the most famous craft, textiles and bookbindings are also
illustrated. Biographies of the school's directors, ceram-
ists, and artisans/decorators are appended. Many of the
pieces illustrated are from the Louisiana State Museum
collection, which has been only recently assembled.

496. Zaug, D. D. Newcomb Pottery. Master's thesis, Tulane
University, 1965.
Not seen. Weidner reports this title as Form as Orna-
mental Objects: Newcomb Pottery, an Essay.

NILOAK POTTERY COMPANY

497. Niloak Pottery Co. Niloak Pottery Catalog. Dumas, Ark.:
Kenneth Mauney, 1971. 15 p. 36 black and white illus.
Reprint of a sales catalog of the Niloak Pottery Co.,
published around 1920, which offered a "small exquisite"
sample vase for 80¢. Prices are listed. Clays of dif-
ferent colors were swirled together to produce the char-
acteristic Niloak look. The interior was glazed, but the
outside remained a soft, unglazed surface. Niloak opened
in 1909 and closed around 1944.

498. Sawyer, Allen. Niloak of the Ozarks. Dumas, Ark.: Ken-
neth Mauney, 1972. 11 p. 17 black and white illus.
Reprint of a little brochure published in 1916 that
praises and illustrates the wares of the Niloak Pottery.
Very little information but much encouragement to buy is
given.

NORTH STATE POTTERY

499. North State Pottery. Hand Made Pottery by North State,
Sanford, N. Carolina. [n. p.]: Mint Museum, 1977.
2 vol., mostly illus.
Facsimiles of pamphlets issued by the North State

Pottery, which "began operation in 1926," as catalogs and price lists for retail and wholesale trade. The firm hired "old potters whose ancestors have made pottery for hundreds of years." About one hundred fifty pieces of pottery are illustrated.

500. Schwartz, Stuart C. The North State Pottery Company, Sanford, North Carolina. Charlotte, N. C.: Mint Museum, 1977. 14 p. 18 black and white illus. Bibliography: pp. 13-14.

The North State Pottery (1924-1959) was begun as a hobby by Rebecca Cooper; soon her husband joined her. Their pottery became quite popular. Schwartz asserts that their firm "was successful in the national marketplace, competing with the art potteries such as Weller, Roseville and Rookwood." The Coopers continually tried new forms and new glazes. The pamphlet recites the history of the firm and illustrates its marks.

ONONDAGA POTTERY COMPANY

501. Onondaga Pottery Co. Little Romances of China. Syracuse, N. Y.: Privately printed for the Onondaga Pottery Co., 1919. 56 p. 9 black and white illus.

"The purpose of this little volume is to recount in simple, readable form a few interesting facts concerning the history of ceramics in various countries of the world." These "quaint stories" would be excluded from this bibliography except for the fact that the last chapter describes the manufacture of Syracuse China by the Onondaga Pottery Company. The Company opened in 1870 and is still operating; its name was changed to Syracuse China Corp. in 1966.

502. Onondaga Pottery Company. Seventy-Five Years of Distinguished American Craftsmanship, 1871-1946. Syracuse, N. Y.: Onondaga Pottery Co., 1946. 86 p., mostly illus. (black and white).

An anniversary publication which does not present a complete history but the "highlights of the past and present." There are many photographs of management and employees; marks and current lines are illustrated, as well as the anti-tank mines and fuses made during World War II.

503. Syracuse China Corp. History of Syracuse China. Syracuse, N. Y., 1967. 4 p. 9 black and white illus.

Leaflet summarizing the history of Syracuse China (formerly Onondaga Pottery). Syracuse was the first American firm to produce tableware that was guaranteed against crackled or crazed glaze.

OTT AND BREWER

504. New Jersey State Museum. An Exhibition of Pottery and Por-
cchicago celain Made by Ott and Brewer at Etruria Works in Trenton,
New Jersey, 1871-1892. [Trenton, N.J.] 1971. 16 p.
24 black and white illus.
Ott and Brewer was established in 1871 and closed in
1892; "within twenty years an American firm produced por-
celain comparable to the finest in Europe." This exhibition
included semi-vitreous ware, Parian, ivory porcelain, Bel-
leek porcelain, and experimental pieces.

PASSMORE POTTERY

505. Berky, Andrew S. The Passmore Pottery, 1828-1911.
Pennsburg, Pa.: Schwenkfelder Library, 1953. 20 p. 10
black and white illus.
The Passmore Pottery was a humble operation, founded
about 1830, which closed in 1911 after the death of the last
potter, John Glaes. It was located in Berks County, Penn-
sylvania, near abundant sources of clay. Photographs made
in the 1890s document the description of this simple, old-
fashioned pottery.

PEWABIC POTTERY

506. Brunk, Thomas W. Pewabic Pottery: Marks and Labels.
Detroit, Mich.: Historic Indian Village Press, 1978.
43 p. 57 black and white illus. Bibliography: pp. 41-42.
Brunk, curator and archivist of Michigan State Univer-
sity/Pewabic Pottery, compiled this list of Pewabic marks
and paper labels during his research for a "definitive his-
tory of the Pewabic Pottery" (not yet published). Marks
were not considered important by the Pewabic potters; they
did not keep records of the various marks used. Pewabic
Pottery, located in Detroit, was founded in 1903 by Mary
Chase Perry Stratton and H. J. Caulkins. The pottery was
taken over by Michigan State University in 1967; Pewabic
pottery is no longer made.

507. Highlights of Pewabic Pottery. Ann Arbor, Mich.: Ars
Ceramica, 1977. 32 p. 13 color, 18 black and white
illus.
Produced to accompany the 70th anniversary exhibit of
Pewabic Pottery, it is stated that this is adapted from
Fred Bleicher's Pewabic Pottery: An Offical History but
this author has been unable to locate the latter publication.
Mary Chase Perry Stratton's life and her relationships with
other early potters are summarized. Her partnership with
H. J. Caulkins, dating from 1892, in the sales of the Rev-
elation Kilns is also explored.

508. Pear, Lillian Myers. The Pewabic Pottery: A History of
Its Products and Its People. Des Moines, Iowa: Wallace-
Homestead Book Co., 1976. 295 p. 557 illus. (color,
black and white). Bibliography: pp. 263-65. Index.
A biography of Mary Chase Perry Stratton and history
of the Pewabic Pottery. Pear took a great deal of infor-
mation from the Pewabic records and from day books and
order books dated 1903-1969 which list designs, exhibitions,
prices, and glaze experiments. Pear investigates persons
who influenced Perry, the sources of Pewabic designs, and
the lives of several prominent employees. An appendix lists
collections and installations of Pewabic pottery.

509. Stratton, Mary Chase Perry. Pewabic Pottery: Commemora-
tive Exhibit to Honor the Pottery's 70th Anniversary. Ann
Arbor, Mich.: Ars Ceramica, 1977. 8 p. 7 color, 2
black and white illus.
A souvenir brochure from the 1977 exhibition which con-
tains two essays by Stratton, the founder (with H. J. Caul-
kins) of Pewabic Pottery. One essay is a "brief memoir";
the other records the "major events at the Pottery during
its first ten years."

510. University-Liggett Antiques Show, 1973. Grosse Pointe
Woods, Mich.: University-Liggett School, 1973. 188 p.
This publication for a fund-raising antique show includes
a chapter on the Pewabic Pottery (6 pages, 6 black and
white illus.) by Roger Ault, Director of the Pewabic Pot-
tery at Michigan State University. He gives a personal ac-
count of Stratton's life, based on her own words and com-
ments from friends.

PICKARD CHINA

511. Platt, Dorothy Pickard. The Story of Pickard China. Han-
over, Pa.: Printed by Everybodys Press, 1970. 85 p.
33 color, 38 black and white illus.
Pickard China was founded in 1893 in Antioch, Illinois,
and continues today, the only china company in America that
is still family owned. This history of the company, its
wares, and decorators was written by the founder's daugh-
ter after receiving many inquiries from collectors and an-
tique dealers. Pickard pottery marks are reproduced.

RED WING POTTERIES COMPANY

512. Bougie, Stanley J., and David A. Newkirk. Red Wing Din-
nerware. Monticello, Minn.: Bougie and Newkirk, 1980.
88 p., mostly illus. (color, black and white).
"Dinnerware made at Red Wing, Minnesota ... arranged
in chronological order, beginning with the Gypsy Trail line

introduced in 1935 and ending ... when the Potteries closed in 1967. Original brochures, supplemented by photographs, are used to show the patterns made over the years." The quality of the reproductions is poor. A 1980-1981 price guide and supplement is available.

513. Simon, Dolores H. Red Wing Pottery with Rumrill. Paducah, Ky.: Collector Books, 1980. 103 p. 54 color illus.
Red Wing Potteries Co. was formed from the Red Wing Stoneware Co. (incorporated in 1878) and the Minnesota Stoneware Co. (founded in 1883); it closed in 1967. During the 1930s it produced pottery for George Rum Rill (hence Rumrill) of Arkansas. Several hundred pieces of pottery are illustrated in this "identification & value guide"; current prices are suggested. The prices have been updated to 1982.

ROOKWOOD POTTERY

514. Burt, Stanley. 2,292 Pieces of Early Rookwood Pottery in the Cincinnati Art Museum in 1916. Cincinnati, Ohio: Cincinnati Historical Society, 1978. 192 p.
The most famous art pottery, Rookwood, was begun in 1880 by Maria Longworth Nichols, a wealthy Cincinnati woman who first painted china with a neighborhood boy, Karl Langenbeck. Rookwood became a very successful and energetic pottery. It faltered during the 1950s and closed for good in 1967. This is a facsimile of "Mr. S. G. Burt's Record Book of Ware at Art Museum," a hand-written description of the collection which was then in the museum. Most of the pieces included are no longer in the Cincinnati Art Museum; they were taken back by the pottery during World War II and many were sold or destroyed as inferior. Stanley Burt was in charge of all production and research at Rookwood.

515. Catalog of Rookwood Art Pottery Shapes. Kingston, N.Y.: P-B Enterprises, 1971-1973. 2 vol.
A card file at the Rookwood Pottery recorded each design produced from the pottery's beginning in 1880 until it closed in 1967. About four thousand shapes are reproduced and when the designer of a particular shape is known, his or her identity is indicated. The shapes designed for the Department of Architectural Faience (including moldings, cornices, and tiles) are omitted, causing gaps in the numbering sequence.

516. Cincinnati Museum Association. Historical Collection of the Rookwood Pottery, from Its Beginning in 1880 Until 1905. Cincinnati, Ohio, 1906. 3 p.
Pamphlet issued with the "special exhibition, February and March, 1906," of two thousand representative speci-

mens of each variety of ware that were placed in the Museum for safekeeping.

517. Cummins, Virginia Raymond. Rookwood Pottery Potpourri. Silver Spring, Md.: Cliff R. Leonard and Duke Coleman; Distributed by Nothing New, P. O. Box 714, Silver Spring, Md., 1980. 136 p. 39 color, 163 black and white illus. Bibliography: p. 108. Index.

This "scrapbook" of Rookwood Pottery contains biographies of 132 artists and other associates, accompanied by old photographs taken by the Rookwood photographer from 1900-1945. Monograms, Rookwood honors, and excerpts from Burt's notebook are also included. An addendum illustrates Rookwood pieces in color.

518. Davis Collamore & Co. Rookwood Pottery, Cincinnati USA: Paris Exposition 1889. [n. p.], 1889. 3 p.

A small advertising flyer for the Paris Exposition of 1889, explaining the history of the Rookwood Pottery and the Japanese influence on its styles. The fine quality of Rookwood is praised.

519. Frame House Gallery, Inc. Rookwood Pottery: 1860-1967. Louisville, Ky.: Frame House Gallery, 1971. 16 p. 19 black and white illus.

Catalog from the first Rookwood exhibition in the Ohio Valley area. A brief history of the pottery is given, followed by a list of the pieces exhibited. The drawings and oils of Grace Young, a decorator, were also shown.

520. Hotchkiss, John F. Price Guide to Rookwood Pottery, Also for Weller, Roseville, Owens, and Zanesville. Rochester, N. Y.: Hotchkiss House, [n. d.] 10 p. Illus.

Not seen.

521. Kircher, Edwin J.; Barbara Agranoff; and Joseph Agranoff. Rookwood: Its Golden Era of Art Pottery, 1880-1929. Cincinnati, Ohio, 1969. 31 p. 14 color illus.

A spiral-bound guide to the work of the Rookwood Pottery. Five painted wall plaques and 132 pieces are illustrated. Rookwood was created by Nichols because she "had long admired the ceramic art of Europe and the Orient, and ... wished to create from her native soil art that was free from foreign influence and original in concept." Summarizing his list published in 1962, Kircher illustrates the factory marks, size marks, clay marks, glaze marks, and the marks of one hundred ten Rookwood decorators. The captions are quite informative. All pieces illustrated are from the private collections of the authors.

522. Kircher, Edwin J. Rookwood Pottery: An Explanation of Its Marks and Symbols. [n. p.], 1962. 18 p.

Rookwood pieces normally carry several marks which

may denote the factory, the year, shape, clay, process, or decorator. Kircher explains and reproduces nearly all these marks, eliminating a few artists' marks that have not been identified and many process marks that were for technical experiments. One hundred seven decorators' marks are identified. Peck, writing in 1968, added five decorators' marks to Kircher's list.

523. Peck, Herbert. The Book of Rookwood Pottery. New York: Crown, 1968. 184 p. 9 color, 95 black and white illus. Bibliography: p. 177. Index.
This lengthy history of Rookwood is based on published works and research in the company archives and the Cincinnati Historical Society archives. Five sections follow its history under Maria Longworth Nichols (1873-1883), William W. Taylor (1883-1913), Joseph Henry Gest (1914-1934) and John D. Wareham (1934-1954). Nichols' rivalry with Mary Louise McLaughlin is also recorded. The appendixes record marks, decorators, and collections of Rookwood, expanding Kircher's 1962 list slightly. Trapp in Maria Longworth Storer (ℓ. 16) notes that this is a "corporate history of the pottery. Peck does not analyze the various artistic periods or influences of Rookwood, nor does he discuss the many talented decorators." Also published: New York: Bonanza Books, 1968.

524. Rookwood Pottery. The Rookwood Book: Rookwood, An American Art. Cincinnati, Ohio: Rookwood Pottery, 1904. 34 p., mostly illus.
A catalog of Rookwood vases and lamps with a price list. The glazes used are described for the potential buyer. The text cautions: "As no piece of Rookwood is ever duplicated, it is impossible to issue a catalogue in the ordinary sense of the term.... The Rookwood Book will nevertheless serve as a guide in ordering Rookwood." Vases were sent out "on approval," if necessary.

525. Rookwood Pottery. Rookwood Pottery, Cincinnati. Cincinnati, Ohio: Press of the Proctor & Collier Co., [1901?] 32 p. 30 black and white illus.
An informational pamphlet put out by the pottery which encourages a visit, gives a little history, and explains the "varieties of Rookwood." Marks and admiring comments are listed at the end.

526. Rookwood Pottery. Rookwood Pottery. Cincinnati, Ohio: Rookwood Pottery Co., [1902]. 47 p. 21 black and white illus.
A history and description of the pottery that is lengthier than the usual company pamphlet. Rookwood honors and marks are listed at the end. Glazes and techniques are described, interspersed with illustrations of the wares, in this attractive booklet. Over the years, Rookwood published many booklets such as this and the one above.

527. Rookwood Pottery. Rookwood Pottery, Founded in 1880: Its
History and Its Aims. Cincinnati, Ohio: Rookwood Pottery
Co., [1930?] 15 p. 3 black and white illus.
One example of the pamphlets that were published with
this title or a variation from around 1915 until 1950. It
describes the wares, glazes, and marks. Rookwood also
published individual catalogs for tiles, mantels, architec-
tural faience, and garden pottery.

528. Storer, Maria Longworth. History of the Cincinnati Musical
Festivals and of the Rookwood Pottery. Paris: Herbert
Clark, Printer, 1919. 14 p.
"I have been asked so often about the early history of
the Rookwood Pottery, that I have decided to print this
sketch written in 1895 ... a scrap of autobiography."
Storer also founded the Cincinnati Musical Festivals. This
was published after she had left the pottery and, following
the death of her husband, had married Bellamy Storer, a
diplomat.

529. Trapp, Kenneth R. Ode to Nature: Flowers and Landscapes
of the Rookwood Pottery, 1880-1940. New York: Jordan-
Volpe Gallery; Distributed by Peregrine Smith, 1980. 89 p.
18 color, 11 black and white illus. Bibliography: pp. 69-
70.
Catalog with knowledgeable text and excellent illustrations
from an exhibition of Rookwood pottery pieces chosen for
the aesthetic success of their composition. Trapp's essay
discusses the fascination of those in the nineteenth century
with floral motifs and landscapes in connection with the his-
tory of Rookwood. Trapp notes: "Today the pottery's rec-
ords, library, and molds are scattered throughout the
United States, and much of the pottery's history has been
destroyed through carelessness and ignorance."

530. Yuma Art Center. Rookwood Pottery: From the Collection
of John H. Loetterle and G. William Stuart, Jr. Yuma,
Ariz.: Yuma Art Center, [1978?] 19 p. 19 black and
white illus.
Catalog from an exhibition, "one of the most comprehen-
sive ever put together from a single collection." One hun-
dred fifty four pieces were illustrated, arranged to reflect
the history of the pottery. The exhibition includes more
than half of the Rookwood artists.

ROSEVILLE POTTERY COMPANY

531. Alexander, Donald E. Roseville Pottery for Collectors.
Richmond, Ind.: Donald E. Alexander, 1970. 78 p. 62
black and white illus.
Traces the history of the Roseville Pottery Company
(Roseville, Ohio; later Zanesville, Ohio), 1890 to 1954.

This guide also lists twenty-six pottery marks used on Roseville and lists the lines and products chronologically.

532. Buxton, Virginia Hillway. Roseville Pottery For Love ... Or Money. Nashville, Tenn.: Tymbre Hill, 1977. 320 p. Many illus. (color, black and white). Bibliography: pp. 306-09. Index.
 History of Roseville Pottery and detailed description of its wares. Many of its lines are illustrated with good color pictures. They are listed as they were introduced over the years. Approximate values and hints for collectors are also given.

533. Clifford, Richard A. Roseville Art Pottery. Winfield, Kans.: Andenken Pub. Co., 1968. 44 p. Illus. Not seen.

534. Huxford, Sharon, and Bob Huxford. The Collector's Catalogue of Early Roseville: An Identification Guide for Over 1,000 Pieces of Roseville Pottery. Paducah, Ky.: Collector Books, [n.d.] 64 p., mostly illus. (black and white). Index.
 Reproductions of the sales catalogs of the Roseville Pottery Company from the 1890s and early 1900s, "much of which was more utilitarian than artistic." The Huxfords feel that most books start at the Rozane line and concentrate on the later art pottery lines. The catalogs reproduced are from the collection of the Ohio Historical Society.

535. Huxford, Sharon, and Bob Huxford. The Collectors Encyclopedia of Roseville Pottery. Paducah, Ky.: Collector Books, 1976. 184 p., mostly illus. (color, black and white). Bibliography: p. 179. Index.
 Illustrates many pieces from the Roseville Pottery (1891-1954) organized by lines as they were developed over the years, beginning with Rozane in the 1900s. Ross Purdy, Secretary of the American Ceramic Society, developed Roseville's first art line in competition with Weller. Frederick H. Rhead designed Roseville's most famous line, Della Robbia. Pottery marks are shown and fifty-nine pages from early catalogs are reprinted. A price guide accompanies the book.

536. Huxford, Sharon, and Bob Huxford. The Collectors Encyclopedia of Roseville Pottery, Second Series. Paducah, Ky.: Collector Books, 1980. 191 p., mostly illus. (color, black and white). Bibliography: p. 190. Index.
 A companion volume to the author's The Collectors Encyclopedia of Roseville Pottery (1976). "New lines, new information, and many fine examples of Roseville's art have been reported to us" and are illustrated. A price guide keyed to both volumes is included. Together these books illustrate thousands of pieces of pottery.

537. Purviance, Louise; Evan Purviance; and Norris F. Schneider.
Roseville Art Pottery in Color. Des Moines, Iowa: Wallace-
Homestead Book Co., 1970. 48 p. 24 color illus.
A companion (along with Weller Art Pottery in Color) to
Purviance's Zanesville Art Pottery in Color, this book sur-
veys the later Roseville lines as well as the earlier lines
of Rozane and Della Robbia. A chronological list of lines
is given; a price list was issued separately.

538. Roseville Pottery, Inc. Roseville. Zanesville, Ohio: Rose-
ville Pottery, Inc., 1931. 24 p. 24 black and white illus.
Small pamphlet which highlights the history of pottery
and illustrates the Roseville product in various decorative
settings.

539. Roseville Pottery Co. Rozane Ware Catalog, 1906. Zanes-
ville, Ohio: Norris F. Schneider, 1970. 22 p., mostly
illus. (black and white).
Schneider's foreword notes this is a reprint, reduced in
size, of the only existing copy of the 1906 Roseville cata-
log. Rozane ware was originated by Ross Purdy in 1900.

540. Snook, Josh, and Anna Snook. Roseville Donatello Pottery.
Lebanon, Pa.: Snook, 1975. 48 p. 43 color illus.
Not seen. The Donatello line was introduced by Harry
Rhead, Frederick Hurten Rhead's brother, after a visit to
Czechoslovakia. He returned from that trip with an Itali-
anate jardiniere; his Donatello line, based on Italian motifs,
became very popular.

SCIO POTTERY

541. Nygaard, Norman E. Lew Reese and His Scio Pottery: The
Story of a Business with a Heart. New York: Greenberg,
1948. 176 p. 8 black and white illus.
An upbeat account of the fortunes of the Scio-Ohio Pot-
tery (1932-present): "The pottery makes an assortment of
white ware, but more important still it makes men and
women, freedom-loving citizens who believe in their jobs,
who get joy out of their work, and who believe in one an-
other." A disastrous fire in 1947 leveled the plant; the
spirited workers rebuilt it.

SHAWNEE POTTERY COMPANY

542. Shawnee Pottery Company. Office and Works. Zanesville,
Ohio: Shawnee Pottery Co., [n.d.] 5 p. 1 black and
white illus.
Catalog of decorative and kitchen wares. Shawnee Pot-
tery Co. opened in 1937 in the Zanesville plant of the
American Encaustic Tiling Co. after American Encaustic
had gone bankrupt.

543. Simon, Dolores H. Shawnee Pottery in Color. Paducah,
 Ky.: Collector Books, 1977. 64 p. 23 color, 3 black
 and white illus.
 "An illustrated value guide" for the Shawnee Pottery
 Co., Zanesville, Ohio (1937-1961). A brief history of the
 firm is given, then many pieces are illustrated. Their
 "high quality yet inexpensive" ware was sold through
 Kresge's, Woolworth's, Sears Roebuck, and Procter and
 Gamble's. Shawnee became popular quickly as public sen-
 timent turned against German and Japanese imports. Shaw-
 nee made Rum Rill pottery during the late 1930s and 1940s.

SOUTHERN POTTERIES INC.

544. Newbound, Betty, and Bill Newbound. Southern Potteries Inc.
 Blue Ridge Dinnerware. Paducah, Ky.: Collector Books,
 1980. 120 p., mostly illus. (color, black and white). In-
 dex.
 Southern Potteries, Erwin, Tenn., was founded in 1920
 and folded in 1957. Many of the Blue Ridge lines are il-
 lustrated (over four hundred patterns were produced in
 1951 alone). The colorful, casual designs were hand-
 painted under the glaze.

STANGL POTTERY COMPANY

545. Dworkin, Joan, and Martha Horman. A Guide to Stangl Pot-
 tery Birds. Lynbrook, N.Y.: Willow Pond Books, 1977.
 22 p., mostly illus.
 A collector's guide to the Stangl Pottery birds which
 were first produced during World War II at the (then) Ful-
 per Pottery Company. The birds were developed under the
 direction of J. Martin Stangl, president of the company.
 In 1955, the company changed its name to Stangl Pottery
 Co.

546. Rehl, Norma. The Collectors Handbook of Stangl Pottery.
 Milford, N.J.: Norma Rehl, 1979. 120 p. 4 color, 88
 black and white illus.
 A brief history of the Stangl Pottery (1929-1978) which
 grew out of the Fulper Pottery Company is followed by il-
 lustrations of the dinnerware lines, mugs, and lamps.
 Some catalogs are reproduced, rather fuzzily. A price
 guide (30 pages) is also available.

547. Stangl Pottery. Stangl: A Portrait of Progress in Pottery.
 Trenton, N.J.: Stangl Pottery, 1965. 30 p. 30 black
 and white illus.
 A short history of the pottery, which produces dinner-
 ware and gift wares, and a look at its current manufactur-
 ing processes are contained in this pamphlet.

STEUBENVILLE POTTERY COMPANY

548. Kerr, Ann. The Steubenville Saga: Emphasis Is on Russel
 Wright, American Modern. Sidney, Ohio: Kerr, [1979?]
 35 p. Illus. (color, black and white).
 Not seen. Russel Wright designed American Modern,
 a dinnerware line that became very popular and was widely
 imitated. A price guide was issued also.

TUCKER

549. Curtis, Phillip H. Tucker Porcelain, 1826-1838: A Re-
 appraisal. Master's thesis, University of Delaware, 1972.
 148 ℓ. 36 black and white illus. Bibliography: ℓ. 96-104.
 A study of Tucker porcelain ("the first commercially
 successful large-scale manufactory of porcelain in the United
 States") which includes chapters on the history of the firm,
 materials and formulae, organization and operation, prod-
 ucts, and techniques of identification. Curtis researched
 the Tucker factory papers: "account books, formula and
 price books, day books, pattern books, letter books, and
 line drawings." Curtis concludes that "the story of the
 Tucker factory presents a classic dichotomy between the
 rise of American nationalism and the American dependence
 on European precedents."

550. McClinton, Katharine Morrison. A Handbook of Popular An-
 tiques. New York: Random House, 1946. 244 p. 30
 black and white illus. Bibliographies. Index.
 Written for collectors, this describes the availability,
 value, and identifying marks of a grab-bag of antiques and
 includes one chapter on Tucker China wares. Jayne, writ-
 ing in the Philadelphia Museum of Art catalog in 1957, dis-
 agrees with some of Morrison's assertions which were
 based on rather early (1906, 1936) articles. Also pub-
 lished: New York: Bonanza Books, 1946.

551. Philadelphia Museum of Art. Tucker China: 1825-1838.
 An Exhibition of Examples of the Porcelain Made in Phila-
 delphia by William Ellis Tucker, Tucker and Hulme, Tucker
 and Hemphill, Joseph Hemphill, and Thomas Tucker. Phil-
 adelphia: Philadelphia Museum of Art, 1957. 36 p. 14
 black and white illus.
 Catalog from an exhibition of over six hundred pieces of
 china, documents, and memorabilia. An engaging essay by
 Horace H. F. Jayne on the Tuckers and the Tucker venture
 precedes the catalog. Jayne updates some of McClinton's
 data presented in A Handbook of Popular Antiques.

UNIVERSITY CITY

552. Thomas, Curtis R. Drawn From the Kilns of University

City. Master's thesis, University of Missouri, 1974.
Not seen.

UTICA

553. Munson-Williams-Proctor Institute. White's Utica Pottery.
Utica, N. Y.: Munson-Williams-Proctor Institute, [1969?]
18 p. 10 black and white illus.
Catalog from an exhibition of White's Utica stoneware
pottery, made from about 1830 to 1900. A list of Utica
potters is appended. Barbara Franco's essay sketches the
history of pottery in Utica and the series of Whites--father,
sons, grandsons--who ran the pottery.

VERNON KILNS

554. Nelson, Maxine Feek. Versatile Vernon Kilns. Costa Mesa,
Calif.: Rainbow Pubs., 1978. 64 p., mostly illus. (color,
black and white). Bibliography: p. 4.
Vernon Kilns (1931-1958), which was Poxon China from
1912 to 1931, made several popular lines of dinnerware.
Rockwell Kent and Walt Disney designed plates and figurines
for this company. Its history is given and many production
lines are illustrated. Versatile Vernon Kilns, Book II, with
special emphasis on dinnerware, was published in 1982.

WELLER POTTERY COMPANY

555. Huxford, Sharon, and Bob Huxford. The Collectors Encyclo-
pedia of Weller Pottery. Paducah, Ky.: Collector Books,
1979. 375 p., mostly illus. (color). Bibliography: p.
370. Indexes.
The Weller Pottery was founded in 1872 by Samuel Wel-
ler. It grew and became very successful but was forced
to close after World War II. Lonhuda Pottery was bought
in 1905; many popular art lines were introduced. A. Rad-
ford and Frederick Rhead worked there. The authors
briefly survey this history and illustrate Weller marks and
hundreds of pieces of Weller pottery.

556. Purviance, Louise; Evan Purviance; and Norris F. Schneider.
Weller Art Pottery in Color. Des Moines, Iowa: Wallace-
Homestead Book Co., 1971. 59 p., mostly illus. (color,
black and white).
A companion to the Purviances' Zanesville Art Pottery
in Color and their Roseville Art Pottery in Color. Inci-
dentally, the authors state, "There is no complete collec-
tion of Weller catalogs." This book concentrates on the
later lines of Weller which were machine-produced and are
more available to collectors. All pieces illustrated are

from the Purviances' collection. An alphabetical list of
Weller lines is included. Price guides were issued in
1971, 1975, and 1982.

WESTERN STONEWARE CO.

557. Martin, Jim, and Bette Cooper. Monmouth-Western Stone-
 ware. Des Moines, Iowa: Wallace-Homestead Book Co.,
 1972. 168 p. Many illus. (color, black and white).
 Not seen.

558. Meugniot, Elinor. Old Sleepy Eye. Tulsa, Okla.: Home-
 stead Press, 1979. 46 p. 12 color, 67 black and white
 illus. Index.
 A guide for collectors of "Old Sleepy Eye," stoneware
 steins, crocks, and vases that were given as premiums in
 sacks of flour sold by the Sleepy Eye Milling Co. (Minne-
 sota). The premiums were made by the Western Stone-
 ware Co. and other potteries. The mill opened in 1883
 and closed in 1921. A guide to prices is included. An
 earlier edition was published in 1973.

SAMUEL WILSON POTTERY

559. Harper, George. Please Don't Call Us Bennington. [n. p.],
 1980. 84 p. 56 black and white illus. Bibliography:
 p. 83.
 A casual book which contains "pictures and descriptions
 of earthenware, made in the Samuel Wilson pottery at Troy,
 Indiana from 1850 to 1892," followed by Wilson family his-
 tory, an outline of the family tree, list of descendants, and
 some of the author's experiences while preparing the book.
 The pieces of pottery depicted are pitchers, vases, and
 bowls with, "what appears to be, two coatings of brown
 slip. "

ZANE POTTERY COMPANY

560. Peters & Reed Pottery Company. Pottery, Decorated and
 Plain. South Zanesville, Ohio: Peters & Reed Co. [n. d.]
 21 ℓ., mostly illus.
 Catalog of the vases and flower pots ("Moss Aztec,
 Pereco, Landsun, Persian, Montene, and Chromal Decora-
 tions") of Peters & Reed (1901-1921), later Zane Pottery
 (1921-1941), then Gonder Ceramic Arts (1941-1957).

561. Zane Pottery Company. Zane Ware, Catalog No. 22. [n. p.,
 n. d.] 14 p., mostly illus. (black and white).
 A facsimile of a catalog of the art pottery of Zane Pot-
 tery Company. Many such catalogs were issued.

XXII. INDIVIDUAL POTTERS

LAURA ANDRESON (b. 1902)

562. Andreson, Laura. Laura Andreson: Ceramics. Los An-
geles: UCLA Art Galleries, 1970. 24 p. 31 black and
white illus.
Catalog from a retrospective exhibition, "Ceramics--
Form and Technique," which included 133 pieces made be-
tween 1944 and 1970. Andreson taught at UCLA for many
years. Brief essays precede the catalog illustrations.

RUDY AUTIO (b. 1926)

563. Ross, Judy. A. Rudy Autio: An Artist and a Potter.
Master's thesis, University of Chicago, 1969. 43 ℓ.
38 black and white illus. Bibliography: ℓ. 43.
Study of the life and art of Autio which begins with his
years at the Archie Bray Foundation and ends with his
abandonment of ceramic sculpture and pottery in 1968.
The appendix lists awards, shows, and commissions.

ARTHUR EUGENE BAGGS (1886-1947)

564. Persick, Roberta Stokes. Arthur Eugene Baggs, American
Potter. Ph.D. dissertation, Ohio State University, 1963.
225 ℓ. 26 illus. Bibliography: ℓ. 194-98.
"An investigation, not only of his accomplishments, but
also the setting out of which he emerged, the conditions
which helped to mold his life and his work." Persick
studies the early developments in ceramic art education,
Baggs's years at Alfred University, and the influence of
Charles Binns. His years at Marblehead Pottery, Cowan
Pottery, and as head of the Ceramic Design Department at
Ohio State University are described in detail. Baggs "was
aiming for higher artistic standards in American ceramic
industry"; his remarks on designing for industry are quoted
at length.

EDWIN BENNETT (1818-1908)

565. Holland, Eugenia Calvert. Edwin Bennett and the Products
of His Baltimore Pottery. [Baltimore, Md.]: Maryland
Historical Society, 1973. 44 p. Bibliography: pp. 20-24.
Biography of the man named "father of the pottery indus-
try in this country" by Edwin AtLee Barber. Bennett's
factory, the Edwin Bennett Pottery Co., founded in 1845,
grew to be one of the largest in the country by 1900; the
factory closed in 1936. He was awarded a gold medal at

the 1876 Philadelphia Centennial. The biography accompanied an exhibition of his wares and 132 pieces were exhibited at the Society. Twenty-four of Bennett's marks are illustrated.

CHARLES FERGUS BINNS (1857-1934)

566. Charles Fergus Binns, Memorial, 1857-1934. Alfred University Publication. University Bulletin no. 3. University Bulletin, vol. 11, no. 11, November 1935. Alfred, N.Y., 1935. 24 p. 4 black and white illus.
 Charles Binns was the first director of the New York State School of Clay Working and Ceramics (now the New York State College of Ceramics at Alfred University). Binns, who taught at Alfred from 1900 to 1931, had great impact on many students who passed through Alfred; he has been called "the father of American ceramics." This memorial volume includes biographical essays by his daughters, the president of the American Ceramic Society, and officials of Alfred University. "E Concremantione Confirmatio," Binns's doctoral address, is reprinted in condensed form.

CHARLES M. BROWN (born 1904)

567. Brown, Charles M. Charles M. Brown: Retrospective, 1951-1969. Jacksonville, Fla.: Jacksonville Art Museum, 1969. 13 p. 13 black and white illus.
 Catalog from an exhibition of ninety-three pieces made by a Florida potter who has won several awards (Florida Craftsmen Annual Award, Wichita National Award, Mint Museum Purchase Award). A list of his exhibitions is appended.

568. Brown, Charles M. Charles M. Brown [Retrospective Exhibition of Ceramic Creations]. October 29th through December 15th, 1978, University Gallery, College of Fine Arts, University of Florida, Gainesville. Gainesville, Fla.: University of Florida, 1978.
 Not seen.

R. GUY COWAN (1884-1957)

569. Cowan Potters, Inc. Dealer's Manual and Retail Price List, July 1, 1930. Lakewood, Ohio: Donald H. Calkins [19-?]. 16 p.
 Reprint of a rare catalog which describes the pottery's products, the colors, glazes, and prices.

570. Cowan Pottery Museum. Rocky River, Ohio: Rocky River Public Library, 1978. 14 p. 8 black and white illus.

A pamphlet published at the founding of the Cowan Pot-
tery Museum (which owns over 800 pieces of Cowan Pot-
tery) at the Rocky River Public Library. The Cowan Pot-
tery Studio (1921-1931) underwent "a constant struggle to
keep in balance the commercial lines needed for financial
stability and the art pottery he and his artists needed for
personal satisfaction." Several prominent potters worked
there, including Baggs, Bogatay, Viktor Schreckengost,
and the Winters.

571. Cowan Pottery Studio. Cowan Pottery. Lakewood, Ohio:
 Donald H. Calkins [19-?] 36 p., mostly illus. (black and
 white).
 A reprint of the 1925 catalog of the Cowan Pottery Studio
 in Rocky River, Ohio, described in a publicity flyer as the
 earliest known Cowan Pottery catalog. A short history of
 the pottery is included and the glazes are described.

SUSAN S. FRACKELTON (1848-1932)

572. Weedon, George A., Jr. Susan S. Frackelton & the Ameri-
 can Arts and Crafts Movement. Milwaukee, Wis.: BOOX
 Press, 1975. 169 p. 28 black and white illus. Bibliog-
 raphy: pp. 131-39.
 Weedon published his master's thesis (University of
 Wisconsin-Milwaukee, 1975). It is basically a catalog of
 over one hundred pieces of pottery made by Frackelton; a
 few are by her contemporaries. The introduction outlines
 Frackelton's life, the influences on her, and her role in
 the Arts and Crafts Movement. The catalog contains lengthy
 notes which give more information on the life and work of
 this energetic woman.

MAIJA GROTELL (1899-1973)

573. Grotell, Maija. Maija Grotell. Bloomfield Hills, Mich.:
 Museum of Cranbrook Academy of Art, 1952. 10 p. 6
 black and white illus.
 Catalog from an exhibition (February 7-March 2, 1952)
 of 103 vases and bowls that were made by Grotell after
 leaving Finland for America in 1927. She became a very
 influential teacher at Cranbrook Academy of Art, working
 there from 1938 to 1966.

574. Grotell, Maija. Maija Grotell. New York: New Era Litho-
 graph Co., 1967. 16 p. 10 black and white illus.
 Catalog from an exhibition of the work of Grotell which
 was held at Cranbrook Academy of Art, Joe and Emily
 Lowe Art Center (Syracuse University), and the Museum of
 Contemporary Crafts. Sixty-five pieces made from 1940 to
 1965 were shown. Tributes from her students compose the
 brief text.

WILLIAM H. GRUEBY (1867-1925)

575. Everson Museum of Art of Syracuse and Onondaga County.
Grueby. Syracuse, N. Y.: Everson Museum of Art, 1981.
32 p. 4 color, 17 black and white illus. Bibliographic notes.
The first museum retrospective of William Grueby was
organized in the belief that his work deserves to be more
widely known. Robert Blasberg wrote the catalog essays
which describe Grueby pottery and tiles as well as the his-
tory of the pottery. As a youth, Grueby worked at the Low
Art Tile Works. Blasberg also analyzes the pottery forms
and glazes and the Egyptian sources of the designs. "Grue-
by ware was both a popular and artistic success"; he intro-
duced the matt glaze to American ceramics.

PAUL HUDGINS (1940-1968)

576. Hudgins, Paul. Paul Hudgins, 1940-1968. A Memorial Ex-
hibition. Raleigh: North Carolina Museum of Art, 1968.
56 p. 1 color, 88 black and white illus.
Hudgins made 105 pots, jars, and vases before his early
death that were gathered for this exhibition. Comments from
friends whom he met while working at Wildenhain's Pond
Farm, Penland School of Crafts, and Berea College pre-
cede the catalog.

HARVEY K. LITTLETON (b. 1922)

577. Piarowski, Albert R. Harvey K. Littleton: Artist-Potter.
Master's thesis, University of Chicago, 1958. 72 ℓ. 7
color, 22 black and white illus. Bibliography: ℓ. 71-72.
Littleton's early life, training in Britain and at the Cran-
brook Academy of Art, glaze experiments, and pottery forms
are described. Awards he has received and invitational ex-
hibitions are listed in the appendix. "In Littleton's short
career of eight years he has achieved recognition in forty-
six National Exhibitions, twenty-nine Invitational Exhibitions
and awards in eighteen competitive exhibitions." Piarowski
based his study on interviews with Littleton.

HARRISON MCINTOSH (b. 1914)

578. McIntosh, Harrison. Harrison McIntosh, Studio Potter: A
Retrospective Exhibition. [n. p.]: Rex W. Wingall Museum-
Gallery, Chaffey Community College, 1979. 44 p. 10
color, 20 black and white illus. Bibliography: pp. 41-42.
First retrospective exhibition of McIntosh, who studied
in California under Lukens, Petterson, and Wildenhain and
works as a studio potter and industrial designer. One
hundred pieces were included in the exhibit. Essays by

Garth Clark and Hazel Bray illuminate McIntosh's life and
aesthetic concerns.

JOHN MASON (b. 1927)

579. Mason, John. John Mason: Ceramic Sculpture. Pasadena,
Calif.: Pasadena Museum of Modern Art, 1974. 32 p.
25 black and white illus. Bibliography: pp. 27-30.
John Mason studied at Otis Art Institute with Peter Voul-
kos and later shared a studio with Voulkos. This is a cata-
log from a retrospective exhibition organized by Barbara
Haskell. Her short but informed essay surveys twenty
years of Mason's work from monumental to minimal sculp-
ture.

580. Los Angeles County Museum of Art. John Mason: Sculpture.
Los Angeles: Los Angeles County Museum of Art, 1966.
20 p. 16 black and white illus. Bibliography: pp. 19-20.
John Coplans' introduction to this exhibition catalog points
out: "Mason, as early as 1956, made the first decisive
move from vessel shapes into sculpture.... That there has
been little or no precedent for the use of this material as a
prime medium for ambitious art is now no longer a matter
of consequence." The pieces shown were made from 1963
to 1966.

MEADERS FAMILY

581. Burrison, John A. The Meaders Family of Mossy Creek:
Eighty Years of North Georgia Folk Pottery. Atlanta:
Georgia State University Art Gallery, 1976. 32 p. 20
black and white illus.
Catalog from an exhibition of 117 pieces of the stone-
ware of this well-known "old-fashioned rural" potting fam-
ily, the last folk potters to use home-made alkaline glazes.
About thirty-five pieces in the show were made by other
Georgia folk potters of the nineteenth and twentieth centu-
ries. Georgia pottery history and techniques are discussed.
The Mossy Creek area has had sixty potters since the
1830s; the Meaders family began a pottery in 1893.

582. Meaders, Lanier. A Conversation with Lanier Meaders.
Cullowhee, N.C.: Chelsea Gallery, Western Carolina Uni-
versity, 1980. 21 p. 12 black and white illus.
Joan Falconer Byrd conducted an interview with Lanier
Meaders which was published to accompany an exhibition at
the gallery. He described to her how he got into potting
and how he feels about his famous "face jugs," some of
which are illustrated.

583. Rinzler, Ralph, and Robert Sayers. The Meaders Family:

North Georgia Potters. Smithsonian Folklife Studies, no. 1.
Washington, D.C.: Smithsonian Institution Press, 1980,
© 1981. 160 p. 78 black and white illus. Bibliography:
pp. 152-53.

"The first contemporary Smithsonian research project
using the methods and perspectives of folklore/folklife
scholarship" is based on interviews with Cheever Meaders
(who died in 1967), Lanier Meaders, and other family mem-
bers. The family, the work processes, the wares, glazes,
and kilns are examined meticulously and intimately; the em-
phasis is on the processes and techniques. Three films of
the Meaders at work supplement the study. The folklore
method produced a particularly lively study.

HENRY CHAPMAN MERCER (1856-1930)

584. Bucks County Historical Society. Henry Chapman Mercer,
Sc.D., Ll.D., Born June 24, 1856, Died March 9, 1930:
Memorial Services. Doylestown, Pa.: Bucks County His-
torical Society, 1930. 40 p. 7 black and white illus.

Henry Mercer was a very active antiquarian, researcher,
and collector. Among his other interests, he sought to re-
vive the traditional German processes of tile making in his
Moravian Pottery and Tile Works. This booklet contains
biographies of Mercer and tributes to him by his friends,
a list of papers presented to the Historical Society by him,
and his description of the building of Fonthill, his unusual
cement home decorated with many tiles.

585. Sandford, Joseph E. Henry Chapman Mercer: A Study.
Doylestown, Pa.: Bucks County Historical Society, 1966.
13 p.

A brief personal memoir of Mercer's life and accomp-
lishments. "These recollections were originally printed in
The Bucks County Traveler, June 1956, to commemorate
the Mercer Centennial, and are now reprinted, with addi-
tions, to mark the 50th year of the museum which he built."

MEYER FAMILY

586. Greer, Georgeanna H., and Harding Black. The Meyer Fam-
ily: Master Potters of Texas. San Antonio, Texas: Pub-
lished for the San Antonio Museum Association by Trinity
University Press, 1971. 97 p. 4 color, 38 black and
white illus.

The Meyer Pottery made slip-glazed household pottery
from 1887 to 1964. "From the small two-man operation
grew an active, prospering plant which enjoyed a peak of
success during the first two decades of the twentieth cen-
tury." In the early years, the potters used salt-glaze from
their native Germany; they then turned to slip and lead

glazes, using a groundhog kiln. Many typical pieces are
illustrated and annotated.

HERMAN CARL MUELLER (1854-1941)

587. Taft, Lisa Factor. Herman Carl Mueller: Architectural
Ceramics and the Arts and Crafts Movement. Trenton:
New Jersey State Museum, 1979. 48 p. 32 black and
white illus.
Catalog from an exhibition of the architectural ceramics,
tiles, and sculpture of Mueller and his Mueller Mosaic
Company (1909-1941). "We know relatively little about the
man because no personal papers or company records relat-
ing to him seem to exist. Fortunately, Mueller published
extensively in trade journals." Taft's text is carefully re-
searched; it is based on her dissertation (see entry below).

588. Taft, Lisa Factor. Herman Carl Mueller (1854-1941), Inno-
vator in the Field of Architectural Ceramics. Ph.D. dis-
sertation, Ohio State University, 1979. 193 ℓ. 64 black
and white illus. Bibliography: ℓ. 187-93.
A biography of Mueller in the context of contemporary
American ceramic history and the Arts and Crafts Move-
ment. His association with the American Encaustic Tiling
Co., the Mosaic Tile Co., and Mueller Mosaic are studied.
A possible connection with Henry Mercer is outlined.
Mueller's "accomplishment brought the philosophy of the
Arts and Crafts Movement sensitively ... into the commer-
cial realm."

GERTRUD NATZLER (1908-1971) and OTTO NATZLER (b. 1908)

589. Natzler, Gertrud, and Otto Natzler. The Ceramic Work of
Gertrud and Otto Natzler: A Retrospective Exhibition.
Los Angeles: Los Angeles County Museum of Art, 1966.
48 p. 8 color, 16 black and white illus. Bibliography:
pp. 45-46.
The Natzlers worked in close collaboration as a team
following their meeting in Vienna in 1933: Gertrud threw
each pot and Otto created the glazes. Their work is var-
ied, inventive, and sometimes astonishing. The Natzlers
selected 175 pieces of pottery from Otto's record file of
23,000 pieces for this exhibition. The years of their resi-
dence in Los Angeles (1939-1966) are represented, omitting
the earlier Vienna work and Otto's sculptures and mobiles.
There is an essay by Otto and lists of previous exhibitions
and museums owning the Natzlers' work.

590. Natzler, Gertrud, and Otto Natzler. The Ceramic Work of
Gertrud and Otto Natzler: A Retrospective Exhibition.
San Francisco, Calif.: M. H. DeYoung Memorial Museum,

1971. 74 p. 12 color, 47 black and white illus. Bibliography: pp. 64-72.
This exhibition included pottery from 1940 to 1971, the year of Gertrud Natzler's death. In lieu of an essay, a conversation with Otto Natzler is recorded. The Natzlers' many exhibitions are listed and a lengthy bibliography is added.

591. Natzler, Gertrud, and Otto Natzler. Ceramics: An Exhibit. New York: Jewish Museum, 1958. 12 p. 5 black and white illus.
Catalog from an exhibition of sixty-three pieces which includes a short essay by Otto, "Earth--Water--Fire." This essay appeared in the catalog for the 1959 Zurich exhibition also.

592. Natzler, Gertrud, and Otto Natzler. Form and Fire: Natzler Ceramics, 1939-1972. Smithsonian Institution Press Publication no. 4858. Washington, D.C.: Published for the Renwick Gallery of the National Collection of Fine Arts by the Smithsonian Institution Press, 1973. 120 p. 39 color, 40 black and white illus. Bibliography: pp. 109-11.
This was the third retrospective Natzler show since 1966. Otto calls it "probably the most comprehensive, for it comprises a complete cross-section of our life's work in pottery from 1939 to 1972." An essay and occasional annotations by Otto add interest to the catalog notes. Daniel Rhodes wrote an essay, "Form and Fire," and past exhibitions are listed. The last pots thrown by Gertrud Natzler were exhibited in this show.

593. Natzler, Gertrud, and Otto Natzler. Gertrud and Otto Natzler: Ceramics. Catalog of the Collection of Mrs. Leonard M. Sperry and a Monograph by Otto Natzler. Los Angeles: Los Angeles County Museum of Art, 1968. 80 p. 18 color, 59 black and white illus.
A complete catalog of Mrs. Sperry's collection of Natzler ceramics with an autobiographical monograph by Otto Natzler. He describes this as a "very personal document ... relating to our earliest working period," which "includes heretofore unpublished material on our Clay and Glazes, on Form and Gertrud's Throwing, which may shed light on our philosophy and attitudes toward our medium." The catalog notes are by Otto, also.

594. Natzler, Gertrud, and Otto Natzler. Keramik von Gertrud und Otto Natzler. Zürich: Kunstgewerbemuseum, 1959. 12 p. 6 black and white illus.
This exhibition was held from April 4 to May 3, 1959. The catalog includes a biography of the Natzlers by Willy Rotzler and an essay by Otto Natzler entitled "Erde--Wasser--Feuer," which was also printed for the 1958 exhibition at the Jewish Museum in New York.

GEORGE E. OHR (1857-1918)

595. Blasberg, Robert W. George E. Ohr and His Biloxi Art Pottery. Port Jervis, N.Y.: J. W. Carpenter, 1973. 40 p. 131 black and white illus. Bibliography: pp. 23-24.
Description of the eccentric genius George Ohr and his imaginative hand-thrown wares. He opened the Biloxi Art Pottery in Biloxi, Mississippi, and was, in his own words, the "unequaled, -unrivaled, -undisputed, -greatest, -art potter on the earth." He worked briefly at Newcomb College but was fired; his personality was not suitable for the women's college. In 1906, Ohr abandoned pottery and began selling cars.

596. Earle, Mary Tracy. The Wonderful Wheel. New York, 1896. 152 p.
Not seen. Solon includes this in his bibliography, Ceramic Literature, and describes it as "a story based on the eccentricities of George E. Ohr, the unique potter of Biloxi, Mississippi."

597. Ohr, George E. The Biloxi Art Pottery of George Ohr. Baton Rouge, La.: Printed for the Mississippi Department of Archives and History by Moran Industries, 1978. 32 p. 36 color, 11 black and white illus.
Catalog from the first museum exhibition of Ohr's pottery. Six thousand of his idiosyncratic and vital pieces were stored for fifty years after his death in 1918. Ohr requested the storage of these pieces, hoping that a future generation could appreciate his work. An essay by Garth Clark outlines Ohr's life, antic behavior, and artistic conviction.

OVERBECK SISTERS

598. Ball State University. Art Gallery. The Overbeck Potters of Cambridge City, 1911-1955. Artists in Indiana--Then and Now. Muncie, Ind.: Ball State University, Art Gallery, 1976. 17 p. 21 black and white illus.
The Overbeck sisters had a small, experimental pottery in Cambridge City, Indiana (1911-1955) where only wheel-thrown or hand-built pottery was made. This is the catalog from an exhibition of forty-nine pieces of Overbeck pottery: vases, bowls, sets, and figurines. Fifteen pieces are illustrated. Kathleen R. Postle's introduction describes the Overbeck sisters' approach to pottery: "all borrowed art is dead art."

599. Postle, Kathleen R. The Chronicle of the Overbeck Pottery. Indianapolis: Indiana Historical Society, 1978. 109 p. 39 color, 50 black and white illus. Bibliography: pp. 101-06. Index.
Paul Evans' foreword states: "Dr. Postle's book offers

for the first time an extensive and detailed study of the Overbeck contributions, and it significantly expands knowledge of and appreciation for the art pottery movement itself." Postle was able to use family records for her research into the Overbecks' artistic background, their work, and their family life. The appendixes list marks and Overbeck contributions to Keramic Studio.

CONWAY PIERSON (b. 1927)

600. Pierson, Conway. Conway Pierson: An Exhibition of Recent Work in Ceramics and Bronze. October 5 to November 5, 1967. The Art Gallery, University of California, Santa Barbara. Santa Barbara, Calif., 1967. 32 p. 4 color, 21 black and white illus.
Catalog from an exhibition in a series of faculty shows. Pierson began teaching at Santa Barbara in 1959. A list of his exhibitions since 1959 is included. There is no text.

HENRY VARNUM POOR (1888-1971)

601. Poor, Henry Varnum. A Book of Pottery: From Mud into Immortality. Englewood Cliffs, N.J.: Prentice-Hall, 1958. 192 p. 5 color, 106 black and white illus. Bibliography: p. 187. Index.
A very personal account of making and firing pottery that is less "how-to" than "how Henry Varnum Poor does it." He includes several of his own pieces and many drawings of tools and techniques. Poor's reflections and his ideas about pottery are an important part of the book.

KENNETH PRICE (b. 1935)

602. Los Angeles County Museum of Art. Robert Irwin; Kenneth Price. Los Angeles, 1966. 29 p. 2 color, 15 black and white illus.
Work from 1961 to 1966 was shown in this exhibition. Philip Leider wrote an essay on Irwin and Lucy Lippard wrote on Ken Price. Price studied with Peter Voulkos at the Otis Art Institute and later received his M.F.A. from the New York State College of Ceramics at Alfred University.

ALBERT RADFORD (1862-1904)

603. Radford, Fred W. A. Radford Pottery; His Life & Works. [Columbia? S.C., 1973] 50 p. 60 black and white illus.
Biography of Albert Radford, who came from a family of English potters and moved to America at the age of

twenty. He created Tiffin Jasperware, based on the famous
Wedgwood ware. He then worked at Weller, Zanesville,
and J. B. Owens potteries. He built the Arc-En-Ceil Pot-
tery and then started the A. Radford Pottery in Clarksburg,
Ohio, where he continued to make jasperware. Several
glaze formulas are given and fifty-five pieces of Radford
pottery are illustrated, though not well.

RUTH RANDALL (b. 1898)

604. Joe and Emily Lowe Art Center. Ruth Randall Retrospective.
 Syracuse, N. Y.: Joe and Emily Lowe Art Center, 1962.
 Not seen.

DANIEL RHODES (b. 1911)

605. Truax, Harold Arthur, Jr. Daniel Rhodes: A Study of His
 Work as Exemplary of Contemporary American Studio Cer-
 amics. Ed. D. dissertation, Columbia University, 1969.
 165 ℓ. 24 photographs. Bibliographies: ℓ. 137-42,
 159-60.
 "This study traces the evolution and development of con-
 temporary American studio-ceramics by focusing on the life
 and work of Daniel Rhodes." There are a chronology of
 Rhodes's life, a list of his exhibitions, and interviews with
 Rhodes. Truax sought to study Rhodes, "the nature of con-
 temporary American studio-ceramics," and Rhodes's posi-
 tion among contemporary pottery. Rhodes published several
 books of importance to contemporary potters: Clay and
 Glazes for the Potter; Kilns--Design, Construction, and
 Operation; Pottery Form; Stoneware and Porcelain: The
 Art of High-Fired Pottery; and Tamba Pottery: The Time-
 less Art of a Japanese Village.

RUTH RIPPON (b. 1927)

606. Holland, Ruth Adams. The Ceramics of Ruth Rippon. Mas-
 ter's thesis, Sacramento State College, 1969. 267 ℓ. 164
 illus. Bibliography: ℓ. 88-89.
 Studies the stylistic development, provides a brief biog-
 raphy, and includes a catalogue raisonné of the pottery of
 Ruth Rippon, a student of Anthony Prieto who did not join
 the avant-garde movement in modern art. Rippon produces
 both wheel-thrown and hand-built pottery, much of which
 uses figures and mythological themes.

607. Holland, Ruth Adams. Ruth Rippon. Sacramento, Calif.:
 E. E. Crocker Art Gallery, 1971. 62 p., mostly illus.
 (color, black and white).
 Catalog from an exhibition of 272 pots, sculpture, and

drawings of Rippon's from 1949 to 1971. Holland's essay
summarizes Rippon's interests and development.

ADELAIDE ALSOP ROBINEAU (1865-1929)

608. Metropolitan Museum of Art. A Memorial Exhibition of Por-
celain and Stoneware by Adelaide Alsop Robineau, 1865-
1929. Essay by Joseph Breck. New York, 1929. 9 p.
2 black and white illus.
Robineau was an important figure who, with her husband,
started Keramic Studio for china painters. Robineau her-
self turned from china painting to the wheel throwing of por-
celain. She was influenced by the writings of Taxile Doat
on porcelain; she studied briefly with Charles Binns, then
went on to do very challenging work in porcelain. This
small exhibition catalog includes a short biographical essay
by Joseph Breck. Seventy-one vases, bottles, and bowls
were shown; only two are illustrated.

609. San Francisco. Panama-Pacific International Exposition,
1915. High Fire Porcelains: Adelaide Alsop Robineau,
Potter, Syracuse, New York. 22 p. 7 black and white
illus.
One hundred two bowls and vases made by Robineau
were exhibited at the Panama-Pacific Exposition. An ap-
preciative essay with explanation of the glazes precedes
the catalog. "In her porcelain work Mrs. Robineau has
been guided simply by the desire of producing something
good, something unusual, different from the work of
others." In case the reader did not understand the dif-
ficulties, the essay elaborates that "commercial porcelain
making and individual artistic work in porcelain are abso-
lutely different things." The pieces are priced from $15
to $1,500 for the famous Scarab Vase.

610. Syracuse Museum of Fine Arts. A Collection of Robineau
Porcelains, Arms, Curios and Medals, Also Japanese Ar-
mor, At the Syracuse Museum of Fine Arts. [n.p., c.
1916] 22 p.
The first eight pages of this catalog list thirty-one
Robineau vases made from 1905 to 1915. Comments on
Robineau's work from contemporary literature preface the
catalog, which lists where the vases had been exhibited in
the past.

611. Tiffany & Co. Porcelains From the Robineau Pottery.
Adelaide Alsop-Robineau, Potter. New York: Tiffany &
Co., Agents, [1906?] 30 p. 12 black and white illus.
An unusually detailed and sympathetic presentation by a
commercial firm which explains why Robineau began her
work, her cooperation with Taxile Doat, her studio, her
glazes, and the nature of "true porcelain." The prices
range from $15 to $50.

612. Weiss, Peg, ed. Adelaide Alsop Robineau: Glory in Porcelain. Syracuse, N.Y.: Syracuse University Press in association with Everson Museum of Art, 1981. 235 p. 13 color, 168 black and white illus. Bibliography: pp. 221-27. Index.

This first full-length study of Robineau is based partly on material collected by Anna W. Olmsted during the 1930s for a book never completed. Chapters have been contributed by several scholars and potters to this attractive, well-researched book. The topics are as follows: a biographical essay, "Robineau's Early Designs" by Martin Eidelberg, "The University City Venture" by Frederick H. Rhead, "Technical Aspects" by Richard Zakin, "Robineau's Crystalline Glazes" by Phyllis Ihrman, and "Inventory of Robineau's Work in Public Collections in the United States" by Leslie Gorman. Weiss hopes that more scholarly work on Robineau will be stimulated.

VIKTOR SCHRECKENGOST (b. 1906)

613. Cleveland Institute of Art. Viktor Schreckengost: Retrospective Exhibition. Cleveland, 1976. 12 p. 18 black and white illus.

An exhibition of Schreckengost's pottery and paintings was held March 14-April 3, 1976. He studied ceramics at the Cleveland Institute of Art under Arthur Baggs and Guy Cowan. He went on to teach design and become a successful industrial designer. The catalog essay summarizes the events of Schreckengost's life and describes his ceramic sculptures.

WALTER STEPHEN (1875-1961)

614. Stephen, Walter Benjamin. The Pottery of Walter Stephen: An Exhibition, the Mint Museum of History. Journal of Studies of the Ceramic Circle of Charlotte, vol. 3. Charlotte, N.C.: Ceramic Circle, 1978. 30 p. 22 black and white illus. Bibliography: p. 11.

Catalog from the first major exhibition of this North Carolina potter who "worked in the Southern traditional standards and produced wares of amazing variety and skill." He worked first at the Nonconnah Pottery in Tennessee, then at the Pisgah Forest Pottery in North Carolina, and specialized in the pâte-sur-pâte technique. A biography accompanies the catalog.

MARIA LONGWORTH NICHOLS STORER (1849-1932)

615. Trapp, Kenneth Raymond. Maria Longworth Storer: A Study of Her Bronze Objets d'Art in the Cincinnati Art Museum. Master's thesis, Tulane University, 1972. 209 ℓ. 54 black

and white illus. Bibliography: ℓ. 206-09.
An informed and close study of "a group of previously
unknown bronze and ceramic objets d'art, twenty-two in all,
in storage at the Cincinnati Art Museum." This work was
done during Mrs. Storer's final years at the Rookwood Pot-
tery (she was actually in Europe much of the time); it is
examined in the context of her previous ceramic work.
Trapp offers a biographical and stylistic history of Storer
before focusing on the bronzes which reflect Oriental and
Art Nouveau styles and end-of-the-century decadence.

LOUIS C. TIFFANY (1848-1933)

616. Koch, Robert. Louis C. Tiffany's Glass--Bronzes--Lamps:
A Complete Collector's Guide. New York: Crown, 1971.
208 p. 352 black and white illus. Index.
While glass dominates, there is a chapter on pottery,
enamels, and jewelry (pages 148-62). Some of the first
pots were thrown by Tiffany himself but most were made
"under the supervision of Louis C. Tiffany" and usually
molded. A price list of 1906 is appended. There is no
bibliography; most of Koch's research took place in antique
shops and shows.

617. Tiffany, Louis Comfort. Tiffany's Tiffany: A Loan Exhibi-
tion From the Morse Gallery of Art, Winter Park, Florida.
Corning, N.Y.: Corning Museum of Glass, 1980. 21 p.
Bibliography: p. 21.
Tiffany glass, architectural details, and pottery from the
collection made by Jeannette and Hugh McKean were exhibi-
ted. They purchased the details from Tiffany's house that
were not ruined in the 1957 fire and have rescued other
Tiffany works since then. Nine pieces of pottery were
shown. The text states that Tiffany experimented with pot-
tery as early as 1898 and that production continued until
about 1914.

ARTUS VAN BRIGGLE (1869-1904)

618. Arnest, Barbara M., ed. Van Briggle Pottery: The Early
Years. Colorado Springs, Colo.: Colorado Springs Fine
Arts Center, 1975. 70 p. 8 color, 11 black and white
illus. Bibliography: p. 37.
Catalog from an exhibition of work from the Van Briggle
Pottery. Most pieces exhibited were from 1900-1906. An
appendix illustrates 746 designs made in the Van Briggle
Pottery from 1900 to 1912. Another catalog of ten pages
with the same title which lists the lenders to the exhibition
was published in 1975 also.

619. Bogue, Dorothy McGraw. The Van Briggle Story. 2d ed.

Colorado Springs, Colo.: Century One Press, 1976. 60 p.
39 black and white illus. Bibliography: pp. 50-52.
Biography of Artus Van Briggle and the history of the
pottery after his death in 1904. He worked at Rookwood
and studied art in Europe before poor health forced him to
move to Colorado where he opened the Van Briggle Pottery.
First published in 1968, the 1976 edition contains supple-
mentary biographical notes.

PETER VOULKOS (b. 1924)

620. Slivka, Rose. Peter Voulkos: A Dialogue with Clay. Bos-
ton: New York Graphic Society in association with Ameri-
can Crafts Council, 1978. 142 p. 24 color, 84 black and
white illus. Bibliography: pp. 139-42.
"This is the most extensive book on a major figure in
modern American crafts. It surveys the range of the Voul-
kos oeuvre--the ceramics, bronzes, and paintings--from
1948 to 1978." Slivka, critic and past editor of Craft Hori-
zons, writes of the life and work of Voulkos through inter-
views with him and his associates. His working methods,
changing attitude toward ceramics, and influential stature
among contemporary artists are described in lively detail.
This book was published with an exhibition organized by the
Museum of Contemporary Crafts.

621. Voulkos, Peter. Peter Voulkos in Houston, 1978. Houston,
Texas: Contemporary Arts Museum, 1978. 5 p. 2 black
and white illus.
Catalog from a retrospective exhibition of Voulkos' clay
pieces from 1949 to 1978. There is a brief biography and
checklist of the exhibition.

622. Voulkos, Peter. Peter Voulkos: Sculpture. Los Angeles:
Los Angeles County Museum of Art, 1965. 14 p. 12 black
and white illus. Bibliography: p. 13.
Catalog from an exhibition of ten sculptures, some of
fired clay, others of bronze. There is no essay in this
catalog.

623. Voulkos, Peter. Sculpture and Painting by Peter Voulkos:
New Talent in the Penthouse, February 1-March 13, 1960.
New York: Museum of Modern Art, 1960. 5 p. 5 illus.
Voulkos' work was first shown in a New York museum
by the Museum of Modern Art in its New Talent series.
He was "still relatively unknown in New York." Six
sculptures and six paintings were exhibited.

FRANS WILDENHAIN (b. 1905)

624. Wildenhain, Frans. Frans Wildenhain: A Chronology of a

Master Potter. Rochester, N.Y.: Rochester Institute of Technology, College of Fine and Applied Arts, 1975. 51 p. 37 black and white illus.

Wildenhain was born in Germany, studied at the Bauhaus, taught, and was inducted into the German army before moving to America. From 1947 to 1950 he was at Pond Farm, Marguerite Wildenhain's studio. He then began teaching at the Rochester Institute of Technology. Sculptural pieces and pots from Wildenhain's long career were shown in this retrospective exhibition. The short text is appreciative rather than biographical or critical. Curiously since it is titled "a chronology," the pots exhibited are not dated in the catalog.

625. Wildenhain, Frans. Frans Wildenhain Retrospective. Binghamton: University Art Gallery, State University of New York at Binghamton, [1974?] 44 p. 27 black and white illus.

There were 161 pieces of pottery, sculptures, and murals included in this exhibition; twenty-six are illustrated. They were made from 1933 to 1973. Biographical information and "appreciations" from colleagues are included.

MARGUERITE WILDENHAIN (b. 1896)

626. Wildenhain, Marguerite. The Invisible Core: A Potter's Life and Thoughts. Palo Alto, Calif.: Pacific Books, 1973. 207 p. 52 black and white illus.

Wildenhain's autobiography describes her childhood, study at the Bauhaus, emigration to America, and teaching at Pond Farm in Guerneville, California in graceful, reflective prose. Woven through are her thoughts on art, craftsmanship, and education. She summarizes: "The good pot will endure through the centuries because of its integrity, its sound and pure purpose, its original beauty, and especially because it is the indivisible, incorruptible, and complete expression of a human being."

627. Wildenhain, Marguerite. Marguerite: A Retrospective Exhibition of the Work of Master Potter Marguerite Wildenhain. Ithaca, N.Y.: Herbert F. Johnson Museum of Art, 1980. 40 p. 1 color, 48 black and white illus. Bibliography: pp. 39-40.

Included are 128 ceramic works, drawings, and portraits, dating from 1920 to 1980. Essays by Nancy Press and Terry F. A. Weihs preface the catalog which contains many quotations from Wildenhain's writings and comments by other potters.

628. Wildenhain, Marguerite. Pottery: Form and Expression. Palo Alto, Calif.: American Crafts Council and Pacific Books, 1973. 157 p. 97 black and white illus.

"This is more than a technical book"; the student will not find basic instruction. Here are Wildenhain's thoughts on the integrity and form of pottery. An influential potter and teacher, she discusses the role of craftsmen, approaches to form and decoration, and pottery in culture. She concludes with an imaginary dialogue between a student and a potter. First published in 1959, this is a reissue of the enlarged 1962 edition (New York: Published for the American Craftsmen's Council by Reinhold).

BEATRICE WOOD (b. 1894)

629. Wood, Beatrice. Beatrice Wood: A Retrospective. Phoenix, Ariz.: Phoenix Art Museum, 1973. 14 p. 1 color, 11 black and white illus.

Catalog from an exhibition of Wood's pottery and figures which date from 1940 to 1973. A brief biography is given in the foreword; she was an actress and dancer who was introduced to modern art through a friendship with Marcel Duchamp. Years later, she began to study ceramics with Lukens and the Natzlers.

AUTHOR INDEX

Adamson, Jack E. 388
Agranoff, Barbara 521
Agranoff, Joseph 521
Alexander, Donald E. 531
Altman, Seymour 459
Altman, Violet 459
American Crafts Council. Research & Education Department 1; see also American Craftsmen's Council
American Craftsmen's Council 257, 262; see also American Crafts Council, Research & Education Department
American Craftsmen's Council. Museum of Contemporary Crafts 25, 66, 251, 253-56, 258-61, 263
American Craftsmen's Educational Council 252
American Encaustic Tiling Company 439
American Federation of Arts 264
Anderson, Timothy J. 435
Andreson, Laura 562
Anscombe, Isabelle 200
Arnest, Barbara M. 618
Association of San Francisco Potters 433
Ault, Roger 510

Badger, Reid 131
Baker, Vernon G. 150
Ball State University. Art Gallery 598
Baltimore Museum of Art 265-66
Barber, Edwin AtLee pp. xiii-xiv, xvii-xviii, xx; 13, 17, 26, 28, 68-70, 121-23, 227, 246, 352, 354, 469
Barglof, Elva Zesiger 415

Barka, Norman F. 151, 163
Barnard, Julian 235
Barnes, Benjamin H. 492
Barons, Richard I. 187
Barr, Margaret Libby 425
Barr, Robert 425
Barret, Richard Carter 442-44
Beard, Geoffrey W. 267
Belknap, Henry Wyckoff 303-04
Berkow, Nancy 475
Berky, Andrew S. 505
Bettinger, Charles 478
Binns, Charles Fergus pp. xiv-xv; 27, 93-95, 100, 291
Bishop, Edith 330
Bishop, J. Leander 135
Bishop, Robert Charles 167, 188
Bivins, John, Jr. 371-72
Black, Harding 586
Blair, C. Dean 389
Blake, William P. 127
Blasberg, Robert W. 468, 575, 595
Bleicher, Fred 507
Boehm, Helen F. 450
Boger, H. Batterson 168
Boger, Louise Ade 14, 168
Bogue, Dorothy McGraw 619
Bohdan, Carol L. 468
Bond, Harold Lewis 169
Bougie, Stanley J. 512
Bower, Beth Anne p. xx; 339
Bowman (George H.) Co. 96
Branin, Manlif p. xx; 299
Branner, John Casper p. xiv; 3
Bray, Hazel V. 434, 578
Breck, Joseph 608
Breininger, Lester P., Jr. 340
Brewer, J. H. 134
Bridges, Daisy Wade 373, 378
Brinker, Lea J. 390

151

TITLE INDEX

SUBJECT INDEX

Abingdon Pottery 438
Abstract Expressionism 73,
 263, 268, 278
Aesthetic Movement 202
African ceramics 60, 155
Afro-American ceramics 60
 Mississippi 386
Alfred University see New
 York State College of
 Ceramics at Alfred
 University
Alkaline glaze 153
 Georgia 581
 North Carolina 373, 381
 Texas 428
 see also Ash glaze
American Ceramic Society
 p. xiv
American Craft see Craft
 Horizons
American Crafts Council
 p. xviii
American Encaustic Tiling Co.
 247, 250, 439-40, 542,
 588
 Langenbeck 104
American Modern (dinnerware
 line) 222, 548
Andreson, Laura 265, 562
Antiques 167-80
Arc-En-Ceil Pottery 603
Archie Bray Foundation 287,
 432, 563
Architectural terra cotta 208
 Chicago 410-11
Arneson, Robert 433
Art education 181-186
 America pp. ix, xiv-xvi;
 128, 564
 Cincinnati 390
 Women's role 71
Art Nouveau 34-35, 202, 615
 Newcomb College 493
Art pottery 42, 56, 63, 120,

 200-16
 Atlanta collections 384
 Bibliography 207-08
 Brooklyn Museum 124
 California 434-35
 Catalog 31
 Chicago 410-11
 China-painting sources
 p. xii
 Cincinnati 390-92, 394
 Collector's guide 54, 58,
 176, 178-79
 1889 exhibition p. xiii
 End of movement pp. xv-
 xvii
 European sources 391
 Exhibition 29, 49
 Exposition display 132
 Identification 33
 Japanese sources 106, 108,
 111
 New England 297
 New Jersey 331
 North Carolina 378
 Ohio 396
 Price guide 43, 520
 Women's role p. xii; 71,
 390, 394, 405
 Zanesville 402, 404
 see also individual potteries
 and ceramists
Arts and Crafts Movement
 pp. ix, xii-xiii; 34-35,
 201, 214
 Britain 200
 Essays 73
 Exhibition 202
 Herman Carl Mueller 588
 Newcomb College 493
 Susan Frackelton 572
 Women's role 71
Ash glaze
 South Carolina 382
 Texas 427

174